COLLECTION FOR A KING

COLLECTION FOR A KING:

Old Master Paintings from the Dulwich Picture Gallery

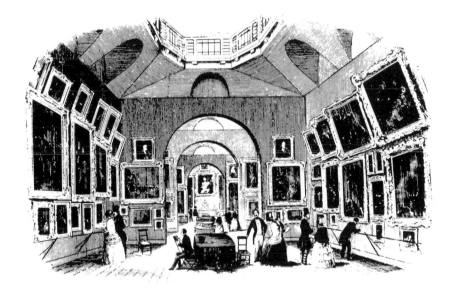

National Gallery of Art, Washington, D.C.
14th April 1985–2nd September 1985

Los Angeles County Museum of Art
3rd October 1985–5th January 1986

Preface

The Dulwich Picture Gallery, one of the oldest public museums in Britain, is surprisingly unknown to the American public. It includes among its treasures paintings of the highest quality and importance, by artists of the stature of Rembrandt, Rubens, Van Dyck, Poussin, Guercino, Murillo and Gainsborough. The selection of works shown in this exhibition bears witness to the extraordinary standard of the Dulwich paintings, and demonstrates the range of this distinguished collection.

The unique opportunity to exhibit this selection has occurred through the generous co-operation of the Governors of the Dulwich Picture Gallery and Giles Waterfield, the Director. The splendid catalogue accompanying the exhibition has also been organized through Mr. Waterfield's untiring efforts.

This exhibition is supported by an indemnity by the Federal Council on the Arts and Humanities.

As discussed in the introduction, the core of the collection consists of works originally assembled in the late eighteenth century for a proposed National Gallery of Poland. The King of Poland, Stanislaus Augustus, was forced to abdicate in 1795, however, and the collection remained in England. These works were among those bequeathed to Dulwich by Sir Francis Bourgeois in 1811.

The magnificent paintings collected for King Stanislaus Augustus were given an appropriately grand setting. The picture gallery constructed by Sir John Soane is a fascinating example of this major architect's work.

Although the Dulwich Picture Gallery has occasionally lent some of its paintings to exhibitions, never before has it shared its riches outside of Great Britain on such a scale. We are particularly pleased to be able to show these works and hope that the exhibition will encourage many to visit Dulwich to admire the setting, the building, and the other masterpieces in its collection.

J. Carter Brown
Director,
National Gallery of Art

Earl A. Powell, III
Director,
Los Angeles County Museum of Art

Foreword

Dulwich Picture Gallery is the earliest, and one of the most appealing, of all the museums of art in England. Its charm lies in its setting, the delightful green suburb of Dulwich four miles from Westminster; in the building, one of the few remaining works of Sir John Soane; and in the collection, a rare surviving example of the taste of the early nineteenth century.

Dulwich Picture Gallery belongs to the charitable foundation of Alleyn's College of God's Gift, and the trusteeship of the collection rests with the Governors of the Foundation. The Gallery receives no public funding apart from a grant, awarded since 1952, from the Greater London Council. Inflation has made the proper running of the Gallery an increasingly difficult task, but in spite of such problems the Governors have, especially in recent years, done everything possible to bring curatorial and conservational care within the Gallery to the highest professional standard. We are extremely grateful to the Trustees of the National Maritime Museum for the extensive help, particularly over conservation, that the Museum has generously given to the Gallery since 1976.

The exhibition of Dulwich paintings in Washington has been under discussion since 1981. We would like to thank the staff of the National Gallery of Art, and especially Mr. Carter Brown and Mr. Arthur Wheelock, for their enthusiastic support throughout the exhibition's planning.

One of the difficulties of Dulwich is that it is too little known. It is hoped that sending some of the finest pictures from the collection to the United States will allow a much wider audience to enjoy these treasures, and that many who visit the exhibition will one day find their way to Dulwich to see all the other riches that it possesses.

Basil Greenhill
Chairman of the Dulwich Picture Gallery Committee

Committee of Honour

Honourable Charles H. Price II,
United States Ambassador to the Court of St. James's.

His Excellency, Sir Oliver Wright, G.C.M.G., G.C.V.O., D.S.C.,
British Ambassador to the United States.

The Rt.Hon. The Earl of Gowrie,
Chancellor of the Duchy of Lancaster and Minister for the Arts

Peter Bowring, Esq.
Sir Hugh Casson, K.C.V.O., P.P.R.A.
Sir Douglas Fairbanks, K.B.E., D.S.C.
Dr. Basil Greenhill, C.B., C.M.G.
Sir Leonard Hooper, K.C.M.G., C.B.E.
Sir Michael Levey, M.V.O.
The Rt.Hon. Lord Shawcross, G.B.E., Q.C.
James B. Sherwood, Esq.

The Governing Committee of Dulwich Picture Gallery

Laurence H. Brandes, Esq., C.B.
Peter Greenham, Esq., R.A.
Dr. Basil Greenhill, C.B., C.M.G.
Judge M.B. Goodman
Jeremy M.B. Gotch, Esq.
Sir Douglas Henley, K.C.B.
Sir Michael Levey, M.V.O.
Miss G.M. Lewis
T.H. Peace, Esq., M.C.

This exhibition has been supported at the National Gallery of Art in Washington by a generous grant from Gerald D. Hines Interest.

Acknowledgements

I am particularly grateful to the following for their help in the preparation of this exhibition:

In conservation of the pictures: The National Maritime Museum, especially the Trustees and the Director for allowing the staff of the Conservation Department to play so active a part in advising on conservation and for making available the Department's technical facilities; Miss Gillian Lewis, Head of the Department; Mrs. Caroline Hampton, Miss Elizabeth Hamilton-Eddy, Mr. Stuart Sanderson, Mr. David Taylor and Mr. Gary Gardner; and Messrs. David and Duncan Drown.

In the preparation of the catalogue: all the contributors for their effective and punctually-delivered entries; Sir Michael Levey for his penetrating advice; and Barry Viney, Director of Art at Dulwich College, for his imaginative and painstaking work on the design.

In the preparation of frames: Mrs. Margaret Guest and the Frame Department of the National Gallery, London.

Within the Gallery: Christina Brocklebank, Patrick Elliott, John Sheeran and Elizabeth Tatman for their hard work and patience.

Giles Waterfield
Director, Dulwich Picture Gallery

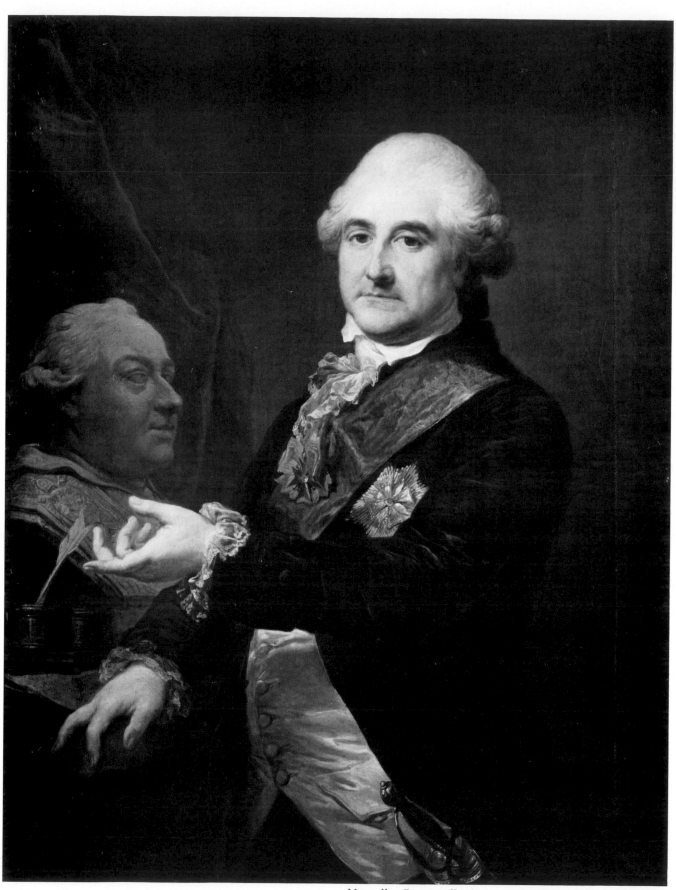

Marcello Bacciarelli (1731–1818): *Stanislaus Augustus Poniatowski, King of Poland*. Canvas. (Private Collection)

Introduction

by Giles Waterfield

Dulwich Picture Gallery

Dulwich Picture Gallery is one of the finest collections in England remaining in private hands. It belongs to the charitable Foundation known as Alleyn's College of God's Gift, originally established in 1619. This Foundation includes among its nine beneficiaries three private secondary schools in Dulwich – Dulwich College, Alleyn's School and James Allen's Girls' School. The status of the Gallery as part of an educational charity is an unusual one, the nearest equivalent being a university museum. The Gallery was known as 'Dulwich College Picture Gallery' until 1979, when the name was changed following alterations in the constitution of the Foundation.

Dulwich (pronounced 'Dullich') is a suburb of London, four miles south of Westminster. Though now engulfed in the city, it retains a charming village and many fields and woods.

This picture gallery is the earliest surviving collection of Old Master paintings to be regularly open to the public in England. Only three paintings in the collection have ever been bought: the rest have been bequeathed or given. The Gallery is indebted to a succession of benefactors, but most notably to Noel Desenfans, his wife Margaret, and their friend Sir Francis Bourgeois.

Noel Desenfans and Francis Bourgeois

The two principal founders of the Dulwich collection, Noel Desenfans (1744–1807) and Francis Bourgeois (1756–1811) were well-known in their day in the artistic world of London; indeed they were notorious, and the numerous references to them in contemporary newspapers, pamphlets and diaries are by no means universally flattering. Neither was English in origin; both came from relatively obscure backgrounds, and both used art, whether as collector or practitioner, as a means of social advancement. Desenfans remarked in the preface to a sale catalogue of 1802 that it was only through the fine arts that the untitled could hope to achieve distinction in society, and such distinction was something both of them craved. In life they sought fame through exhibitions and intrigues at the Royal Academy, through auctions, collecting, and manipulation of the Press; in death they pursued the same aim by a bequest, and finally achieved what they desired.

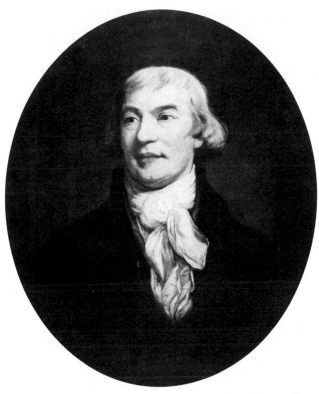

James Northcote, R.A. (1746–1831): *Noel Joseph Desenfans* 1796. Canvas. (Dulwich Picture Gallery)

Noel Desenfans

The most substantial source for the early life of Desenfans is the *Memoir* written in 1810 by 'JT', presumably his friend, John Taylor, a journalist and author. It is not a particularly reliable source, being a panegyric, and tending to exaggerate and even falsify. Desenfans was born in 1744 in Douai, to parents of whom nothing is known; the rumour that he was a foundling appears unjustified, since in later life he made a regular allowance to a relation in Paris, continued by his wife in her will. Douai, a town about twenty-five miles south of Lille in north-east France, was best-known in the eighteenth century for its ancient university, where as a boy Desenfans received his education. By the 1750s the university was somewhat in decline, but it introduced him to such lasting friends as John Philip Kemble, later a great tragic actor on the English stage, and to Charles-Auguste de Calonne, who was to become first minister of France in the 1780s and a major collector of paintings. According to the *Memoir*, Desenfans won every important prize at Douai, and achieved equal success at the University of Paris, to which he moved at the age of eighteen. In Paris he embarked on a literary career in 1763 with *L'Elève de la Nature*, a work which, we are told, won him the approval of Rousseau.

Douai had an old association with England through its

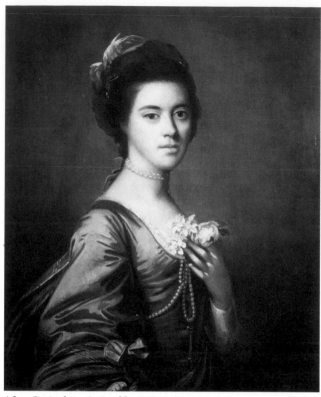

After Sir Joshua Reynolds, P.R.A. (1723–92): *Margaret Morris, later Desenfans.* Canvas. (Dulwich Picture Gallery). Margaret Morris was painted by Reynolds around 1757, when she was in her twenties.

Catholic English College, and it may have been this connection that encouraged the young man in 1769 to seek his fortune in London. He worked as a teacher of languages before establishing himself by marriage. On 10th June 1776 at the age of 31 he was married at St. Marylebone Parish Church to the aunt of two of his pupils, Margaret Morris, a Welsh lady aged 45. It appears to have been a hasty marriage and is unlikely to have met with the approval of the Morrises, a family from Swansea in South Wales, which had recently become prosperous through the rope trade and had been granted a baronetcy. Margaret Morris had the advantage of a respectable private income (though not the capital sum of £5,000 traditionally attributed to her). She evidently settled without complaint into the role of unobtrusive wife: almost no descriptions remain of her beyond Taylor's comment, after her husband's death, that of her *"It is enough to say that her mind and heart fully entitled her to such a husband, and (she) too well proves her sense of his worth, by inconsolable regret".*

Desenfans set himself up during the 1770s as a picture dealer, and made, at least until the 1790s, a fair amount of money. His knowledge of art was limited: several anecdotes are told of tricks being played on him, in one case by Joshua Reynolds, by which he was induced to enthuse over or buy modern forgeries of Old Masters. His judgement was especially exposed by a spectacular and absurd legal case in 1787, when he sued a rival dealer, and personal enemy, Benjamin Vandergucht, for selling him a false Poussin. Desenfans won the case, in which most of the leading artists in London appeared as witnesses, but his reputation cannot have been enhanced. In a London where picture collecting was becoming increasingly popular, but where most collectors were more interested in famous names than in quality, Desenfans was assisted by a number of factors, especially his close business relationship with Jean-Baptiste-Pierre Lebrun (1748–1813), his friendships with such important Frenchmen as Calonne, and the active assistance of Francis Bourgeois.

Lebrun was one of the most remarkable connoisseurs and dealers of his time, and in many ways Desenfans modelled himself upon this compatriot. They collaborated for a long period – Lebrun wrote after Desenfans' death: *"Never again could I find such a partner as my friend Desenfans with whom I conducted business for thirty years to our mutual satisfaction"* – and were on close personal terms. In 1789 Lebrun wrote to Desenfans that he had received overtures from Vandergucht, which he had rejected because of his successful working relationship with Desenfans, and commented that it would amuse him to lure their mutual enemy into making an unwise purchase. Lebrun lived in considerable style (in spite of his unhappy marriage to the portraitist Mme. Vigée Lebrun), in a house in the rue de Cléry in Paris. There he built a gallery, which housed his personal collection (items from which he sent to London for sale by Desenfans in 1789, to his great regret as he claimed). He was given to writing extended catalogues for his sales, and presenting himself as a connoisseur who dealt, by the way, in paintings. In all these respects Desenfans imitated him. He, too, kept a large house with a major collection which, for much of the time, he claimed to regard as his personal one; he too wrote a long catalogue, to accompany his sale of 1802, and he too liked to be seen as a gentleman rather than a dealer. In the 1780s a newspaper scathingly remarked of him that *"A certain foreign gentleman who is said to be a great encourager of the arts has found that* secret *of dealing in pictures without passing as* a dealer, *of exhibiting them without* being an exhibitor, *and of heaping money without passing for a monied man."*

Lebrun also regularly furnished his London colleague with important pictures, including Murillo's *Flower Girl* (no. 22), Poussin's *Triumph of David* (no. 24) and *Les Plaisirs du Bal* (inv. no. 156) by Watteau. Lebrun's paintings were sold by Desenfans by private arrangement or at auction and the proceeds were divided equally between the two. Desenfans had other suppliers, such as Gavin Hamilton, the well-known Scottish artist-collector in Rome, but Lebrun was easily his most fruitful connection.

Francis Bourgeois, R.A.

The other major influence on Desenfans was his friend and collaborator Francis Bourgeois. Bourgeois was the son of Issac (sic) Bourgeois, a Swiss, and of Elizabeth Gardin, an Englishwoman. Issac (or Isaac), probably the child of that name baptized in the Huguenot Church in London in 1707/08, was a descendant of a Swiss family, originally from Yverdon in the Vaud, but living in London. He appears to have practised as a watchmaker in Saint Martin's Lane. According to Benjamin West, (reported by Farington), Bourgeois senior, on the death of his wife, *'quitted England and left the two children* [there was a sister] *here unprovided for. Desenfans by some means became with others interested in the fate of these children to whom he was in no way related.'* The daughter was sent to Switzerland and young Francis became the charge of Desenfans. The likelihood of this story is confirmed by a letter in the Dulwich College archives, written by Isaac Bourgeois to Desenfans after the latter's marriage, in which he extols Desenfans' goodness to the family and asks him to look after the girl as well. It was a suggestion to which the anticipated benefactor evidently did not agree, though Francis Bourgeois in later life made an annual payment to a 'Miss Bourgeois', to whom he left money in his will. Farington recorded a conversation with Bourgeois in 1805 in which the latter recalled having been with Desenfans from the age of ten. This precarious early life is at variance with the 'official' biography presented in *Public Characters of 1799–1800*, in which Bourgeois is depicted as *'destined by his father to the profession of arms in consequence of the friendship entertained for the family by the late Lord Heathfield'*, who had supposedly promised the boy a commission. Such a discrepancy is typical of the hyperbolic early accounts of the lives of these two men.

Desenfans, fascinated by the power of art, decided that his protégé Francis Bourgeois should become a painter. He was sent as a pupil to De Loutherbourg, the gifted French artist who had lived in London since 1771 and whose style shaped that of Bourgeois. He also, by his own account, learnt from Nature, and in 1776 was sent by Desenfans on a Grand Tour of France, Italy and Switzerland. On his return he moved back into the Desenfans household, and stayed with his benefactors for the rest of his life.

Bourgeois and the Academy

Desenfans was determined that his friend should make a reputation as an artist. Positions at Court and membership of the Royal Academy constituted official recognition, and these aims Desenfans resolved to achieve on Bourgeois' behalf. He worked hard on publicity, frequently inserting complimentary paragraphs in the

Sir William Beechey, R.A. (1753–1839): *Sir Francis Bourgeois, R.A.* c.1805. Canvas. (Dulwich Picture Gallery). Bourgeois is wearing the medal and ribbon of the Order Merentibus, awarded him by the King of Poland.

newspapers, some of which – *The London Chronicle, The Morning Herald, The World* – regularly contained flattering notices of Bourgeois' work. A comment from *The World* of 7 May 1791 is characteristic. *"From the crowds which daily encircle the celebrated picture of* The Convicts, *by Sir F. Bourgeois at the Exhibition at the Royal Academy, you are continually hearing the observation 'And is it possible that this Painter can have been excluded from the Royal Academy?'."*

He was not excluded for long. His first attempt at election as Associate of the Royal Academy at the age of twenty-five was not a success (he received no votes) but in 1787 he did become an Associate, and in 1793 the Academicians, (fortified, it was rumoured, by Desenfans' hospitality) after four ballots elected him to full membership. His position was further assured by appointments as Painter to the King of Poland in 1791, and in 1794 Landscape Painter to King George III of England.

Dulwich Picture Gallery possesses twenty-one paintings by Bourgeois. Late in the nineteenth century several of them hung in the Gallery Mausoleum; now (with one exception) they do not hang at all. His talent, except for a dashing virtuosity in some of his sketches, was inconsiderable, tending to imitate the freely executed hot

Sir Francis Bourgeois' Diploma as a Royal Academician, 1793, signed by King George III. Engraving. (Dulwich Picture Gallery)

Sir Francis Bourgeois, R.A:
William Tell. Canvas. (Dulwich Picture Gallery)

manner of De Loutherbourg. Many of the reviews of his works shown at the Royal Academy reflect contemporary scepticism, his colouring being found particularly offensive. In May 1794 *The Morning Post* declared his *Sans Culottes* the worst picture in the Academy Exhibition,

adding: "*Sir Francis Bourgeois last year exhibited a penny ride in the Royal Academy. We wish that this year he would treat himself to a pennyworth and gallop out of the exhibition.*" Nonetheless, he established a fair reputation. His works were bought by the Royal Family, by Joshua Reynolds and John Soane, by such major collectors as Lord Methuen for Corsham and Lord Egremont for Petworth; and he received commissions from the King of Poland and the Empress of Russia.

The House in Charlotte Street

After a number of moves, the Desenfans' and Bourgeois settled in 1786 in two new houses at No. 38 and No. 39 Charlotte Street, Portland Place (now Hallam Street). The house (now demolished) was at the end of the street, beside open country. It was a most respectable neighbourhood; other residents of the street included in 1796 an admiral, a colonel and a clergyman. Externally it seems to have been a building of some pretension, with its 'back front' on Portland Road adorned with a bas-relief showing *The Sacrifice of Bacchus*, measuring fourteen feet by six and designed by Robert Adam. Two inventories of the contents, made in c.1802 and in 1813, reveal the spaciousness of the interior, with a Saloon, a Parlour and Ante-room, a Drawing Room, Dining Room, a 'Berchem Room' and a 'Cuyp Room', a Little Parlour with an adjoining closet, and a Skylight Room at the top for the largest pictures. At its peak, with 360 paintings crowded inside, fourteen Poussins in the Dining Room and twelve Cuyps in the Library, and in the Skylight Room, Reynolds' *Mrs. Siddons*, a nine-footer, above a picture seven feet in height, it must have been spectacular. Bourgeois and Desenfans were enthusiastic hosts, giving many dinner parties, from which, even when the company was mixed; Mrs. Desenfans was absent. James Boaden, a regular guest, warmly recalled Desenfans' hospitality on these occasions.

Their circle of friends was important to the two men, and they were at pains to expand it. It included representatives of the theatre, especially Kemble; of painting and architecture in Beechey, Farington, West, Soane; of literature, in such men as John Taylor and Boaden. What it lacked was representatives of high society. Desenfans was on friendly terms with such figures as the Duke of Gloucester, a brother of the King, for whom he acted as agent, and in 1786 his collection was visited – to the accompaniment of numerous notices in the Press – by the Royal Family, but he could not claim the aristocratic intimates whose attention he craved. His habit of leaving tickets for his box at the opera or the circus with members of the nobility was not received with enthusiasm. Though both Desenfans and Bourgeois were well known, even to the King, they seem to have been viewed

with scepticism and some hostility in society. Leigh Hunt's account of meeting Bourgeois may be regarded as typical: *"He was in buckskins and boots, the dandy dress of that time; and appeared to us a lively, good-natured man, with a pleasing countenance. Ever afterwards we had an inclination to like his pictures, which we believe were not very good; and unfortunately, with whatever gravity he might paint, his oath and his buckskin would never allow me to consider him a serious person."* (The Companion, 25th June 1828).

Desenfans and Bourgeois as Dealers

During the 1780s Desenfans and Bourgeois worked closely together. Their co-operation was such that it is misleading to regard them as possessing separate collections, particularly as the money was Desenfans'. They held a number of sales at Christie's, most notably one on 8th April 1786 which included Holbein's *Henry VIII Delivering the Charter to the Surgeon Barbers' Company of London*, (Royal College of Surgeons, London) and works from the Palazzo Barberini in Rome, especially Claude's *St Ursula* (now in the National Gallery, London). The catalogue to this *"truly Superb, and well-known collection"* was characteristically flowery. By 1790 Desenfans was a familiar name in the London art world, and it was not surprising that when in that year, Prince Michael Poniatowski, brother of the King of Poland, spent a few months in London, he should, having an interest in the arts, have made the acquaintance of this well-known dealer; or that he should have asked Desenfans to abandon commerce and devote himself to assembling Old Masters for the Polish King in order, according to the *Memoir*, to *"promote the progress of the fine arts in Poland."* Desenfans, realising the possible advantages, agreed, and from 1790 to 1795 dedicated himself to that task.

Stanislaus Augustus, King of Poland

In the late eighteenth century Poland was in a particularly difficult position: a republic, dominated by Russia, ruled by a king whose powers were severely limited, with a parliament in which proposed legislation on matters of state could be rejected by a single negative vote, and a seriously under-developed economy. It appeared in 1792 to an English visitor, Archdeacon Coxe, *"of all countries the most distressed"*. In the early part of the century Poland had been governed by the Electors of Saxony, acquiring a superficial Western European flavour. From 1764 to 1795 the king was a Pole, Stanislaus Augustus Poniatowski (1732–1798) who wished to introduce Western ideas more conclusively. Stanislaus was a man of the Enlightenment: in his youth he had spent six years travelling in the West, and retained strong links with France and England. He had also presumably been

Paul Sandby (1725–1809): *Francis Bourgeois and Noel Desenfans* Watercolour. (Dulwich Picture Gallery)

John Britton, Inventory of the Charlotte Street house, 1813. (Dulwich College archives).

enlightened by a youthful spell as one of Catherine the Great's lovers. Frustrated to a large extent in his administrative ambitions, he worked to create a *'new Poland'* (a favourite expression for the King and his circle) through the arts.

Stanislaus was helped by the easy charm of his manners and by the interest already apparent among some of the Polish nobility in French, Italian and English civilization. He was the most active patron of his time in Poland, in

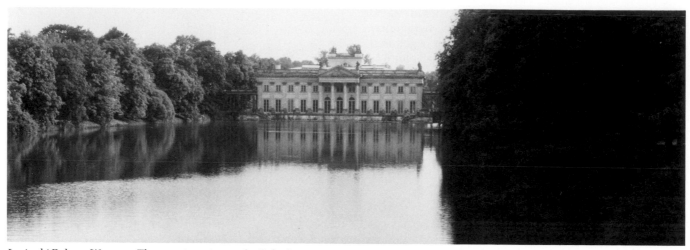

Lazienki Palace, Warsaw. The country retreat rebuilt for his own use by Stanislaus Augustus, 1775–95. (Photo: Adam Zamoyski)

The Royal Castle, Warsaw – The Study and Dressing Room of Stanislaus Augustus. The photograph shows the recent restoration of these apartments. (Photo: Royal Castle, Warsaw)

both architecture and painting, and aimed to establish a native school of painting, aware of the most advanced Western tastes. A school of architecture has been named after him, a neo-classical style first proposed by the French architect Victor Louis who visited Warsaw in 1765, and developed by the Italians Domenico Martini and Jacopo Fontana.

Though the King was generally short of money, he erected such country retreats as the Lazienki Palace, from 1775 to 1795, and remodelled the State Rooms in the Royal Castle in Warsaw (destroyed in the Second World War and now restored). He invited foreign artists to his Court, where a number spent extended periods and others visited for short lengths of time en route to St. Petersburg, where royal patronage of Western artists was also strong. They included Jean-Baptiste Pillement, Bernardo Bellotto, and in particular Marcello Bacciarelli, who became the King's favourite portraitist (Stanislaus was fond of being painted) and supervisor of artistic activity at Court.

Stanislaus' collecting was assisted by the agents who acted for him in all the major cities of Europe, including Paris, Rome, Naples, Genoa, Venice and Florence. In many cases these agents were his diplomatic representatives, such as the Marchese Antici, Polish chargé d'affaires in Rome; they tended to be rewarded not with money but with titles and portraits of their patron. Eager to establish a school of Polish art, Stanislaus sent young practitioners on allowances to France and Italy, and provided free instruction in art in the Royal Castle. His personal collection was extensive, being numbered in 1795 at 2,289 paintings and 30,000 prints, though many of the pictures were copies, bought as such for didactic purposes. The collection was especially rich in the works of Rembrandt, Rubens and Van Dyck.

Like Antici, Desenfans was to combine the roles of diplomat and dealer. He, too, was rewarded with a title – Consul-General of Poland and Colonel of the Royal Guard – and Bourgeois received a knighthood, which King George III of England recognized. Portraits of Stanislaus and of Prince Michael were sent to Desenfans, probably in 1795. In terms of social standing the new position was ideal for Desenfans: as he explained in his *Memorandum* of 1801 to the Tsar of Russia, he gave up "commerce" for the dignified task of collecting for a king, and his new post was recorded in all his subsequent publications and announcements. Financially the new arrangement was less satisfactory. Desenfans found himself in 1793 obliged to pay the debts of Chevalier Bukaty, the Polish Ambassador, and only £1,300 of the loan of £1,800 was repaid by Stanislaus. He later felt it his duty to give financial assistance to a number of Poles in exile.

The 1790s were an especially suitable time for the formation of a major art collection in London. Important paintings were entering Britain in larger numbers than

ever before, partly because of the activities of agents working on behalf of British dealers, purchasing works of art from the nobility and religious communities in Italy for sale in England, and partly on account of the collections sent over from France for sale in London as a result of the French Revolution. Desenfans profited from both sources. Veronese's *St. Jerome and a Donor* (inv. no. 270), a large altarpiece bought from a family chapel in north Italy by an unknown agent in the 1790s, and cut into several fragments to appeal to buyers, is a good example of an Italian source, but France was more important to him. The most notable French aristocratic collections to be sold in London in the 1790s were those of the Duc d'Orléans, from which ultimately came Wouwermans' *Halt of a Hunting Party* (no. 37) and Le Brun's *Massacre of the Innocents* (no. 19), and of Charles-Antoine de Calonne. Calonne employed Desenfans to handle the 1795 sale of his collection, arranged on behalf of needy French emigrés. At this sale Desenfans bought a number of extremely important works, notably Poussin's *Triumph of David* (no. 24), Murillo's *Flower Girl* (no. 22), Rembrandt's *Young Man* (no. 27) and Vernet's *Italian Landscape* (no. 33). By 1795 Desenfans had assembled a remarkable group of pictures, including examples of all the major artists of the past admired at the time, though contemporary art was less well represented. The Polish King's tastes, for Van Dyck and Rubens, Charles Lebrun, Gaspard Poussin and Rembrandt, were naturally taken into account and Desenfans' purchases were closely supervised from Poland.

The pictures never reached Poland. In 1795 the country was partitioned for the third and final time, between Russia, Prussia and Austria. Stanislaus was forced to abdicate, and Desenfans was left with over 180 pictures on his hands.

Desenfans' Efforts to Dispose of the Polish Collection

Between 1790 and 1795 Desenfans had spent, according to a memorandum that he sent to the Tsar of Russia in 1801, almost £9,000 on pictures for Poland, and had received no reimbursement; and he had given up the business which in the 1780s had brought him between two and three thousand pounds per annum. For some time he hoped that the king, (whom he expected to retire to Italy), or his family would purchase the paintings, but on the death of Stanislaus in 1798 it became apparent that such a solution was unattainable. Through the half-hearted mediation of the British Ambassador in St. Petersburg, Desenfans wrote in 1798 to the Tsar, Paul I, who had undertaken to pay Stanislaus' debts, asking for repayment of the remaining sum owed him by the former Polish Ambassador. He wrote again in 1799, suggesting that the Russian Government might like to buy the entire

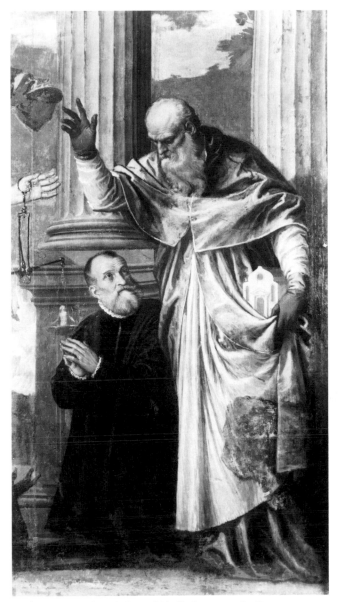

Paolo Veronese (c.1528–1588): *St. Jerome and a Donor.* Canvas. (Dulwich Picture Gallery)

collection, strengthened by some Italian pictures, for the amount it had cost him. In 1801 yet another memorandum was sent, to the new Tsar, detailing his expenses and losses resulting from the Polish connection (by this time some £4,000) and again suggesting that the Tsar should acquire the pictures. This was a less unlikely scheme than it might seem, since Catherine the Great had in 1779 acquired the collection of Sir Robert Walpole from Houghton, but the Tsar did not reply.

In 1802 Desenfans held an auction of the paintings acquired for Poland at the premises of Skinner and Dyke in Berners Street. It was preceded by an exhibition lasting ten days, for which tickets were sold, and was announced in impressive terms in the catalogue, a two-volume work

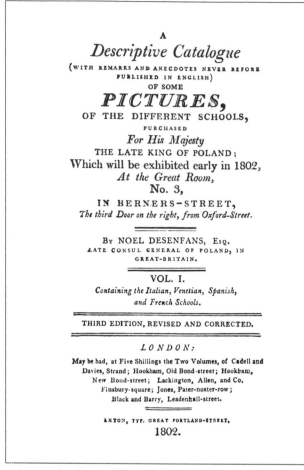

Title page for the *Descriptive Catalogue* for the Sale of 1802

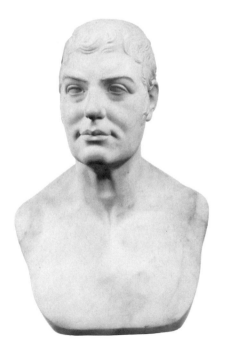

Sir Richard Westmacott, R.A. (1775–1856): *Noel Desenfans.*
Marble. (Dulwich Picture Gallery)

with long explanatory texts in which Desenfans tried to emulate Lebrun. It is a quaint publication, indicative of prevailing ignorance in the history of art (entertaining falsehoods abound about the life, of, for example, Rembrandt), of the writer's excitable naïveté, and, more dangerously, of his strong personal animosities. Both Bourgeois and Desenfans were currently involved in disputes within the art world. These concerned the Presidency of the Royal Academy, and Desenfans had embarked on pamphlet warfare with Martin Archer Shee, later President of the Royal Academy, who launched a violent counter-attack. He used his sale catalogue as a context to comment on the excellence of French connoisseurs, the jealous character and general mediocrity of contemporary artists, and the incompetence of English "experts". This exercise was foolishly self-indulgent. The auction was not a success and relatively few of the pictures were sold – hardly surprising in view of Desenfans' vitriol, and the unpredictable nature of the British market. (The letters of a leading dealer of the period, William Buchanan, reveal the relative scarcity of English buyers at the time, made cautious by the wars against France, and their fondness for pleasing subject-matter.) It seems likely that many of the pictures were bought in.

A letter from Desenfans to Benjamin West, undated but, on internal evidence, of around 1803, reveals the events that first led to the bequest to Dulwich. Desenfans writes that he has been "*full of troubles & anxieties*" and is "*at the eve of parting with S͏ͬ Francis . . . I am forc'd to take these steps I am now about, if I will not Be reduced to Beggary . . . Such is his passion for pictures, that it will render him miserable, and makes it now impossible for me, to continue with him*". He describes how Bourgeois had persuaded him to keep the pictures intended for Poland, with "a few costly pictures" from the Calonne collection, plus some more pictures. Sir Francis had promised to buy no more, but "*he has been since, at every sale & every picture Room, where, like a child who wishes for everything in a toy shop, he has been buying whatever he saw; to put where? in my garret. One day, 'tis one Hundred guineas for a Guercino, the next three Hundred for a Vanderwerff, . . .*". Since "*last December*" Bourgeois had spent over £2,000 on his "*whimsical purchases*". Desenfans and Bourgeois never did part company, but the letter shows the very strong involvement of Bourgeois in their purchases (Desenfans was in his last years kept mostly at home by a nervous ailment) and Bourgeois' determination, rather than Desenfans', not only to keep the collection intact but to embellish it. It seems likely that the idea of leaving the pictures as a permanent collection originated not with Desenfans but with his friend.

Desenfans died in 1807, having in 1803 made a will which left his property jointly to his wife and Sir Francis, apart from the pictures, which became exclusively Bourgeois'. The artist felt himself obliged by Desenfans'

parting wishes, he stated in a letter of January 1810 to the Duke of Portland, to find a way of making the collection *"conducive to the advancement of a Science to which his anxious views and unremitting labours had been invariably directed."*

Bourgeois' first idea was to maintain the collection in the Charlotte Street house, but his request in 1810 to the landlord, the Duke of Portland, to be allowed to purchase the property so that the house *"may be gratuitously open . . . to Artists as well as to the Publick"*, was abruptly refused. According to Farington who visited Bourgeois on 13th December 1813, he had rejected his first idea of leaving the paintings to the British Museum because of the arbitrary "aristocracy" governing that institution, which might not keep the collection intact, and had decided instead to bequeath his pictures to the venerable institution of Dulwich College. By his will, dated 20th December 1810, he left his pictures to Mrs. Desenfans, on condition that after her death they should go to the College. Bourgeois, at the time he made the will, had been injured by a fall from his horse, and the decision may well have been made in haste. He died two weeks later.

Museums in Regency England

An interest in the creation of museums, and especially of a national gallery, is a recurrent theme in England in the late eighteenth and early nineteenth centuries. The opening of the Louvre in 1793 had a powerful effect in London. Such prominent artists as two Presidents of the Royal Academy, Joshua Reynolds and Benjamin West, canvassed for a national gallery; so did politicians such as Richard Brinsley Sheridan and Charles James Fox, and dealers including William Buchanan and Desenfans himself. Desenfans had in 1799 published *A Plan for Establishing a National Gallery*, an ingenious proposal for adding picture galleries to Montague House (the then British Museum), in which both contemporary works and Old Masters would be on view. He canvassed on behalf of his *Plan* at the Royal Academy, but the Government was not enthusiastic. Numerous collectors, artists and architects reacted against such official indifference by creating their own galleries in their London houses, to which the decent public was admitted. Apart from a number of aristocratic houses so open, the most distinguished examples included the galleries of Thomas Hope, John Nash, John Soane (whose collection now forms the Sir John Soane Museum), and J.M.W. Turner. The house in Charlotte Street had very much the character of a private museum of this type. The young painter David Wilkie, who was taken to see it in 1808, was one of many visitors, and Bourgeois was generous with invitations, especially to young artists who he felt might profit from study.

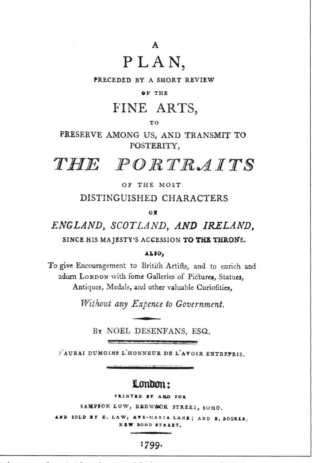

A
PLAN,
PRECEDED BY A SHORT REVIEW
OF THE
FINE ARTS,
TO
PRESERVE AMONG US, AND TRANSMIT TO POSTERITY,
THE PORTRAITS
OF THE MOST
DISTINGUISHED CHARACTERS
OF
ENGLAND, SCOTLAND, AND IRELAND,
SINCE HIS MAJESTY'S ACCESSION TO THE THRONE.
ALSO,
To give Encouragement to Britifh Artifts, and to enrich and adorn LONDON with fome Galleries of Pictures, Statues, Antiques, Medals, and other valuable Curiofities,

Without any Expence to Government.

BY NOEL DESENFANS, ESQ.

J'AURAI DUMOINS L'HONNEUR DE L'AVOIR ENTREPRIS.

London:
PRINTED BY AND FOR
SAMPSON LOW, BERWICK STREET, SOHO.
AND SOLD BY C. LAW, AVE-MARIA LANE; AND E. BOOKER;
NEW BOND STREET.

1799.

Title page for *A Plan for Establishing a National Gallery* (1799)

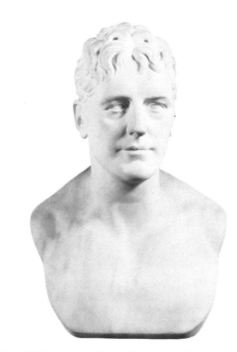

Sir Richard Westmacott, R.A.: *Sir Francis Bourgeois.* Marble. (Dulwich Picture Gallery)

Dulwich College

British School: *Edward Alleyn.*
Canvas. (Dulwich Picture Gallery)

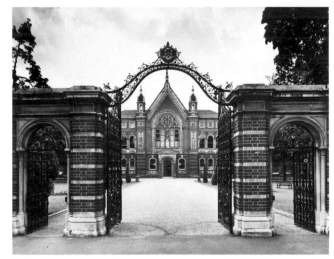

Dulwich College. The main entrance on College Road.
The College was moved to these new premises in 1870, following the reform of the old Foundation and the development of Dulwich as a prosperous residential suburb. The building, designed by Charles Barry junior, is a striking piece of architecture in the Lombard Romanesque style, The College, which is now an independent school for 1400 boys, maintains close links with Dulwich Picture Gallery

Dulwich College in the early nineteenth century was a prosperous and indolent institution, better known for its hospitality than for educational zeal. The College had been founded in 1619 by the actor-manager Edward Alleyn (1566–1626), Lord of the Manor of Dulwich, an urbane individual with connections at Court. His institution was intended to shelter the old (there was accommodation for six 'Poor Sisters' and six 'Poor Brothers') and to educate the young (twelve 'Poor Scholars') but by the early nineteenth century the officers appointed to this task, Master, Warden and four Fellows, were content to exercise minimal supervision. In 1814 an account commented that "*for many years past*" no boy had been educated for university. A painting by W.C. Horsley (now at Dulwich College) conveys the untroubled atmosphere of the 1820s. The artist's father had as a boy been used to visiting the College, which he remembered tenderly and with amusement at the unworldly incompetence of his host, the Reverend Lindsay, who so disliked rising in the morning that he conducted his teaching from his bed. By the early nineteenth century the College was not only notorious for its inactivity but was partially in collapse physically.

From Bourgeois' point of view, the College seemed an appropriate beneficiary. As a visiting surveyor described Dulwich in 1808, "*The estate for its entirety, the beauty and variety of its views . . . is scarcely to be equalled . . . It is embosomed in a rich and fertile vale, whose surface is varied by detached eminences and is thus secluded . . . from the bustle and activity of trade and commerce, from the noisome air of manufactures and the 'busy hum of men'.*" One of the reasons why Bourgeois settled on Dulwich was indeed the freshness of the air which, he felt, would benefit the pictures. The Governing Body was known for its "urbanity" and "liberality of mind", especially Lancelot Baugh Allen, who was the Master (from 1811), J.T. Smith, the Senior Fellow, described by Horace Walpole in 1791 as "*a smart divine . . . très bien poudré*" and the gentlemanly third Fellow, the Reverend Robert Corry. Corry was on friendly terms with Bourgeois, probably through their mutual friend the actor J.P. Kemble, and had had the curious distinction of officiating at the Desenfans mausoleum in Charlotte Street.

The choice of Dulwich was given further plausibility by the fact that the College already possessed a picture gallery, containing the collections of Edward Alleyn and of William Cartwright. Alleyn had left Dulwich his own paintings – portraits of himself and one of his wives, and sets of the Kings and Queens of England, of Apostles and of Sibyls. A picture gallery for these works existed by at least 1661. These paintings, many of them the work of one Gibkin from whom Alleyn bought them at some expense

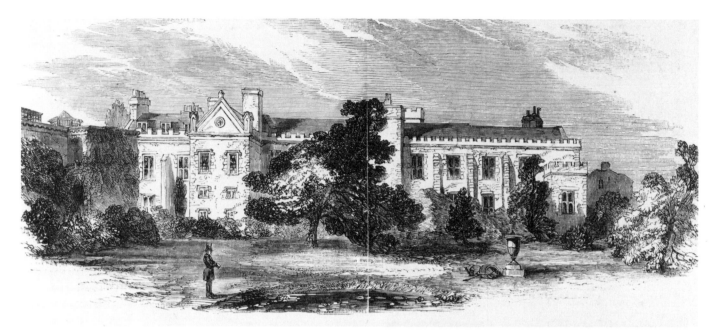

(Above) *The old College at Dulwich*, c.1840. Engraving.

(Below) W.C. Horsley (1855–1934): *Old Time Tuition at Dulwich College in 1828*. Canvas. (Dulwich Picture Gallery)

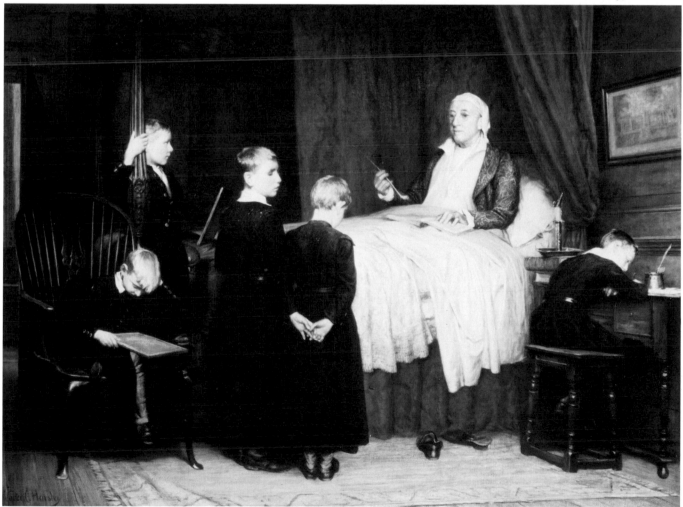

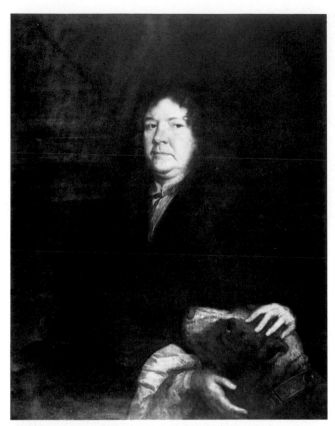

John Greenhill (c.1640–1676): *William Cartwright.*
Canvas. (Dulwich Picture Gallery)

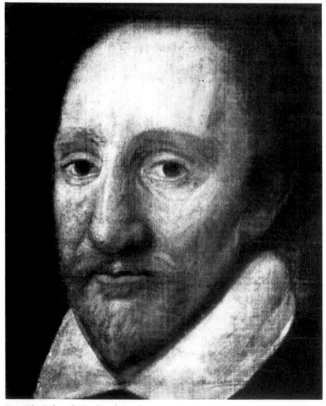

British School: *Richard Burbage.*
Canvas. (Dulwich Picture Gallery)

in 1620, still exist for the most part, and have considerable antiquarian interest as a rare survival of an Elizabethan collection of relatively high quality.

The rest of the old Dulwich paintings had been bequeathed to the College in 1686 by William Cartwright (1606/07–1686), an actor and bookseller. Though only a third of his pictures eventually reached Dulwich, these eighty or so paintings, together with an inventory of the original collection, constitute an important record of the taste in pictures of a man of moderate wealth in the seventeenth century – a taste that included portraits of his family, of the Royal Family and of leading actors, still lifes and illusionistic paintings, and a crude attempt to assemble works after the Old Masters. The modest quality of the paintings, some of them by artists otherwise obscure or unknown, paradoxically makes them of interest as unusual survivors. All these pictures hung in the old College gallery, where in the eighteenth century they were seen by a number of (generally rather critical) visitors.

The Character of the Collection

The pictures bequeathed to Dulwich College constitute a collection in the grand taste of the early nineteenth century. Most of the great Regency collections made in England have been wholly or largely dispersed; where they survive they are generally submerged within much larger holdings, as with the Angerstein or Beaumont pictures in the National Gallery, London, or the Prince Regent's collection. The Dulwich paintings, housed as they are in a contemporary gallery built to contain them, represent as a group a highly important document of taste from 1790 to 1810.

What the present day visitor sees is not only the Bourgeois collection. It is not precisely the group of paintings bought for the King of Poland, since only 56 of the pictures in the 1802 can be identified as Dulwich pictures. Bourgeois continued to buy and sell. The collection as left in 1811 contained some 350 pictures, of which over a hundred are nowadays not on view. The old inventories suggest that the Bourgeois paintings were conceived as forming a representative collection of all the artists most admired at the time, and that in his last years Bourgeois was endeavouring to assemble an exemplary gallery. The fortunes of art dealing obviously affected the selection of works: it includes such paintings as Van Dyck's *Samson and Delilah* (inv. no. 127), which appeared in Desenfans' sales five times, and Watteau's *Les Plaisirs du Bal*, (inv. no. 156) which he twice sold and rebought. Still, the early attributions are so strikingly representative of contemporary taste that it seems evident that Bourgeois pursued a clear policy in his acquisitions.

In many ways the selection is traditional, looking back

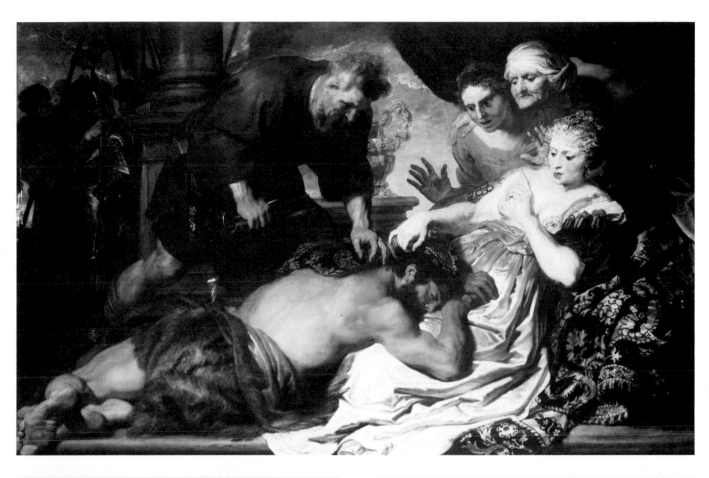

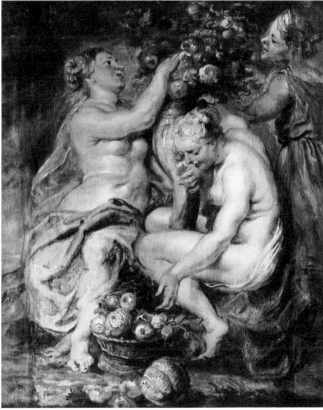

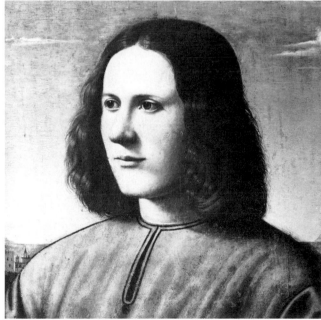

(Top) Sir Anthony Van Dyck (1599–1641): *Samson and Delilah*.
Canvas. (Dulwich Picture Gallery). (Left) Sir Peter Paul Rubens
(1577–1640): *Ceres and Two Nymphs with a Cornucopia*. Panel.
(Dulwich Picture Gallery). (Above) Piero di Cosimo (c.1462–?
1521): *A Young Man*. Panel. (Dulwich Picture Gallery)

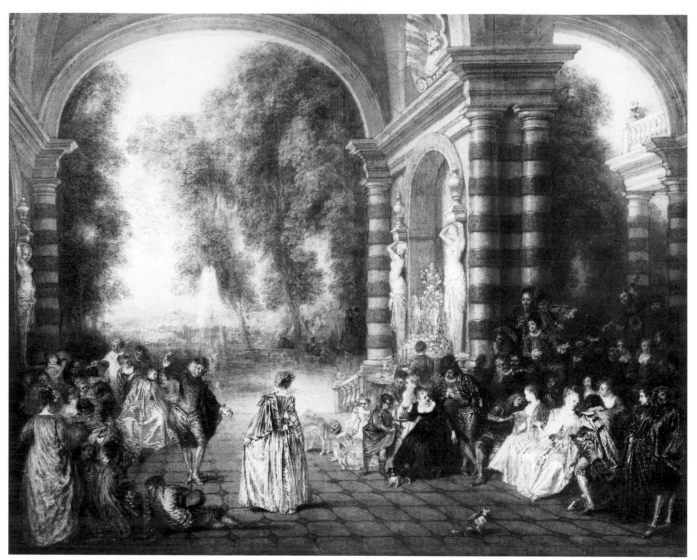

(Above) Antoine Watteau (1684–1721):
Les Plaisirs du Bal. Canvas. (Dulwich Picture Gallery).
This painting of about 1715 was described by John Constable in a letter of 1831: "(It) seems as if painted in honey; so mellow, so tender, so soft, so delicious . . . this inscrutable and delicious thing would vulgarise even Rubens and Paul Veronese."

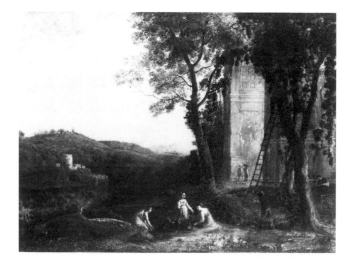

(Left) Claude Lorrain (1600–1682):
Gathering Grapes. Canvas. (Dulwich Picture Gallery).
This damaged painting is accepted by Professor M. Röthlisberger as an original work by Claude, though for many years this attribution had been rejected. The painting was particularly admired by J.M.W. Turner. Röthlisberger points out that this is the only painting by Claude depicting a vintage scene and dates it to c.1641.

to eighteenth century taste as established in England by the Grand Tourists. Italian art, which, as Desenfans recognized in his 1802 catalogue, presented particular difficulties for English collectors, has turned out to be the weakest School at Dulwich, in quality though not numbers. The sixteenth century Venetian School was represented, theoretically, by Titian and Veronese. There

22

were thirteen works by the Carracci (almost all mistakes) and seven by Guido Reni (only one now accepted). The list boasts three works by Leonardo da Vinci (one now attributed to Piero di Cosimo, the others unattributed). Correggio, Caravaggio, Andrea del Sarto and Raphael were all included in theory, though Bourgeois did not lay claim to a Michelangelo.

The strength of the collection lies in the Dutch, Flemish and French Schools, also bought on generally traditional principles. Van Dyck (13 in the collection), Rubens (20) and Teniers (22) were the most popular Flemish artists. Although vernacular Dutch landscape painters such as Ruisdael and Hobbema contributed a few works, the taste of the eighteenth century is reflected in the very strong assembly of decorative Italianate landscapes: numerous paintings, mostly of high quality, by Cuyp (18), Philip Wouwermans, Berchem, Both and Dujardin. Low-life cabinet pictures, much esteemed at the time, are less fully represented in a collection whose creators were conscious, perhaps, of the need to maintain dignity. As for the French School, pride of place went to an artist who was very popular and expensive at the time: Nicolas Poussin. Though of the seventeen pictures originally attributed to him only seven are now accepted, they still comprise one of the most important existing groups of work by this artist. Claude, the other favourite French artist among noble English collectors, was represented by eight paintings, of which only two (one, now, in wrecked condition) are still thought to be his.

Not all the paintings were by artists of the past, and the selection made by Bourgeois and Desenfans of contemporary work is very revealing. Desenfans was known for his attacks on living British artists, whom, like many others, he regarded as inferior to painters of earlier centuries. Of the forty works by Desenfans' contemporaries, 21 are by Bourgeois, reflecting the two collectors' determination to raise him to the status of major artist. A number of pictures are portraits of Desenfans or Bourgeois (though they did not trouble to have Mrs. Desenfans commemorated) and of their close friends: De Loutherbourg, J.P. Kemble, the painter John Opie, and Pybus C.S. (Pybus) M.P., a banker and business partner of Desenfans. Gainsborough features merely as the portraitist of De Loutherbourg (no. 8). The only British painters included by Bourgeois for work other than portraiture were, apart from himself, Richard Wilson and Reynolds. Wilson, an artist whose reputation had risen sharply in the 1790s, is represented by one landscape (no. 36), while Reynolds emerges as the only painter considered by Bourgeois and Desenfans as on a par with the old Masters. The works by Reynolds in the Gallery are, on the whole, not portraits but essays in historical painting: *The Death of Cardinal Beaufort*; *Mother with sick child*. The most striking is the large *Mrs. Siddons as the Tragic Muse*, more history painting than portrait. The

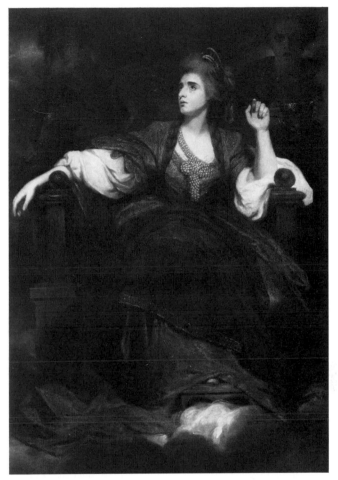

Sir Joshua Reynolds P.R.A. (1723–1792): *Mrs. Siddons as the Tragic Muse* 1789. Canvas. (Dulwich Picture Gallery)

original (now in the H. Huntington Art Gallery) was regarded by many contemporaries as the artist's greatest work, and was so much desired by Desenfans that, unable to buy it, he commissioned a second version in 1789 from the artist for the large sum of £735.

In their approach to the Old Masters and to British art, Desenfans and Bourgeois reflected contemporary attitudes, but in one respect they were unusual, and here the influence of J.B.P. Lebrun seems clear. Lebrun was notably enthusiastic about rediscovering obscure artists and was for many years the first connoisseur again to recognize the greatness of Vermeer. His taste is reflected in the Dulwich collection. Saenredam (under the name "Sanadram", dates unknown), Le Nain (dates equally unknown), Holbein and Antolinez (one of the Spanish painters in whom Lebrun took an interest) all feature in the first catalogue of Bourgeois paintings (See F. Haskell, *Rediscoveries in Art*) (1976). The effect of Calonne, with his interest in contemporary French artists, is less apparent, though Bourgeois did bequeath a group of paintings by one of Calonne's favourite artists, Claude-Joseph Vernet (e.g. no. 33).

23

C. Turner, after Sir T. Lawrence, P.R.A.: *Sir John Soane, R.A.*
Mezzotint and aquatint, 1830.

Sir John Soane

With his paintings, Bourgeois left Dulwich College an endowment of £10,000 and £2,000 for erecting a new gallery, on the death of Mrs. Desenfans. She was eager for work to begin at once, as she made clear to the Master of the College: *"The only consolation (she could) receive in this life (would) be to see the wishes and intentions of her dear Friend Sir Francis Bourgeois carried into effect in the most compleat and expeditious manner."* Since she was willing to surrender possession of the pictures as soon as a gallery had been built to receive them, preparations began at once.

In his last illness, Bourgeois had expressed a wish to the Master of Dulwich College that the architect of the new gallery should be Sir John Soane. Soane (1753–1837) was one of the best-known architects of the period in Britain, holding several official positions including the Surveyorship of the Bank of England. The rebuilding of the Bank, from 1788 to 1833, was the major achievement of his career (though as with many of his works, little of the original structure survives.) He also designed numerous public buildings and private houses including his own House and Museum in Lincoln's Inn Fields, London. The individuality of Soane's style, and his desire to create a new architecture based on classical principles but appropriate to the modern age, made many of his contemporaries distrust his work.

Soane and Bourgeois had been close friends. They had fought on the same side in the Royal Academy battles of 1804; Soane kept Bourgeois' portrait, and two of his paintings, in his Museum; and Mrs. Soane visited Bourgeois on his deathbed. The architect particularly relished the Dulwich commission, described in 1812 by a friend as his *"favourite subject"*. He was moved by friendship, but also by the unusual terms of the commission: he was required to design not only a gallery – a type of structure in which he was particularly interested – but a mausoleum for the bodies of the founders.

On the death of Desenfans in 1807 Soane had erected a mausoleum for his body at the back of the Charlotte Street house. Bourgeois wanted a similar edifice to be raised at Dulwich, to house the bodies of the Desenfans', and his own. The expense was to be met by his executors. The erection of a private mausoleum was not unknown at this time – C.H. Tatham had designed such a structure for the Marquess of Stafford at Trentham in 1807 – but it was unusual, particularly for private citizens. Soane had never had an opportunity to design such a building, and it was a type that he found of extreme interest. His fascination with death, and with its symbolic commemoration, is apparent from the succession of designs for mausolea exhibited by him at the Royal Academy from 1777 onwards, from his incorporation of numerous references to death in his first home at Pitshanger Manor, and from his

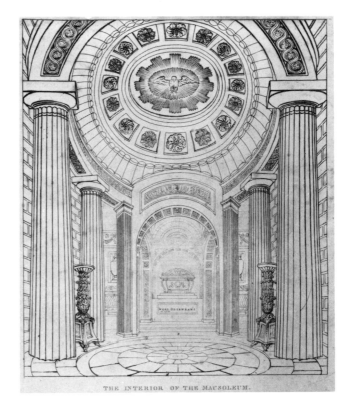

THE INTERIOR OF THE MAUSOLEUM.

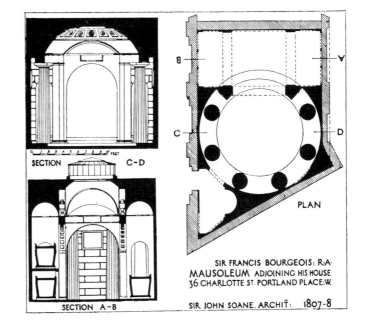

SIR FRANCIS BOURGEOIS: R.A.
MAUSOLEUM ADJOINING HIS HOUSE
36 CHARLOTTE St PORTLAND PLACE:W.

SIR JOHN SOANE. ARCHIT: 1807-8

(Top) Mausoleum at 36 Charlotte Street, Section and plan (From A.T. Bolton, *The Works of Sir John Soane*)

(Above) The Mausoleum for Noel Desenfans, Charlotte Street, London. Engraving, 1807.

25

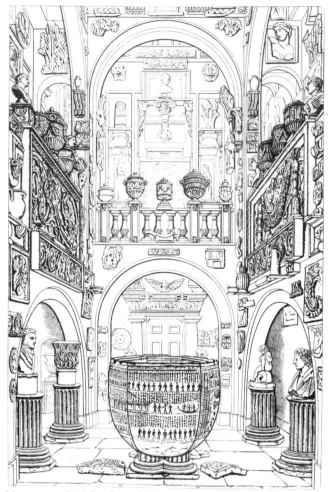

Museum at Sir John Soane's House. Line engraving, 1835.

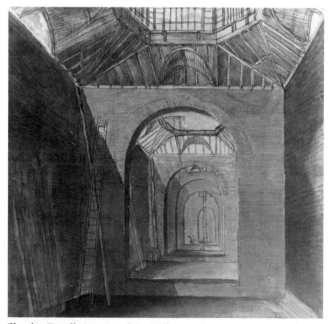

Charles Tyrell: *Interior of the Gallery under construction*, 30th July 1812. Pen and wash. (Sir John Soane's Museum)

house at Lincoln's Inn Fields. There the central portion of the museum has Roman funerary urns arranged around an Egyptian sarcophagus, and his own bust set in the midst. For Soane, as for Bourgeois, a personal museum was the most fitting memorial for a man who had dedicated his life to the arts. Bourgeois could not have chosen an architect better fitted to design his Gallery and tomb.

Early designs for the Gallery

Bourgeois' will proposed that the pictures should be accommodated in the existing west wing of the College, after *"repairing, improving and beautifying of the old building"* (Minutes of Private Sittings . . . Dulwich College). Soane made his first site-visit on 8th January 1811, the day after the patron's death. He recommended that in view of the ruinous condition of the wing it would be preferable to build anew behind the existing college, *"in the Back Yard at right Angles to our present Kitchen,"* (ibid) and the proposed was agreed to by the Governing Body.

Soane at first proposed the demolition of the two decayed wings of the old College and their replacement with a quadrangle to the south of the existing buildings. Several schemes were produced, of which one example (Design No. 5, May 1811 – Sir John Soane's Museum) conveys the architect's thinking at this stage. The chapel wing of the old College was to be retained at the north side of the quadrangle (on the right in the drawing). The block with skylights was to house the pictures and anticipates the plan of the building as erected. Opposite the gallery a further exhibition room was planned as a library: it was at one time Soane's intention, if neither of his sons became architects, to leave his own library and antiquities to Dulwich. The remaining wing would house almshouses and further accommodation for the College.

The style of these early elevations is a strange one. The authorities are supposed to have wanted a building in sympathy with the Jacobean buildings of the old College, the most prominent features of which were the mullioned and transomed windows and the giant pilasters. Soane, whose attitude to non-classical architecture was ambiguous, produced a compromise. The south block is a repetition of the old building. The gallery retains the Jacobean windows, but the pilasters round the entrance, and on the end bays, are typically Soanean in their thinness with recessed centres, as are the minimal decorative motifs over the doors. In other early designs Soane experimented with both an H-shaped and a cruciform arrangement. Though the new quadrangle was rejected by the authorities, it remained in the architect's mind. When studying the Gallery today it is important to recall that the building was referred to during construction as the *"new West Wing of the College"* (ibid), and that the proximity of the old buildings influenced its character.

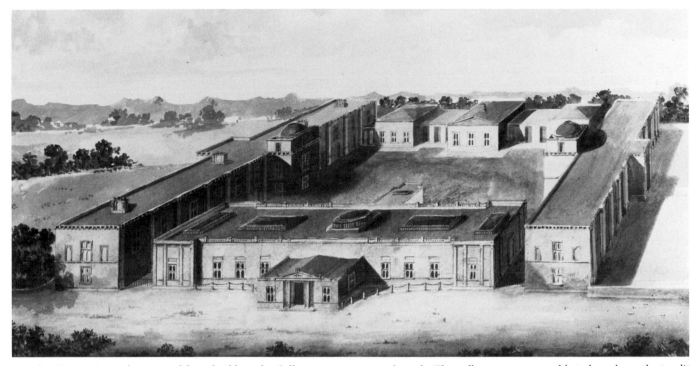

Sir John Soane: An early proposal for rebuilding the College. May 1811. Pen and wash. Soane proposed demolishing the wings of the old College (on the right) and erecting a new quadrangle. The gallery was presumably to have been the top-lit structure in the foreground. (By permission of the Trustees of Sir John Soane's Museum)

In July, Soane and the College agreed on a design for a free-standing single block, to be carried "*into execution immediately*" (ibid) but difficulties arose over money. Soane submitted an estimate in July of £11,270, including £1,000 for the mausoleum. The Master and Fellows could contribute only £5,800, which with the £2,000 from Bourgeois and an additional £1,000 for the mausoleum still left a deficit. Though pressed to do so, Soane was unable to reduce his estimate, and even proposed making up the sum himself. The problem was resolved by Mrs. Desenfans, who in September offered a further £4,000. The offer was accepted, and on 11th October the Governing Body agreed that the building should be erected according to Soane's plan.

During the summer and autumn of 1811 Soane produced a variety of designs for the new building and continued to do so after the plan had been accepted. He was influenced particularly by the Governors' wish to accommodate the "Poor Sisters" in the new building, and in November 1811 to move the mausoleum from the east to the west side of the gallery. His proposals for the mausoleum were still developing in the spring of 1812. After November 1811 work proceeded rapidly and was largely completed by 1813. The pictures were brought to Dulwich in the summer of 1814 and in March 1815 the mausoleum received its new inhabitants. Work continued on the almshouses, and on the erection of a temporary porch to the Gallery (by another architect, George Tappen), until 1815. Only in 1817, following difficulties over such questions as the heating system, were final details including a brass railing and a "*green floor cloth*" completed, and the collection opened on a regular basis to the public.

The Character of the Building

Dulwich Picture Gallery is a building that requires study; its quality is not easily appreciated. One reason is its austerity, partly the result of financial constrictions. Soane wrote in August 1811 to the Master of Dulwich College, "*Every attention in my power shall be paid to economise the expenditure as far as is consistent with solidity and durability of construction,*" and, being scrupulously professional, he succeeded. He did not charge for his own services, and the building was erected for only £9,788, less than his estimate, though a further £900 had to be spent on the almshouses. Such economy demanded sacrifices, in particular the proposed arcade on the garden front, which was never built. A drawing in the Soane Museum, probably intended to illustrate a lecture at the Royal Academy, shows the building as Soane envisaged it. Statues flank the mausoleum, the sides and summit of which are decorated with carving; the surrounds to the ground floor windows are in an elaborate version of

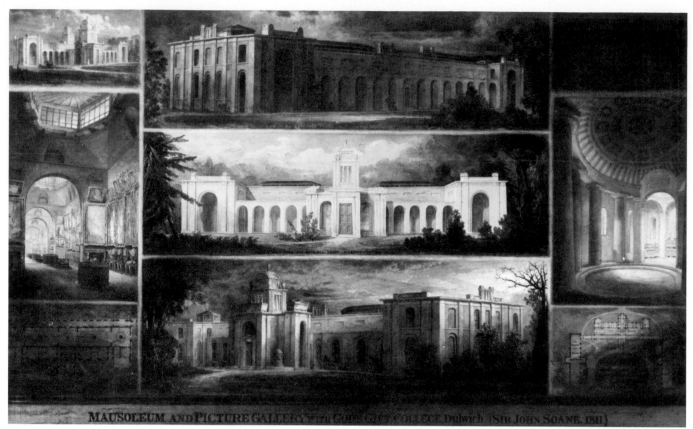

MAUSOLEUM AND PICTURE GALLERY with God's Gift College, Dulwich (Sir John Soane, 1811)

J.M. Gandy (1771–1843): "*Mausoleum and Picture Gallery with God's Gift College, Dulwich*". c.1823 Watercolour.
This set of watercolours shows: (top left to bottom left) the east front, as projected; the interior; the plan; (top centre to bottom centre) the east front, as built; the east front, as projected; the west front, with Mausoleum, as built; (right top and bottom) the Mausoleum; the new College quadrangle, as projected. (By permission of the Trustees of Sir John Soane's Museum)

Jacobean, and a balustrade links the chimney stacks on the skyline. The drawing is also interesting in suggesting the element of emotion in the architect's approach. The building is presented dramatically, beset by stormy weather, and the figures, much smaller in relation to the building than they would be in reality, demonstrate Soane's manipulation of scale to evoke the sublime.

Soane had for many years been interested in primitivism in architecture, in returning to the essentials of design as practised in the early days of civilization. It was a theme that he had previously explored principally in such buildings as stables and dairies. The Gallery, with its rustic setting, its aesthetically uncritical authorities, and its stringent budget, gave him an opportunity to abandon established architectural modes for a new manner. For a museum, Soane's contemporaries would have expected a structure in stone, or at the least stucco, using a classical Order. These expectations were not met at Dulwich. The building, consisting of mausoleum, gallery (Rooms I–V) and almshouses (Rooms VI–IX), was erected in browny-yellow London stock brick, the cheapest material available at the time, and in dignified buildings, normally concealed if used at all. Soane found brick, with its variety

of shades, a sympathetic medium, and carefully supervised the quality of brickwork. The only expensive substance employed was the Portland stone applied to the lantern and the frieze.

Even more startling to contemporaries was the abandonment of a classical Order. Soane's concession to the classical canon was his application to the wings of a series of vertical brick projections, which can be seen as pilasters but are not differentiated in material from the rest of the building as a pilaster would normally be. These projections are supported by a strip of stone at ground level, suggesting a base, and conclude in a band of Portland stone which serves as entablature. There is no other concession to the language of classical architecture.

His simplification of forms allowed Soane to concentrate on the qualities that he regarded as important: the interplay of elements, the contrast of light and shade, the creation of a visually exciting skyline, the "art of surfaces." His interest in surface can be studied in the north and south elevations of the building. Just as, at the Soane Museum, he dissolves the boundaries of rooms by means of arches and mirrors, making space indefinable, so in these elevations he manipulates surface, creating five or

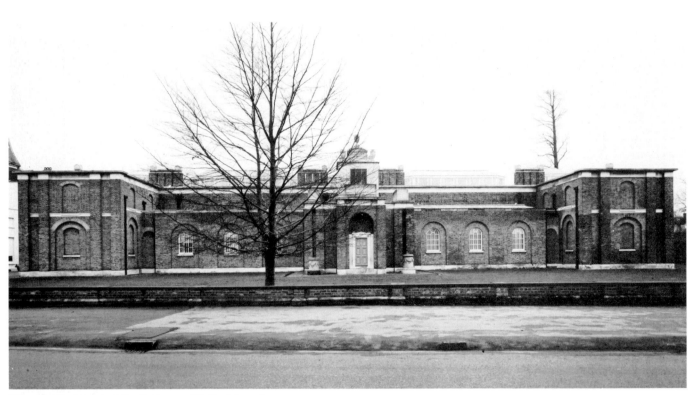

(Above) West front of the Gallery, with the Mausoleum.
(Photo: Michael Duffett)

(Below) South front of the Gallery
(Photo: Michael Duffett)

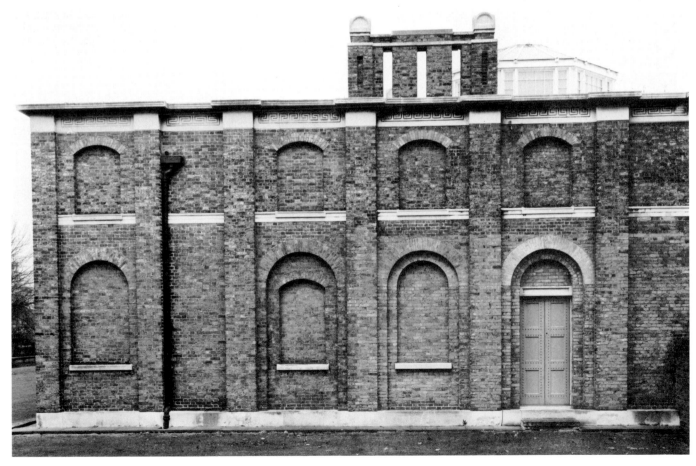

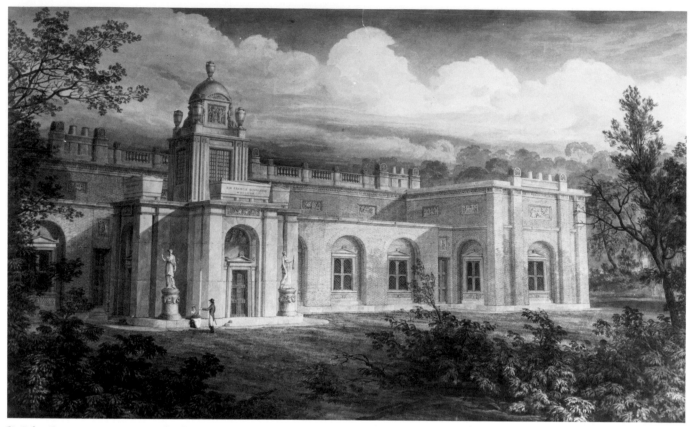

Sir John Soane: c.1815. *Design for the west front of the Gallery.* Pen and wash. A more elaborate version of the building than the one executed. The manipulation of scale, and the dramatic lighting effects in this view, are notable and convey the spirit in which Soane wished his building to be seen.
(By permission of the Trustees of Sir John Soane's Museum)

six layers within the brick. It is not clear which of these layers represents the basic wall that a viewer expects immediately to identify in a building.

The individuality of the Gallery is most apparent in the mausoleum. Its function is expressed externally by such symbols as the urns, the sarcophagi (above the doors), the sacrificial altars in the corners, and the doors, never to be opened, and shaped to recall a classical funeral monument. The three tiers of the structure, their proportions carefully related to one another, culminate in the topmost urn. Characteristically, the decoration is sparse, confined to the "Order" on the lower level and to the funereal accessories and incised lines above. Soane's concern with the contrast of solid and void is apparent in the arches containing the doors: the space above each portal, and the narrow openings in the brick at the side of each projection, create a sculptural and indeed painterly effect which reflects his belief that *"the Poetry of Architecture"* could embrace the other visual arts.

Soane's manipulation of scale can be seen in the doors themselves. Though only five feet high, they are made to seem larger by their position above two shallow steps, and by their tapering sides. As Sir John Summerson has

pointed out, the Gallery achieves an extraordinary nervous strength from the isolation, what he calls the "quasi-independence", of all the elements in the design from one another, whether they are individual motifs, or sections of the building. Everything is distinct; nothing superfluous.

The interior of the Gallery consisted originally of a sequence of five rooms (I–V). The arrangement derives from the traditional Long Gallery in a country house, a form of room that was being revived in early nineteenth-century Britain to accommodate expanding private collections. The gallery of 1800–1 at Castle Howard, by C.H. Tatham, a design quite close to Dulwich, is a good example. The plan at Dulwich is straightforward, an alternation of cube and double cube, reflecting English Palladian faith in the virtue of perfect proportion. The rooms are linked by a succession of arches, as in earlier galleries such as George Dance's Shakespeare Gallery of 1789. There are no more classical references inside than out; only an allusion to pendentives in the unusual coved ceiling. The lighting system, which consisted originally of the vertical glasses alone, was intended by Soane to shed the clearest possible light on the pictures while avoiding a

glare, and is close to the design in the picture room of his own Museum. Top lighting, a regular feature of contemporary galleries, was particularly desirable when, as at Dulwich, as much space as possible was needed for hanging paintings.

In the mausoleum, Soane passed from the practical to the theatrical. He had already created a similar space in the Charlotte Street mausoleum of 1807, and the Dulwich interior is close to this prototype. The visitor enters a circular vestibule with an artificial ceiling supported by a Greek Doric peristyle. This area was intended as a chapel, though never used as such at Dulwich. The chamber is minimally lit, by two narrow windows at the side. All the materials are sham, the porphyry columns being merely painted wood, but the effect is not. By ingenious means – the creation of a circle within a square, the lowering of the centre of the floor by two steps, the concave ceiling – Soane creates an impression of monumentality in miniature.

From the vestibule an arch leads to the burial chamber itself. The contrast in light is striking, since this burial chamber is lit by four openings in the lantern, filled with yellow glass. The effect of *"mysterious light"* (Soane's phrase) pouring into the mausoleum from above is highly Baroque, typical of the drama, and the colour, that Soane sought in his interiors. The decoration, by contrast, is simplified, using only the Greek key pattern, serpents (a symbol of eternity) in relief above the arches, and classical figures, also in relief, on the ceiling. The sarcophagi, rectilinear and with stylized handles, constitute a strikingly advanced piece of design.

The atmosphere that Soane wished to evoke is conveyed by a passage from his *Memoirs of the Professional Life of an Architect:* "We have only to fancy the Gallery brilliantly lighted for the exhibition of this unrivalled assemblage of pictorial art, – whilst a dull, religious light shews the Mausoleum in the full pride of funereal grandeur . . . calling back so powerfully the recollections of past times." The emotional power that he wanted to express is evident.

The Gallery was not favourably regarded by all Soane's contemporaries. A number of criticisms survive, notably one by the Revd. T.F. Dibdin which the victim bitterly quoted, years later, in his *Memoirs.* Dibdin objected to what he considered the oddity of the building, and its lack of a classical Order: "What a thing – What a creature it is! A Maeso-Gothic . . . Semi-Arabic, Moro-Spanish, Anglico-Norman – a what-you-will production! It has all the merit and emphatic distinction of being unique."

Critics throughout the nineteenth century regarded the building with caution, and the attitude towards it of past administrators is apparent from a photograph taken around 1910, showing it veiled in ivy. Only relatively recently has the force of the design been fully recognized.

Fortunately the architects responsible for enlarging the Gallery have always been sympathetic to its character.

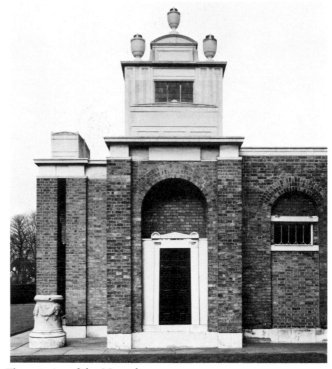

The exterior of the Mausoleum
(Photo: Royal Commission on Historical Monuments of England)

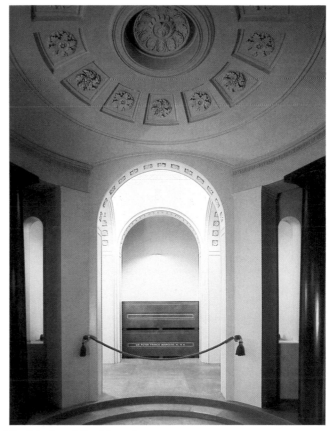

The interior of the Mausoleum

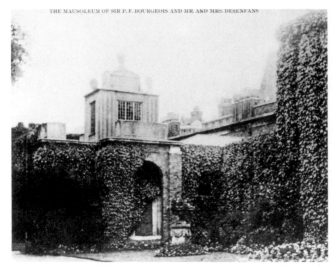

The west front of the Gallery, c.1910.
The attitude of the period to Soane's architecture is apparent.

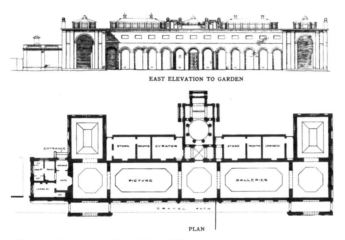

The east front and plan of the Gallery, in 1909.

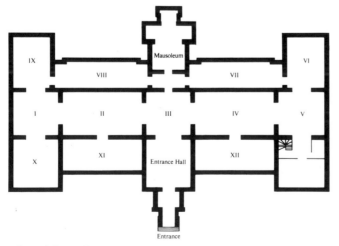

Plan of the Gallery, 1985.

The first major addition to the exhibition space was made in 1884, when the almshouses were converted into galleries (Rooms VI to IX). Further rooms were added around 1910 on the east side of the building by the College's architect, E.S. Hall, who removed the loggia at each end of the façade and created a succession of galleries which both internally and externally show a sensitive understanding of Soane's architecture. In 1936 the final room in this suite was added. During the post-War reconstruction the lobby added in 1866 at the south end of the building by Charles Barry junior was removed and a new entrance erected in the centre of the building on the east side, as originally intended by Soane.

Dulwich and The Royal Academy

Trusteeship of the collection was at first in the hands of the Master, Warden and Fellows of Dulwich College. When the institution was reformed in 1857, it passed to the Governors of the new Foundation, Alleyn's College of God's Gift. A separate endowment fund was then set up to support the Gallery. From the earliest days a stipulation made by Bourgeois and Mrs. Desenfans has existed that the Royal Academy should advise on the care of the paintings. In her will Mrs. Desenfans left, (in addition to some handsome pieces of furniture and busts of her husband and Bourgeois), £500, the interest on which was to pay for an annual dinner in the Gallery for all Royal Academicians who wished to attend. She also left china and plate for the occasion, and requested that the servants in attendance should wear her husband's livery. These dinners were lavish: at the 1817 dinner, attended by, among others, West and Copley, Beechey, Fuseli, Mulready and Soane, Farington recorded that there was *"Turtle Soup & Venison at both ends of the table. Madeira, Claret, Port, Sherry, – Champaigne &c'* and that they sat at table from six till nearly nine. Not surprisingly, these entertainments soon became unmanageably expensive and were reduced in number despite strong protests from Bourgeois' executors. The Academicians were intended on these occasions to inspect the state of the paintings, but rarely made comments.

A more important result of this link was the annual loan of five or six paintings from the Gallery to the Royal Academy, for the students to copy. This arrangement, which continued until the Second World War, prompted the Royal Academy in 1815 to establish its first school of painting.

The Gallery in the Nineteenth Century

Until the reform of the College in 1857, the Master and Fellows tended to regard the Gallery as a private perquisite. Though it was open to the public from 1817,

admission tickets could not be taken at the door but had to be obtained in advance from one of several shops in central London, presumably to ensure that only respectable persons visited. After some disturbing incident, school parties were not admitted, nor children under fourteen. For lack of space elsewhere, the Gallery was used for prize-givings until the mid-century. And in the 1820s one of the Fellows, Mr. Lindsay, was regularly given permission to borrow a Poussin or a Van Dyck for his own rooms.

This amateurish organization of the Gallery was reflected in the comments of visitors, especially the German art historians Passavant and Waagen. Waagen, in his *Treasures of Art in Great Britain* of 1854, wrote: "*In none of the galleries which I have hitherto seen in England do the pictures agree so little with the names given to them, nor is so much that is excellent mixed with much that is indifferent and quite worthless.*" The first scholarly catalogue, by J.P. Richter, appeared as late as 1880.

The proprietorial attitude of the Fellows towards the Gallery did result in one important bequest, the set of portraits of the Linley family (see nos. 9 and 18). This family of distinguished musicians, including Elizabeth, later Mrs. Richard Brinsley Sheridan (her portrait hangs in the National Gallery of Art, Washington), lived in Bath and London during the nineteenth century and formed part of the theatrical circle with which Desenfans was connected. One of the Linley brothers, Ozias (1766–1831), a highly eccentric clergyman, became Junior Fellow and Organist of Dulwich College in 1816. Ozias' brother, William (no. 18) bequeathed the family portraits, including works by Gainsborough and Lawrence, to the Gallery.

Throughout the nineteenth century the Governing Body employed a Keeper, or curator, whose duties as specified in 1821 were to supervise repairs and loans, to check "*impropriety or irregularity*" in visitors, and "*to have a general care of the pictures*", especially "*to clean and varnish them at his own expense.*" The most memorable Keeper was Stephen Poyntz Denning (c.1787–1864), who held the position from 1821 until his death. As had been the custom in private galleries since at least the time of Teniers, this curator was also a practising artist. Denning specialized in small scale portraits; his *Princess Victoria, Aged Four* is one of the Gallery's most popular works.

Under the new constitution the collection was supervised by a Committee, and standards became more professional. One of the more notable Chairmen of this Committee, from 1908 to 1919, was Henry Yates Thompson, an important collector and benefactor, who during his tenure practically became curator as well. He gave the Gallery pictures, furniture and books, paid for the addition of four exhibition rooms, and encouraged a major gift of paintings in the 1910s.

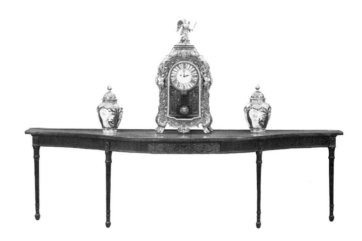

Furniture from the Desenfans bequest.
In her will Mrs. Desenfans left the College some fine furniture, including "*a sofa and ten chairs covered with green velvet, two commodes with drawers inlaid with brass and tortoise-shell, two ebony tables with gilt legs, an inlaid commode drawer, a mahogany side table with a cistern under it, a French clock standing on a marble slab . . .*". Almost all this furniture remains in the Gallery's collection. The late eighteenth-century English side table, and the early eighteenth-century Boulle clock (with its later dial), are shown here.

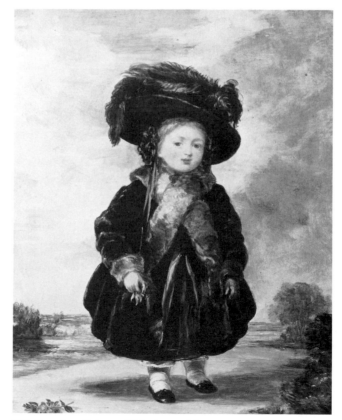

S.P. Denning: *Princess Victoria, aged four.*
Panel. (Dulwich Picture Gallery)

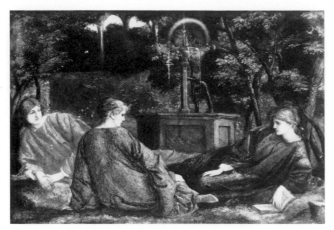

Charles Fairfax Murray: *The King's Daughters.*
Panel. (Dulwich Picture Gallery)

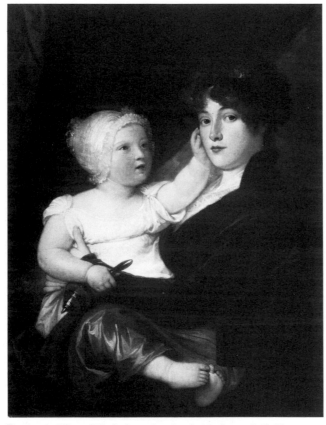

Benjamin West, P.R.A. (1738–1820): *Mother and Child.*
Canvas. (Dulwich Picture Gallery)

The donor was Charles Fairfax Murray (1849–1919). Murray was an artist and picture dealer, who as a young man worked as assistant to Sir Edward Burne Jones and was intimate with the Pre-Raphaelite circle; they knew him, on account of his odd squat physique, as "*dear little Muffy*". During his youth Murray, in company with his friend and biographer W.S. Spanton, frequently visited the Gallery, and he did not forget it. He spent much of his life

in Italy, becoming an authority on Italian art and, unobtrusively, one of the most important figures in the history of English collecting. By 1900 he was rich. His generosity was outstanding: he made major gifts to the British Museum, the Fitzwilliam Museum, and the Birmingham City Art Gallery. Murray believed that British portraiture was inadequately represented in public collections, and his gift to Dulwich was intended to remedy this gap. The forty-one paintings which he gave between 1911 and his death comprise, together with three Old Masters (including Bourdon, no. 2), portraits by all the leading portraitists working in England from the late seventeenth to the early nineteenth centuries (apart from Reynolds and Lawrence who were already represented), and interesting examples of lesser-known artists like Dahl and Vanderbank. The only painting in the collection by an American, West's *Mother and Child* (inv. no. 586), is part of this group.

Visitors

For at least the first thirty years of its existence the Dulwich College Picture Gallery (as it was known until 1979) was the most important accessible collection in London. The National Gallery, opened in 1824 in John Julius Angerstein's house in Pall Mall, contained a choice but much smaller selection of paintings. The visits to Dulwich of numerous literary, artistic and political figures are recorded: Hazlitt (who wrote about the Gallery at length, in 1824), Dickens, Carlyle, Tennyson, George Eliot; Canova, Samuel Palmer, David Cox, William Etty, Frith; among American artists, Chester Harding (who admired Van Dyck's *Emmanuel Philibert*, (no. 6)) and Washington Allston. The hero of Charles Kingsley's *Alton Locke*, a young man new to London, describes the atmosphere around 1830: "*The rich sombre light of the rooms, the rich heavy warmth of the stove-heated air, the brilliant and varied colouring and gilded frames which embroidered the walls, the hushed earnestness of a few visitors, who were lounging from picture to picture, struck me at once with mysterious awe*". When Henry James visited in 1869 the atmosphere was more chilly – "*A pale English light from the rainy sky – a cold half-musty atmosphere & solitude complete save for a red-nosed spinster at the end of the vista copying a Gainsborough – the scene had quite a flavour of its own.*"

A number of important figures gained early impressions from the Gallery. Robert Browning, who as a child lived nearby, wrote in 1846 of "*that Gallery I so love and am so grateful to*", and several of his poems are inspired by paintings in the collection. Holman Hunt copied there regularly as a student. And John Ruskin, who in his youth lived nearby at Herne Hill, used many of the Gallery's pictures as fuel for his violent attack on the Old Masters in

Modern Painters: he recorded in his diary for 30th January 1844 – "*Walked down to Dulwich Gallery, and thought the pictures worse than ever; came away encouragingly disgusted.*"

By the late nineteenth century the Gallery's reputation for quietness had made it, apparently, an ideal meeting-place for lovers. W.B. Yeats in the 1890s conducted a love-affair at "*Dulwich Picture Gallery and in railway trains*", while in George Moore's *Evelyn Innes* (1898) two lovers regularly meet in these peaceful surroundings, though "*they were ill at ease on a backless seat in front of a masterpiece.*" Fewer visits by literary personalities are recorded in this century. Evelyn Waugh, trying to visit in 1928, grew bored with waiting for a bus and instead went to buy a marriage licence. D.H. Lawrence was more persevering, and described in 1909, "*such a splendid little gallery – so little, so rich.*"

The Gallery was open to copyists from an early date, and by 1835 the number was so great that restrictions on numbers had to be introduced. Some of the lists of pictures copied survive, and these lists, together with the comments of visitors and guidebooks, give an interesting insight into nineteenth century taste. The most popular pictures for copyists (some of them students and professional artists, but mostly amateurs) throughout the century were Murillo's *Flower Girl* (no. 22) and Rembrandt's *Girl at a Window* (no. 26). Aert de Gelder's *Jacob's Dream* (then attributed to Rembrandt (no. 11), was constantly extolled; and a picture now regarded as a school work, Guido Reni's *St. Sebastian* (inv. no. 268) aroused powerful excitement. Visitors tended to regard the Cuyps and the Murillos as the jewels of the collection. The Poussins – nowadays often considered the most important group of paintings at Dulwich – aroused little enthusiasm among copyists, though the Royal Academicians regularly selected them as loans for the Academy Schools. Many of the visitors commented (as they do today) on the rustic charm of the setting; and quite a number, seeing an unweeded Gallery, with all the copies crowded on the walls with the masterpieces and many of the pictures in a poor state of conservation, remarked on the collection's very uneven quality.

The Decoration and Arrangement of the Gallery

The Gallery's appearance has altered considerably over the years, reflecting changing attitudes to museums. A watercolour of c.1823, in the Soane Museum, shows the interior of the building soon after completion (Illus. p.39). The walls were painted in the colour, "*something like burnt Oker, but heavier*" (Farington), recommended by Benjamin West as President of the Royal Academy: the floor was covered in green cloth, and the Desenfans' furniture was arranged around the walls. The circular protrusions in the

The Keeper of the Gallery and his dog, in front of *Mrs. Siddons as the Tragic Muse* (c.1900)

After Guido Reni (1575–1642): *St. Sebastian*. Canvas. (Dulwich Picture Gallery)

centre of the floor were stoves, part of the heating system which caused so much trouble. The pictures were hung two or three deep, with the top layer canted forward – even the piers were used as hanging space. The first catalogue (c.1816) shows that the paintings were not strictly arranged – it would hardly have been possible – by School; but the Dutch and Flemish paintings were placed in two rooms at the south end of the building, and those

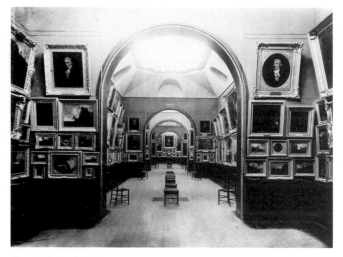

The Gallery, Interior, c.1910.

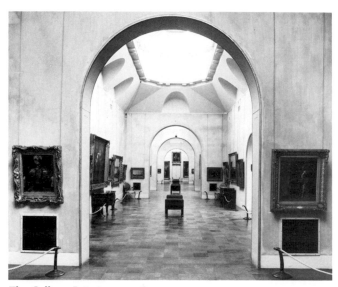

The Gallery, Interior, c.1960.

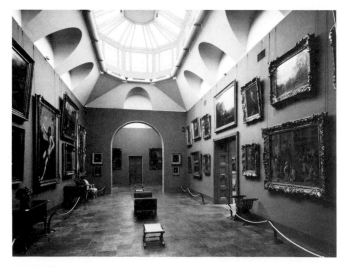

The Gallery, Interior, 1985.

of the Italian, Spanish and French Schools at the north end. The traditional fondness for hanging pictures as pendants dominated the arrangement as it had the original selection. The character of Dulwich at this time was that of a private collection, comparable to a gallery in a great country house.

By 1910, under the influence of Yates Thompson, the Gallery had been tidied up. A metal barrier had been erected round the walls, a dado introduced, the top row of pictures had been removed to the new rooms, and one of these served as a 'Tribune' for a selection of what were regarded as the best pictures. Some of the walls had been covered in rich red damask, not perhaps the most suitable material. Many of the pictures had by this time been put under glass, and others consigned to the store room.

Such severity is even more apparent in the photograph of the Gallery as rearranged after the restoration of 1952. This was the era of the neutral setting and of the belief that the spectator's appreciation of a painting was enhanced by creating around it as colourless an environment as possible. Consequently, the walls were given a wash of grey paint, and the pictures, with the exception of the English portraits, which were double-piled in minor rooms, were arranged at eye-level in a single tier. The effect was cool and elegant, but not faithful to the original character of the building, and the pale walls made the paintings, with their dark grounds, appear darker.

With the increasing interest during the last few years in restoring the original character of older buildings as well as in the architecture of Soane, the need for major redecoration provided an opportunity in 1980 to re-consider the appearance of the interior. It was decided to return the main galleries, as far as possible, to their original look. Only "as far as possible", because the rooms themselves had been altered, with large apertures opened in the walls for access to the side galleries, and because the range of exhibited pictures had changed considerably. Such elements as the skylights (with the top, diagonal, sections glazed in 1910) and the introduction of artificial light, had also changed the building's character. What was achieved had to be a compromise, though in one detail, the opening of the mausoleum to the public, it was possible to return to Soane's original intention. The brownish-red that was chosen recalls the colour known to have existed in the nineteenth-century Gallery, and was derived by the consultant, Mr. Ian Bristow, from a recipe of 1828 for *"a colour for picture galleries"* which *"harmonises with paintings and gilt frames"*. The paintings were rehung, not as close together as they had been in the early nineteenth century, but in large-scale symmetrical arrangements such as were often found in major galleries in the Regency period.

The Gallery since 1900

The additional galleries and the gift of pictures by Fairfax Murray represented a flowering in the Gallery's fortunes around 1910. The Governors felt that every necessary aim had been achieved. The proximity of the Crystal Palace at Sydenham, one of the most popular tourist attractions in London, benefited the Gallery, which was quite heavily visited at this time. The Governors had reckoned without the World Wars. The Gallery was little affected by the First World War, though with the beginning of air-raids a group of the most important paintings were taken for safety to the cellars of the Royal Academy. In 1939 eighty pictures were removed to Wales, to be followed the year after by the rest of the collection. It was a wise decision, for in 1944 one of the many bombs which struck Dulwich fell just outside the building, which was severely damaged. After some debate over whether the Gallery should be re-erected in a modern idiom, it was decided to rebuild in replica. The work, conducted under the consultancy of Arthur Davis, R.A. and Sir Edward Maufe, R.A. by the firm of Austin Vernon Associates, was completed in 1952, when the Gallery reopened.

Since then the collection's history has not been smooth. A break-in in 1966 in which eight pictures were stolen, including three Rembrandts and three Rubenses (all subsequently recovered), was the first of four notorious thefts, in which the same picture, a small early Rembrandt of *Jacob de Gheyn III*, has been among the victims. The need to raise money prompted the Governors in 1971 to send one of the paintings from the Bourgeois collection, Domenichino's *Adoration of the Shepherds*, for sale at Sotheby's: it raised £100,000 but the sale, a very unusual step for a museum in Britain, aroused much controversy. It is not the policy of the present Governors to sell any further pictures. In recent years it has become possible for the Foundation to which the Gallery belongs, and for the three schools with which it is linked, to provide more funds, and the Gallery has been much helped by the National Maritime Museum (especially with conservation) and by the Friends of the Gallery. Nevertheless its financial problems remain considerable.

The Gallery has no funds for acquisitions and, apart from occasional gifts of drawings or prints relating to its history, the collection has become static. It is not, however, lifeless; in recent years it has been redecorated, rehung, relabelled and relit while an active educational programme and a series of exhibitions and concerts have helped to revitalize the Gallery, and the number of visitors has risen. But Dulwich Picture Gallery is not a place that lends itself to excessive modernization. The contemporary visitor can still feel, as Hazlitt did, that when he comes to Dulwich he is escaping from the noise and bustle of London to parks and fields, surrounding a precious collection of paintings originally intended for a King.

The Gallery after war damage. (Photo: National Monuments Record). The bomb which fell just outside the Gallery in July 1944 damaged it severely. The mausoleum and the north-west corner were particularly badly hurt. The existence of numerous architect's drawings in the Soane Museum allowed a careful reconstruction to be carried out.

The principal sources for the history of the Gallery are as follows:

BOURGEOIS AND DESENFANS
J.T., *Memoirs of the late Noel Desenfans, Esq.* (1810)
Desenfans archive (Dulwich College)
Desenfans letter to Benjamin West (Historical Society of Pennsylvania)
N. Desenfans, *Catalogue of the King of Poland's Pictures* (1802)
Desenfans sale catalogues (Christie's archives and Courtauld Institute of Art)
Royal Academy of Arts, General Assembly Minutes
Whitley Papers (British Museum)
J. Farington, *Diaries*
Contemporary newspapers and memoirs

POLAND
Desenfans archive (Dulwich College)
T. Mankowski, *Galerja Stanislawa Augusta* (1932)
J. Fabre, *Stanislas-Auguste Poniatowski et l'Europe des lumières* (1952)

DULWICH COLLEGE
Minutes of Private Sittings of the Master, Warden and Fellows of Dulwich College 1805–29 (Dulwich College)
G. Warner, *Catalogue of the Manuscripts and Muniments . . . at Dulwich* (1881)
W. Young, *History of Dulwich College* (1889)
S. Hodges, *God's Gift* (1980)

THE BUILDING
Drawings and notebooks in the Sir John Soane Museum
A.T. Bolton, *The Works of Sir John Soane* (Soane Museum Publications No. 8)
J. Summerson, *Soane, the Man and his Style* in *John Soane* (1983); and elsewhere
G.-T. Mellinghoff, *Soane's Dulwich Picture Gallery Revisited* in *John Soane* (1983)
Minutes of the Governors of Dulwih College

LATER HISTORY
Bourgeois Book of Regulations (Dulwich College)
Minutes of the Governors of Dulwich College
W.S. Spanton, *An Art Student and his Teachers in the Sixties* (1927)
E. Cook, *Catalogue of the Pictures at Dulwich . . .* (1926)
P. Murray, *Dulwich Picture Gallery* (1980)

I am most grateful to the following for their help:
Mr. C. Bailey, Mrs. S. Bury, Mr. B. Ford, Mrs. B. Greenhill, Mr. A. Hall, Mr. S. Jervis, Mr. G.-T. Mellinghoff, Miss C.-A. Parker, Dr. J. Piggott, Miss E. Ross, Mrs. D. Scarisbrick, Miss C. Scull, Mrs. R. M. Slythe, Mr. P. Thornton.

Note on the catalogue

Several catalogues have been compiled of the collection at Dulwich Picture Gallery. The first scholarly catalogue was published in 1876 by J.C.L. Sparkes, but was superseded by a new work by the German art historian J.P. Richter in 1880. This was revised by Sir Edward Cook in 1914, and again in 1926. In 1980 a new catalogue, by Professor Peter Murray, was published. References to all the paintings in the present exhibition may be found in Murray, which in some instances gives fuller information on provenance and literature.

The artists are listed in alphabetical order. All the works are painted in oil on canvas. In all entries dimensions are given in centimetres and inches; height before width.

The term 'Inv.no.' signifies the inventory number of that painting within the Dulwich Picture Gallery collection.

'Insurance List 1804' refers to the list of Desenfans' collection made for insurance purposes on 6th July 1804.

The items listed in the 'Literature' section in each entry have been selected by individual contributors, and are not necessarily exhaustive.

Abbreviations of institutions and literature frequently cited:

Art Quart.	*The Art Quarterly*
Bernt	W. Bernt, *"Die Niederländischen Maler des 17 Jahrhunderts"* (1948)
Bredius-Gerson	A. Bredius, *"The Paintings of Rembrandt"* 3rd edition, revised by H. Gerson (1969)
Buchanan	W. Buchanan, *"Memoirs of Painting, with a Chronological History of the Importation of Pictures by the Great Masters into England since the French Revolution"* (1824) 2 vols.
Burl.Mag.	*The Burlington Magazine*
Gaz. des B-Arts	*La Gazette des Beaux Arts*
J. of W.C.I.	*The Journal of the Warburg and Courtauld Institutes*
HdG	Hofstede de Groot, *"A Catalogue Raisonné of the Works of . . . Dutch Painters of the Seventeenth Century, based on the Work of John Smith"* (1907–28), 10 vols.
N.G., London	The National Gallery, London
N.P.G., London	The National Portrait Gallery, London
R.A., London	Royal Academy of Arts, London
Rosenberg/Slive	J. Rosenberg, S. Slive and E.H. ter Kuile, *"Dutch Art and Architecture 1600–1800"* (1966)
Smith	John Smith, *"A Catalogue Raisonné of the Works of the most Eminent Dutch, Flemish and French Painters . . ."* (1829–42) 9 vols.
Waagen	G.F. Waagen, *"Treasures of Art in Great Britain"* (1854)
Walpole Soc.	*The Walpole Society Journal*

Contributors to the catalogue

C.B.	Christopher Brown
P.C.	Philip Conisbee
D.C.	David Cordingly
J.D.	Jeffery Daniels
J.F.	Jennifer Fletcher
K.G.	Kenneth Garlick
I.G.	Ivan Gaskell
M.K.	Michael Kitson
M.L.	Sir Michael Levey
J.G.L.	J.G. Links
D.M.	Denis Mahon
M.R.	Malcolm Rogers
J.S.	Jacob Simon
L.S.	Lindsay Stainton
R.V.	Richard Verdi
G.W.	Giles Waterfield
C.J.W.	Christopher White
C.J.N.W.	Christopher Wright

Photographic credits

Photographs for the comparative illustrations are acknowledged in the text, except the following:

Courtauld Institute of Art, London (Cat. 7) fig. 1, (Cat. 20) fig. 1, (Cat. 24) fig. 1, (Cat. 26) fig. 1, (Cat. 31) figs. 1 & 2.
Fototecnica, Vicenza (Cat. 30) fig. 1
Tapporo e Trentin, Vicenza (Cat. 31) fig. 3

The Catalogue

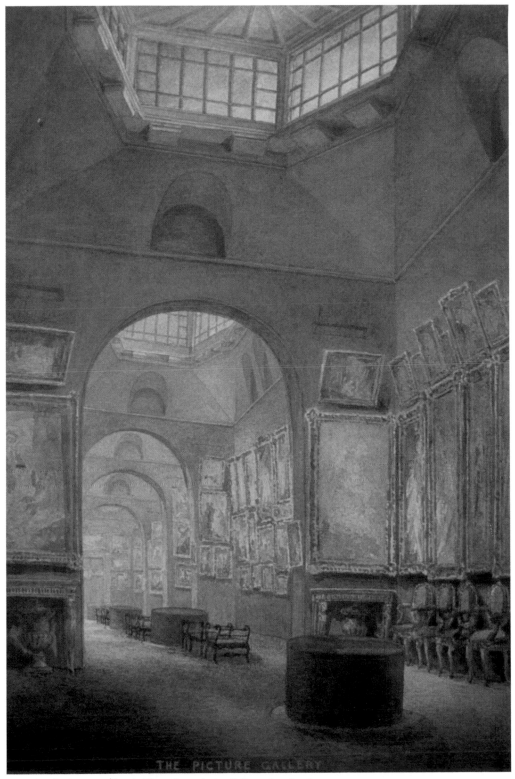

THE PICTURE GALLERY

J.M. Gandy (1771–1843): *Vista through the Gallery*. (c.1823)
Watercolour. (By permission of the Trustees of Sir John Soane's
Museum)

1 Ludolf Bakhuizen

Emden 1631–1708 Amsterdam

Bakhuizen belonged to the last generation of great Dutch seascape painters. He was born at Emden in Germany, but moved in about 1649 to Amsterdam, where he took up painting. When the Van de Veldes left for England in 1672, Bakhuizen became the leading marine painter in Holland. His work was in great demand, his patrons including Frederick I of Prussia and Peter the Great. He died in Amsterdam in 1708.

Boats in a storm

Canvas, 63 × 79 cm., 25 × 31¼ in.
Signed: L. BAKHUZEN (or L. BAKHUZYN) and dated 1696, on a plank.
Inv. no. 327.

Bakhuizen excelled in the depiction of stormy scenes on the windswept coasts of Holland. He was as skilful as Van de Velde the Younger at the drawing of ships, and his finest works have a dramatic power seldom equalled by any of the Dutch seventeenth century marine artists. This picture shows part of a river estuary: on the extreme left can be seen the far bank with two sailing vessels heeling before the strong wind, while the cluster of masts and the church tower visible over the dunes on the right indicate the distant course of the river.

Dark storm clouds provide a backdrop to the brilliantly illuminated activity in the foreground. The wind is blowing on to this stretch of river-bank, making it into a dangerous lee shore. The large sailing vessel, which is the focal point of the picture, is a *wijdschip*. She appears to have been swept on to the wooden groin and is in difficulty. Her jib has been backed to help her bear away from the groin against which she is being battered. The gestures of some of the passengers on board indicate their alarm. On the bank people are hurrying down to the water's edge to watch the action, or to help. One man carries a boat-hook, and two men on the far side of the groin are hauling on a rope to steady the stern of the *wijdschip*. The smaller vessels in the foreground seem to be hurrying to the assistance of the larger vessel. A sturdy fishing boat, probably a *kaag*, has lowered her sails and drawn alongside her, and two other small boats, both *weyschuits*, are heading in the same direction.

The artist has signed his name on the stern of one of the small boats, and on a floating plank in the lower left of the picture he has inscribed the date "1696". This indicates that the painting is a late work, executed at the age of sixty-five. While some of Bakhuizen's later storm scenes suffered from an empty and stereotyped formula, this example shows no lessening in his powers. There is a freshness about the picture which suggests that it is based on an incident witnessed by the artist. Boats and figures are finely observed, while the movement and translucence of the water are portrayed with a masterly touch. D.C.

PROVENANCE: Probably Desenfans Sale, Christie's, 14th May 1785 (21); Desenfans Private Sale, 8th. ff. April 1786(89); Bourgeois Bequest, 1811.

LITERATURE: HdG VII, no. 235; Bernt, I, no. 36, fig.

2 Sébastien Bourdon

Montpellier 1616–1671 Paris

Bourdon: *Soldiers playing cards outside their tent*, 1643. Canvas. (Staatliche Kunstsammlungen, Kassel, Gemäldegalerie Alte Meister)

Bourdon was born in the South of France, in Montpellier. At an early age he went to Paris where he was the pupil of a certain Barthélemy. By 1634, he was in Rome, where he came under the influence of Claude, Poussin and Pieter van Laer, called il Bamboccio. Returning to Paris in 1637, he evolved a soft and intimate style of portraiture. Bourdon was a founder member of the French Academy in 1648, and from 1652–54 court painter to Queen Christina of Sweden. He then returned to Montpellier, until in 1663 he moved permanently to Paris.

A Brawl in a Guard-Room

Canvas, 74.9 × 60.6 cm., 29½ × 23⅞ in.
Inv. no. 557.

Sébastien Bourdon was the most versatile of all French seventeenth century painters, and this explains the confusion in identifying the present picture in the early part of this century (see Provenance below). He painted in many different styles, assimilating other painters' methods with great facility. As a result, his pictures are impossible to date with any accuracy. The identification of the guard-room piece as a Bourdon was first made at the time of the Burlington Fine Arts *Le Nain* exhibition of 1910 when it was compared to two rather similar pictures in the Gemäldegalerie Alte Meister, Schloss Wilhelmshöhe, Kassel (see *Katalog I*, 1980, pp. 52–5, illustrated), especially the *Soldiers Playing Cards Outside Their Tent* (dated 1643).

It is not generally realised that low-life genre was favoured by French artists working under the influence of the Dutch colony in Rome. Bourdon's contemporary Jean Tassel of Langres came under the same influence. Bourdon's approach is totally anti-classical and he uses the striking device of allowing his figures on the left to come to blows while leaving the crouching soldier on the right totally indifferent to the violence. He also introduces an idea familiar from some of the best pictures of the Le Nain brothers, which is that one of the models, in this case the small child, stares out of the picture towards the spectator. The picture, far from being a scene of squalid violence, contains a more subtle conflict. On grounds of similarity with the Kassel picture of 1643 it should be dated from approximately the same time.

Bourdon's chameleon-like abilities are particularly well displayed in this picture which has every appearance of being a genre work painted by a Dutchman. Indeed it was this ability to imitate other artists' work which gained Bourdon recognition amongst his contemporaries. Each figure in the painting, although in half-shadow as befits the subject, is painted with attention to every precise detail, exactly as a Dutchman would have done. Bourdon's personal characteristics are seen in the smoky blueness of the general tonality – a feature he carried over into his classical compositions, which imitated those of Nicolas Poussin.

C.J.N.W.

PROVENANCE: Anon. Sale, Christie's, 20th June 1903, lot 136 as Karel Dujardin, Anon. Sale, Christie's, 12th May 1906, lot 100 as "Le Nain" bt. Agnew, acquired by Fairfax Murray by 1907; his Gift, 1911.

LITERATURE: G. Isarlo, *Les Frères Le Nain*, La Renaissance (1938), p. 206, no. 6, confirming Bourdon attribution; A. Blunt, *Art and Architecture in France 1500–1700* (1970), p. 186 and note 140.

3 Giovanni Antonio Canal, called Canaletto

Venice 1697–1768 Venice

Canaletto first studied painting under his father, a scene-painter in the theatre. About 1720 he began making independent oil paintings, particularly views of the city of Venice. By 1726 his work was selling to English patrons through agents resident in Venice. From 1746 he was based in England, probably making two short visits to Venice before returning there permanently in about 1755.

Old Walton Bridge over the Thames
Canvas, 48.8 × 76.7 cm., 19¼ × 30¼ in.
Inv. no. 600

Giovanni Antonio Canal became known as Canaletto, no doubt to distinguish him from his father. Canaletto's early work was atmospheric and theatrical and his large, somewhat dark paintings found favour with Venetian and other Italian connoisseurs. His connections with England began in the mid-1720s when he was taken up by Owen McSwiney, an Irishman in Venice, and later encouraged to paint small, sunny topographical views for McSwiney's English clients. The English merchant and collector, Joseph Smith, long resident in Venice, in turn took Canaletto under his wing and throughout the 1730s had much success in selling the greater part of the artist's work to English tourists.

Travelling became difficult for the English after the outbreak of the War of the Austrian Succession in 1741 and the demand for Canaletto's work fell off. By the mid-1740s, Smith was virtually his only patron and Canaletto decided to visit England. He arrived in 1746 and was well received by old and new patrons.

This painting is one of the six works executed for one of his last important English patrons, Thomas Hollis. Hollis

Fig. I. Canaletto: *Detail from "Old Walton Bridge over the Thames"*.

was a rich and highly eccentric recluse with republican sympathies who, in 1754, was thirty-four years old and had recently returned from some years travelling on the Continent; while in Venice he had become friendly with Smith, who had been made British Consul. Of the six paintings Hollis received from Canaletto, five can have called for no imaginative effort on the artist's part, being based largely on earlier work. *Old Walton Bridge* stands alone in conception and execution and there is always the possibility that it had been painted three years earlier, at the time of the opening of the bridge, and the inscription (see below) added later for Hollis's benefit.

The latticed timber bridge is seen from a point on the north (Middlesex) bank of the Thames, looking upstream. It appears to be curved, and wider in the centre, whereas old plans show it to have been straight and of equal width throughout; this is one of a number of adjustments to the facts made by Canaletto for artistic reasons. In the background, on the Surrey side of the river, can be seen part of another bridge which had been built much earlier

Fig. 2. Canaletto: *Old Walton Bridge*, 1755. Canvas. (Yale Center for British Art, Paul Mellon Collection)

than Walton Bridge across fields apt to flood, so as to give access to the ford and ferry across the Thames. Behind this are a number of houses, one of which belonged to Samuel Dicker, a member of Parliament who had paid for the building of Walton Bridge in 1747. In the foreground, according to an old catalogue, are Thomas Hollis, his friend Thomas Brand, to whom Hollis later bequeathed the picture, his servant Francesco Giovannini, and his dog Malta (fig. 1). To the left of these figures is an artist at work, presumably Canaletto himself. A summer shower seems about to fall from a characteristically English cloud.

Thomas Hollis evidently demanded authentication of his pictures in the artist's hand. Four of them bear a label with similar wording which, in the case of *Old Walton Bridge*, reads:

> Behind this picture on the original canvas is the following inscription by Canaletto: *Fatto nel anno 1754 in Londra per la prima ed ultima volta con ogni maggior attenzione ad instanza del Signior Cavaliere Hollis padrone mio stimatissimo / Antonio Canal detto il Canaletto*. It was necessary to new line the picture in 1850 so the inscription is hid. John Disney, 1850.

John Disney's father had inherited the six pictures from Hollis's friend Brand and it is safe to assume that originally all six bore similar labels.

It was hardly true that Canaletto had painted the bridge for the "*ultima volta*" (last time). Within a year Samuel Dicker, who had paid for the bridge, commissioned another version (now Paul Mellon Collection, Yale) (fig. 2) and this bears an inscription, presumably also transcribed from one on the original canvas, in more or less the same words, substituting the date 1755 for 1754 and "*Signore Cavaliere Dickers*" (sic) for Hollis's name. In the same year Canaletto made a drawing (also Yale) on which he wrote that it was "after" the picture he had painted in London for Dicker, and an engraving of this drawing was dedicated by the publisher to "*Samuel Dicker Esqr at whose sole Charge the said Bridge was Erected in the year 1750*"; this identifies Dicker's house and other properties and notes that the central arch of the bridge was 130 feet wide. It was claimed as the widest arch in Britain in an attempt to overcome the bargemasters' objections to the building of the bridge when Dicker had first petitioned Parliament for it.

Canaletto was perhaps justified in stating that Hollis's picture had been painted "for the first and last time", since Dicker's version is entirely different. The bridge is seen *en face* with the loss of almost all the charm of the Hollis version. The brickwork approaches have become a distracting feature. Most notably the old bridge and the stone extension linking it with Walton Bridge are shown in their entirety, necessitating a canvas more than half as wide again as Hollis's.

It is often said that Canaletto was always willing to sacrifice topographical accuracy to produce a better picture and this is nowhere better demonstrated than in his first painting of *Old Walton Bridge*. Thomas Hollis

received at least four mediocre paintings for his patronage but this is surely among the three or four finest works of Canaletto's ten-year stay in England.

J.G.L.

PROVENANCE: Painted for T. Hollis, 1754; bequeathed by him to T. Brand (later Brand-Hollis) in 1774; bequeathed by him to Rev. J. Disney, 1804, then to John Disney and Edgar Disney; Anon. (Mrs. E. Disney) Sale, Christie's 3rd May 1884 (130), bt. Denison; C. Becket Denison; sold Christie's 13th June 1885 (858), bt. H. Yates Thompson; presented by Miss E. Murray Smith, 1917.

LITERATURE: H. Finberg in *Walpole Soc.* IX (1920–21), p. 66; W.G. Constable, *Canaletto*, 2nd edn., ed. J.G. Links (1976), I, pp. 40, 145–6, II, no. 441 (nos. 442 and 775 are the Mellon versions); J.G. Links, *Canaletto* (1982), pp. 173, 175, 177–8.

4 Claude Gellée, called Claude Lorrain

Chamagne 1600–1682 Rome

Born of humble parents in the Duchy of Lorraine, Claude went to Rome at the age of perhaps thirteen, and was certainly established there by the time he was twenty. There he worked as an assistant to Agostino Tassi. Apart from a return visit to Nancy in 1625–26, he spent the whole of his long career in Rome working for a wide circle of patrons, including many of the nobility. All his mature works are landscapes or seascapes, populated by classical or biblical figures. They exerted a great influence on later landscape painting, particularly in Britain, where his works were highly sought after. He recorded his paintings in a book, now in the British Museum, called the *Liber Veritatis* ("Book of Truth"). It contains 195 drawings, with, on the backs, indications of the patrons for whom or the places for which the pictures were executed.

Landscape with Jacob, Laban and his Daughters

Canvas, 72 × 94.5 cm., 28½ × 37¼ in.
Signed and dated: CLADIO IVF ROMAE. 1676
Inv. no. 205.

The Dulwich *Landscape with Jacob, Laban and his Daughters* is one of the most lucid and serene of Claude's late works. It lacks the high seriousness of the Ashmolean *Ascanius*, the drama and grandeur of *The Arrival of Aeneas at Pallanteum* (Anglesey Abbey, Cambridgeshire, National Trust) and the romance of the mysterious *Perseus, or the Origin of Coral* (Holkham Hall, Norfolk), all of which are more complex pictures. In compensation it brings to the fore those simple, or simple-seeming, qualities for which Claude's art has always been famous: harmony, repose, a sense of order and the creation of an image of nature more perfect than nature itself.

A tall tree with lesser trees clustered about it dominates the composition just off centre to the right. To the left and set further back in space rises a tree-clad hill surmounted by a round tower and other buildings, a motif that was by this time almost a cliché in Claude's compositions. Beyond the line of shrubs on the right stretches the obligatory light-filled distance, its alternating bands of pale silvery-blue (for the water), green, yellow and violet-grey establishing a series of firm horizontals that are echoed in the folds in the ground in front. These horizontal bands are contrasted with the vertical forms of the central tree, the round tower, and the figures, a framework which gives the composition unusual stability. Two other lines receding diagonally contribute to this effect: one, the more emphatic of the two, runs from the shadow in the bottom right corner through the figures and the bridge in the middle distance to the hill at the extreme left; the other, lesser one passes from the bottom left corner through the figures once more and fades out in the distant plain on the right. All these directional lines meet in or are in some way related to the figures, which are situated in the exact centre of the composition measured across its width. At the edges and in the foreground there is little clutter. No dark tree appears to one side as is usually the case in Claude's works, nor are there picturesque shrubs, broken branches, bits of fallen masonry or butting goats to catch the viewer's eye; on the contrary, the few plants shown are highly stylized and even the sheep are shorn. However, Claude had been painting centralized compositions with comparatively empty foregrounds and with figures set back in space for some time before this, most notably in the *Landscape with Jacob, Rachel and Leah at the Well*, of 1666 (Hermitage, Leningrad). (fig. 1) That he used a similar type of composition for the Dulwich picture may not be entirely coincidental, given the related subject, though the painting in Leningrad is much grander.

Colour and light enhance the tranquil mood. The light comes from low down outside the picture to the left, its angle of incidence revealed by the way in which the lower branches of the trees are illuminated and by the long shadows cast by the figures and animals. The warmth of the light suggests evening. Somewhat unusually, there are no large areas of dark shadow in the picture, and the tonality is generally blond. The sky, which contains a few white clouds, is pale blue turning to white-ish yellow over the horizon. The trees and parts of the foreground and distance are painted in varying tones of green mingled with golden browns and yellows. Warm brownish yellows are also used for the sheep and the buildings. As is characteristic of Claude, the colours in the figures take up in intensified form the colours diffused throughout the landscape: blue, green, yellow and even a muted red. Other qualities that reveal the picture as a late work are the softness and delicacy of the forms and the smoothness of the tonal transitions. The trees are so diaphanous that they hardly interrupt the continuity of the air, and the hill with buildings on the left has the flatness of an image projected on to a gauze screen. The figures, thin and elongated, have the immaterial quality suited to wanderers in an enchanted land.

The subject is Jacob's marriage to both Leah and Rachel, the daughters of Laban, as recounted in *Genesis* XXVIII–XXXIII. Jacob had been instructed by his father, Isaac, to seek a bride not from among the local Canaanite women but from his ancestral home, far to the north, where his uncle, Laban, lived. On arrival he met and fell in love with Rachel, the younger daughter, as she came down to the well to water her father's sheep. In order to win her hand he contracted with Laban to look after the sheep for seven years; after they had passed, however, Laban deceived him by giving him Leah. Jacob then agreed to look after the sheep for another seven years so that he could marry Rachel as well.

Jacob's first meeting with Rachel had been popular in art ever since Raphael had included it among the scenes executed to his designs in the Vatican *loggie*, and the story

of Jacob, his journey and his wives is, in fact, among the prime sources of pastoral subject matter in the Old Testament. The representation of Laban is less common, though Raphael had shown him bargaining with Jacob for Rachel's hand in another fresco in the *loggie*. It is this scene which Claude depicts, though he chooses a different arrangement of the figures from Raphael's; Jacob, gesturing with his right hand towards the sheep, now confronts Laban who is flanked by both his daughters (Rachel, as the younger, is presumably the one on his left). The treatment of the subject is also much less dramatic than that by Raphael.

Claude first represented Jacob, Laban and his daughters in one of his largest canvases, that at Petworth, dated 1654, executed for the Roman nobleman and passionate art collector, Carlo Cardelli. He repeated this composition on a smaller scale five years later for an obscure Frenchman named Delamart.

In 1666 he returned to the story in a painting for Henri van Halmale, Dean of Antwerp Cathedral. For this important patron, Claude took the opportunity to re-design the composition and he also chose the earlier moment in the story, when Jacob first meets Rachel at the well; for the figure group he used Raphael's fresco of the subject as a direct model. It was this painting for Halmale (now in Leningrad), that formed the basis, in reverse, for the Dulwich picture. Another source was Claude's etching, *The Goatherd*, of 1663. Claude scaled down the composition of the Dulwich picture to accord with the status of the client, Freiherr Franz Mayer von Regensburg. Mayer was adviser to the Elector of Bavaria, who was a friend of Claude's biographer, Sandrart, and probably already owned four paintings by the artist. He was a less important purchaser than Halmale, not to mention the great Roman patrons of Claude's last years, such as Altieri and Colonna, and so did not "rate" one of the artist's profound and original late masterpieces. He seems to have been a man of conservative tastes and to have preferred, possibly at Sandrart's prompting, Claude's early works to his late: two of the paintings he acquired in the 1670s (they are now in Munich) were re-workings of early etchings. Still, he was an enthusiast, as Sandrart testifies, and was one of Claude's comparatively few foreign patrons in the last dozen years of the artist's life. In the Dulwich *Landscape with Jacob, Laban and his Daughters*, Claude executed for him a painting which would not have shocked him by its eccentricity. Of medium size and exquisite craftsmanship, it would have given his client a taste of the classic works of the artist's middle period.

No preliminary sketches for the painting are known, and the three drawings that survive are all highly finished and correspond closely to the picture. The most important is the record Claude made for the *Liber Veritatis*, which is signed on the front, *1676 CLAVDIO*, like the painting, and is inscribed in the artist's hand on the back, *quadro facto per ill^mo sig^re / francesco Mayer / di ottobre 12 1676 Roma / Claudio Gillee / fecit. I.V.* (fig. 2). This drawing is number

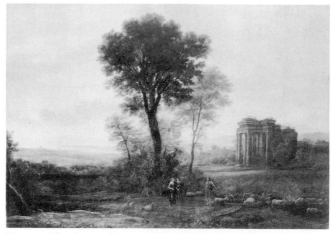

Fig. 1. Claude: *Landscape with Jacob, Rachel and Leah at the Well*, 1666. Canvas. (Hermitage, Leningrad)

Fig. 2. Claude: *Landscape with Jacob, Laban and his Daughters*, 1676. Pen and ink with grey/brown wash and black chalk. (The Trustees of The British Museum, London)

188 in the book. The other two drawings may also have been executed after, rather than as preparatory studies for, the painting.

M.K.

PROVENANCE: Franz Mayer, Regensburg, for whom painted; Earl of Halifax, sale, 10th March 1739 (80 – "A Morning"); Duke of St. Albans, sale ("The Property of a Nobleman"), Phillips, 8th June 1798 (78), "£220.10s, Sir F. Bourgeois for Desenfans" (added in handwriting in the copy of the sale catalogue in the Courtauld Institute of Art); Bourgeois Bequest, 1811.

DRAWINGS: 1. *Liber Veritatis* no. 188 (British Museum). 2. Louvre, Paris (Röthlisberger, "*The Drawings*", no. 1094). 3. Morgan Library, New York (Röthlisberger, *op. cit.* no. 1095).

LITERATURE: M. Röthlisberger, *Claude Lorrain: The Paintings* (1961), I, pp. 442–3, II, p. 188, fig. 308; *idem., Claude Lorrain: The Drawings* (1968), under nos. 1094–6; *idem.*, and D. Cecchi, *L'opera completa di Claude Lorrain* (1975), no. 266; M. Kitson, *Claude Lorrain: Liber Veritatis* (1978), under no. 188.

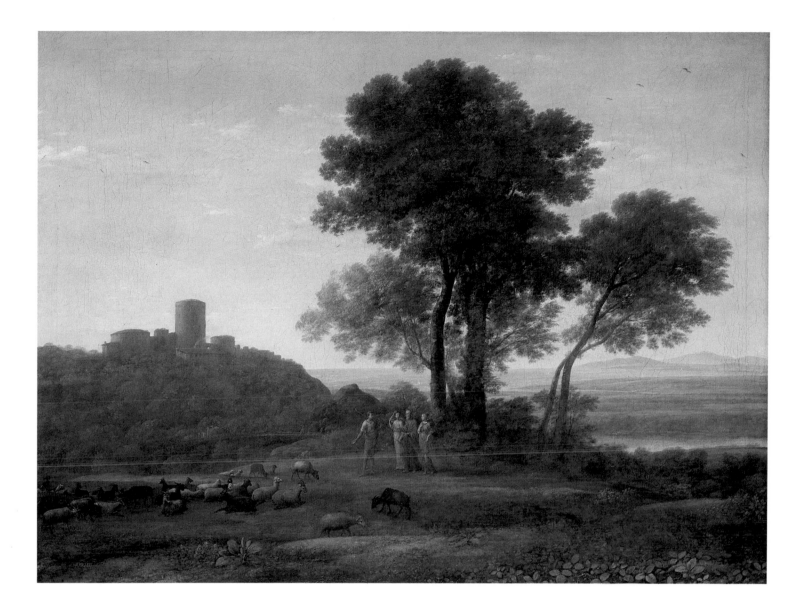

5 Karel Dujardin

Amsterdam c.1623–1678 Venice

Karel Dujardin is said by Houbraken to have been a pupil of the Italianate landscape painter Nicolaes Berchem in Haarlem. He travelled to Italy in the late 1640s, and lived in Rome for several years. He had returned to Amsterdam by 1650, and in 1657 and 1658 is listed as a member of *Pictura*, the painters' confraternity in The Hague. By May 1659 he had again settled in Amsterdam, where he lived and worked. He is last mentioned there in November 1674. In c.1674/75 he went to North Africa, and from there to Italy.

A Smith shoeing an Ox

Canvas, 38 × 42.8 cm., 15 × 16$\frac{7}{8}$ in.
Signed, lower right: K DV IARDIN fe
Inv. no. 82.

During his stay in Rome, Dujardin joined the *Schildersbent*, the Netherlandish artists' society, in which he was given the nickname *bokkebaart* (goat's beard). He was particularly impressed in Rome by the work of the *bamboccianti*, a group of artists named after the Haarlem painter Pieter van Laer, whose *Bent* name was *bamboots* or *Il Bamboccio*. Van Laer and his followers painted scenes of Italian street life. To the already established Dutch genre format of small-scale paintings of full-length figures glimpsed going about their everyday lives, Van Laer brought the naturalism of Caravaggio – which had so shocked and excited contemporaries – as well as that artist's dramatic lighting techniques. Van Laer had returned to Haarlem by 1639 but his influence continued to be strongly felt in Rome; among his closest followers during Dujardin's years in the city were the Fleming Jan Miel and the native Roman painter Michelangelo Cerquozzi.

In this painting Dujardin has taken a typical *bamboccianti* subject, a scene from working life, in this case the shoeing of an ox outside a blacksmith's forge. The smith can be glimpsed inside hammering a shoe while his young apprentice nails on another. Beside him in a voluminous cape and broad-brimmed black hat stands a man, perhaps the ox's owner, talking to a second apprentice. The dress of this man, the buildings, and the strong fall of sunlight, identify the scene as Italian; it is presumably meant to suggest a small town near Rome.

Dujardin's fully-fledged bambocciantesque phase was relatively short-lived. Brochhagen, who is the only author to have established a credible chronology for Dujardin, dates this painting to the second half of the 1650s, comparing it with a painting of 1658 in Hamburg (Kunsthalle, 1966 cat. no. 180: HdG 312).

C.B.

PROVENANCE: Cornelis van Dijck sale, The Hague, 10th May 1713 (lot 6: Nog een stuk van Carel du Jardyn, verbeeldende een Os die Beslagen word voor Een Smidts Winckel, van zyn aldertederste en eelste Kouleur, zeer aengenaem en schoon: sold for 107 guilders); J.H. van Heemskerk sale, The Hague, 29th March 1770 (lot 64; sold for 305 g. to Van der Marck); J. van der Marck sale, Amsterdam, 25th August 1773 (lot 142: sold for 330g. to Van der Schley); Catherina Bullens (widow of Justus Oosterdijk) sale, Amsterdam, 23rd July 1777 (lot 15; 510 g. to Gilden); P. van Spijk sale, Leiden, 23rd April 1781 (lot 44; 370 g.); Jan Gildemeester sale, Amsterdam, 11th June 1800 (lot 103; *Haut 15, large 17 pouces. Sur toile. Un Maréchal Ferrant. Vers le milieu du tableau se voit un boeuf attaché par les cornes, qu'un maréchal ferre au pied de derrière; devant celui-ci se tient un homme en manteau parlant à un garçon: un charriot vuide est en arrière, & le fond présente la boutique du maréchal. Quelques poules mangeant d'un bac terminent cet ensemble. La belle fonte & l'harmonie des couleurs, la légèreté & l'extrême delicatesse de la touche, brillent au plus haut point dans ce tableau.* Sold for 814 g. to J. Yver). [MS. note in the copy of the catalogue in the National Gallery Library gives the price as 840 g.]; Crawford sale, Christie's, London, 26th April 1806 ("*A Catalogue of a small but exquisite assemblage of thirty-two cabinet pictures recently consigned from abroad . . .*") (lot 1: K. DU JARDIN. 1. Outside of a Farrier's Shop; a Farrier shoeing an Ox; a Peasant and a Boy standing by; painted in a thin but clear Tone; the sky silvery and brilliant – a sweet Gem: According to Buchanan [vol. 2, p. 181] sold to Mr North for £126); Bourgeois Bequest, 1811.

VERSIONS: Smith and, following him, Hofstede de Groot confuse this painting with another by Dujardin in the Torrie Collection deposited at the National Gallery of Scotland, Edinburgh (Inv. no. 25: *Halt at an Italian wine-house*: Canvas, 81 × 89.6 cm.). The composition is quite different.

LITERATURE: Smith V, no. 15; HdG IX, no. 336: E. Brochhagen, *Karel Dujardin* (1958), p. 57 and note 215.

6 Sir Anthony Van Dyck

Antwerp 1599–1641 London

Van Dyck was a pupil of Hendrik van Balen in 1609, and an independent master by 1618, when he probably entered the studio of Rubens. In 1620, he spent several months in London in the service of James I, before leaving the following year for Italy. There he travelled widely, returning to Antwerp by 1628. Van Dyck was invited to England in 1632 and became Principal Painter to Charles I. Excepting short visits to the Continent, he remained in England until his death.

Emmanuel Philibert of Savoy, Prince of Oneglia

Canvas, 126 × 99.6 cm., 49⅝ × 39¼ in.
Inv. no. 173.

In the spring of 1624, Van Dyck journeyed to Palermo in Sicily, perhaps in the hope of gaining the patronage of the wealthy Genoese community there. Bellori writes: *"Antonio wished to go to Sicily, where Philibert of Savoy was then Viceroy, and he painted his portrait. At that time, however, there was an outbreak of plague, and the Prince died of it . . . Antonio having suffered some sort of disaster in Palermo, left in haste, as if in flight, and returned to Genoa."*

Emmanuel Philibert (1588–1624) was the third son of Charles Emmanuel of Savoy by his wife Catherine, a daughter of Philip II of Spain. He spent his life in the service of Spain. A Knight of Malta, he was appointed *Capitan General de la Mar* in 1612, created Prince of Oneglia in 1620, and Viceroy of Sicily in 1621. This painting was convincingly identified by Van de Put in 1912 as the portrait of him mentioned by Bellori, on the evidence of his armour, the decoration of which incorporates the motif of a crown or coronet enclosing branches of palm. This motif is found on a number of pieces of armour associated with the House of Savoy (in Madrid, Turin, the Wallace Collection, etc.), and, though the Duke of Savoy had five sons in all, the portrait can by process of elimination only represent Emmanuel Philibert. No other painted portrait of the sitter is known, but the depiction agrees well with a marble bust of him in Turin. Only the omission of the insignia of the Order of St. John (a star of eight points), which as a Prior of the Order the Prince was entitled to wear, is disturbing. However, Van de Put points out that by a treaty of 16th May 1624 between the Dukes of Savoy and Mantua, Emmanuel Philibert was to renounce the Priorate of the Order to marry Princess Maria Gonzaga of Mantua. Gianfrancesco Fiochetto, the Prince's surgeon, records in his post-humous life of his master that the Prince received a portrait of his prospective bride, and had a portrait of himself painted to send to Mantua in return. The painter is not named, but it is possible that this may be the picture. It makes perfect sense that the Cross of St. John (an order which required celibacy of its members) should be omitted

Van Dyck: *Witch being led to Execution (From the Italian Sketchbook)*, 1624. Pen and ink. (The Trustees of The British Museum, London)

from any portrait of the Prince painted at about the time he was to renounce his membership in order to marry. It follows that this picture was painted after 16th May 1624, and before the Prince's death on 3rd August. Van Dyck left Palermo in September. Nothing is known of the "disaster" mentioned by Bellori which led to his hasty departure.

Something of the atmosphere in Palermo during the summer of 1624 can be gathered from Van Dyck's other works of this time. In the *Italian Sketchbook* (British Museum) are several hasty drawings made in the streets of the city: of actors and acrobats, characters from the *commedia dell'arte*, and a witch being led to the stake. They evoke the frantic hedonism and panic in the plague-ridden city. The religious paintings of the period are redolent of sensational piety.

The portrait of *Emmanuel Philibert* is, in contrast, controlled and, for all its splendour, almost austere. The Titianesque pose is notably static in a period when the artist was experimenting with effects of movement. The Prince is portrayed as a military commander, in armour and holding his commander's baton, a man of action glimpsed in repose. He stands stiffly, caught in a shaft of light which penetrates one of the rooms of his sombre palace. The fall of light defines the splendours of his

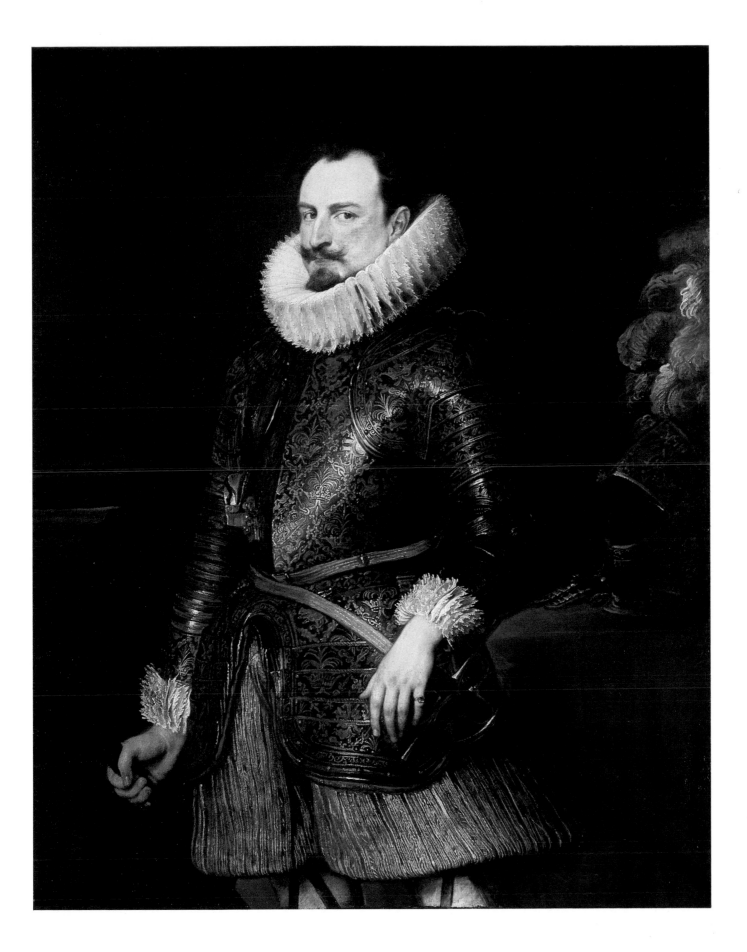

gilded armour and the rich fabric of his trunk-hose: a Titianesque effect which Van Dyck renders with meticulous attention to detail, avoiding any tendency towards a hasty virtuosity. Only the plumed helmet and gauntlet in the background, glimpsed in the half-light, are rendered in a thinner, more relaxed technique, the plumes of the helmet realised with a silky featheriness of touch. The greatness of the portrait rests above all in the tension which Van Dyck establishes between the grandeur of the Prince's physical presence, his armour, starched lace and gold embroideries – the trappings of wealth and power – and the sense of his controlling intelligence. His gaze is penetrating, and his high domed forehead, the lights touched with accents of cold grey, emphasizes this ascetic intellectual quality. It is characteristic of Van Dyck's sympathy with his sitters, that, as a foil to the head, he concentrates on the Prince's left hand. Elegant, pale and delicate, it is expressive of a sensitivity which modifies our understanding of Emmanuel Philibert's character.

M.R.

PROVENANCE: Presumably Palermo; V. Donjeux Sale, Paris, 29th April 1793 (132), bt. Desmarets; Bourgeois Bequest, 1811.

LITERATURE: G.P. Bellori, *Vite dei Pittori . . .* (1672), p. 257; Waagen II, p. 342; A. van de Put, *Burl. Mag.*, XXI (1912), pp. 311–14; XXV (1914), p. 59; C. Sterling, *Burl. Mag.*, LXXIV (1939), p. 53; C. Brown, *Van Dyck* (1982), pp. 78, 82.

Fig. 1. Van Dyck: *Sir Kenelm Digby in Mourning Dress, with Sunflower*, c.1633. Canvas. (Private Collection)

7 Sir Anthony Van Dyck

Lady Venetia Digby

Canvas, 74.3 × 81.8 cm., 29¼ × 32¼ in.
Inv. no. 194.

Lady Venetia Digby is rare among portraits: the subject was painted on her deathbed. Born in 1600, Venetia Stanley was brought to London as a young girl. Her beauty (as described by John Aubrey) was exceptional: *"She had a most lovely and sweet-turned face, delicate dark brown hair. . . . Her face, a short oval; dark brown eyebrow, about which much sweetness, as also in the opening of her eyelids. The colour of her cheeks was just that of the damask rose, which is neither too hot nor too pale."* According to Aubrey, as a girl she was the mistress of more than one nobleman, but in 1625, against his family's opposition, she became the wife of Sir Kenelm Digby. The Digbys' marriage was celebrated in Sir Kenelm's *Private Memoirs* (published in 1827): *"It was the perfect friendship and noble love of two generous persons, that seemed to be born in this age by ordinance of heaven to teach the world anew what it hath long forgotten, the mystery of loving with honour and constancy, between a man and a woman; both of them in the vigour of their youth, and both blessed by nature with eminent endowments, as well of the mind as of the body."* Much of the *Private Memoirs* is devoted to rebutting *"that monster which was*

begot of some fiend in hell . . . Fame" whose *"false construction of her actions"* he denies in detail. His love of Venetia is apparent in his descriptions of her beauty, the *"excellency of her wit . . . masculine and vigorous"* and *"the sweetness of her disposition"*. Whatever her early activities, as a wife she was irreproachable.

Like his wife, Kenelm Digby was exceptional, a fact he made widely known (fig. 1). Born in 1603 to a Catholic family whose father was to be executed for his involvement in the Gunpowder Plot, his sensational life was led close to power and genius. In 1623 he was in Madrid, in the suite of Charles, Prince of Wales, then courting the Infanta. At home, he shone at Court, *"a party in all the royal diversions"*; abroad, he was amorously pursued by the Regent of France, Marie de' Medici, and embarked on a privateering expedition against the French in the Mediterranean. He spent the period of the English Civil War on the Continent, becoming Chancellor to Queen Henrietta Maria in exile. He spoke several languages, published poetry and philosophy, conducted scientific experiments (he has been described as the first researcher to predicate the existence of oxygen), and was intimate with Descartes. He was famous in his time, but left behind little of value.

Venetia died very suddenly in her sleep, on the night of 1st May 1633. Her husband summoned Van Dyck, a close friend, to draw her *"the second day after she was dead"*

Fig. 2. Van Dyck: *Lady Venetia Digby as Prudence*, c.1633. Canvas. (National Portrait Gallery, London)

And by the awfull manage of her Eye
 She swaid all bus'nesse in the Familie!
To one she said, Doe this, he did it; So
 To another, Move; he went; To a third, Go,
He run, and all did strive with diligence
 T'obey, and serve her sweete Commandements."

The Biblical allusion is explicit.

Numerous portraits exist of both Digbys, some by Van Dyck, including several posthumous works. Another version of no. 7, regarded by Dr. Garlick as a copy, has been at Althorp, Northamptonshire since at least the eighteenth century. Peter Oliver executed a mourning miniature (formerly Strawberry Hill, now Sherborne Castle). In 1633 Digby commissioned from Van Dyck a spectacular allegorical portrait of her as Prudence (also in several versions, including one at Windsor Castle and another, especially fine, recently acquired by the National Portrait Gallery, London) (fig. 2). The Dulwich picture is the most personal of all these works.

This type of portrait, a dead person shown as though asleep, their head on the pillow and framed by the bed hangings, was not unusual around the 1630s. Early examples of such pictures are the pair of portraits of a man and woman by Bartolomeus Bruyn the Younger (Royal Museum of Fine Arts, Brussels), dated 1568, very similar to *Lady Venetia* in composition (fig. 3). Other examples date from the same period as *Lady Venetia*; a Dutch School portrait of *A Child of the Honigh Family*, of 1630 (Mauritshuis, The Hague), or the School of Van Dyck *Duke of Buckingham* of 1628 (Marquess of Northampton). Such portraits continue the tradition of mediaeval and Renaissance funerary monuments, which they resemble in the portrayal of the dead person asleep, as well as in the pose of head resting upon hand. For Digby, as for the creators of many monuments, the memorial was intended not only as a commemoration of the dead person but as a *memento mori*, a reminder of the brevity of life. In the depiction of sleep there lay, perhaps, consolation. In a sermon preached at Court, only five years before, Donne had recalled *"that till Christ's time death was called death, plainly, literally death, but after Christ, death was called but sleepe."*

For William Habington, a young Catholic poet, the same comforting belief that for the virtuous, death is only a temporary sleep, is implicit in his lines on Venetia:

"She past away
So sweetely from the world, as if her clay
Laid onely down to slumber. Then forbeare
To let on her blest ashes fall a teare.
But if th'art too much woman, softly weepe,
Lest griefe disturbe the silence of her sleepe."

(To Castana: Upon the death of a Lady.)

It is tempting to read religious associations into the work, though these are not explicit. Van Dyck and Digby were both associated with the Catholic group around the

(Aubrey), and the portrait was delivered to him seven weeks later. For Sir Kenelm, the picture was intended as a perpetual memorial of his wife. He retired at her death to Gresham College where he remained for two years leading the existence of a hermit and engaged in scientific experiment. He described the picture in a letter to his brother: *"This is the onely constant companion I now have. . . . It standeth all day over against my chaire and table . . . and all night when I goe into my chamber I sett it close by my beds side, and by the faint light of candle, me thinkes I see her dead indeed."*

Venetia's death was widely mourned. The Digbys were intimately connected with the most advanced artistic circles of the Court, one of their closest friends being Ben Jonson, the first complete edition of whose poems Sir Kenelm saw into print. Jonson, like other Court poets, wrote an elegy to her. Though such poems were a commonplace, the profusion of them occasioned by Venetia's death is striking. In Jonson's *Eupheme*, a set of ten poems dedicated to *"that truly-noble lady, the Lady Venetia Digby"*, the *Elegie on my Muse*, or her *Apotheosis* raises her to sainthood while evoking her humanity:

"She had a mind as calme, as she was faire,
 Not tost or troubled with light lady-aire;
But, kept an even gate, as some streight tree
 Mov'd by the wind, so comely moved she,

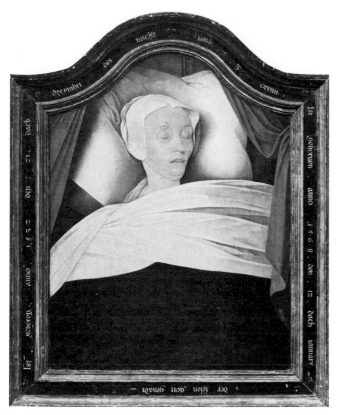

Fig. 3. Bartolomeus Bruyn the Younger (c.1530–c.1610): *Portrait of a Woman on her Deathbed*, 1568. Panel. (Institut Royal du Patrimoine Artistique, Brussels. Copyright A.C.L. Brussels)

Queen, Henrietta Maria. According to Bellori, Van Dyck painted a number of pictures for Digby, apart from portraits, including a *Crucifixion*, a *Descent from the Cross*, and a *Magdalen* (all lost). The setting of *Lady Venetia*, with the figure shown asleep between draperies, and the introduction of the rose, may to contemporaries have recalled the symbolism of the Virgin Mary. Certainly, religious associations are strong in the numerous elegies on Venetia's death.

According to Sir Kenelm, Van Dyck painted Venetia as he saw her, adding *"onely a rose lying upon the hemme of the sheete, whose leaves . . . being pulled from the stalke in the full beauty of it, and seeming to wither apace, even whiles you looke upon it, is a fitt Embleme to express the state her bodie then was in"*. This tender symbol has now, too aptly, faded: indeed the whole picture has suffered at the hands of restorers. Even so, its gentle reposefulness, the surviving fineness of execution, and the harmonies of blue and white with the faint pink (rubbed, according to her husband, into her cheeks after death), give this example of a melancholy genre a fair claim to be, as Sir Kenelm with characteristic hyperbole put it, *"the Master peece of all the excellent ones that, ever Sir Antony Vandike made"*.

G.W.

PROVENANCE: Presumably Sir Kenelm Digby, and lost when his pictures were dispersed in the 1640s; perhaps the picture seen by John Aubrey at Mr. Rose's, "a Jeweller in Henrietta st. in Convent Garden"; Bourgeois Bequest, 1811.

LITERATURE: Smith III, under no. 222; J. Aubrey (ed. O.C. Hick), *Brief Lives* (3rd edn. 1971), pp. 100–1; V. Gabrieli, *Sir Kenelm Digby* (1957), p. 65, n.I. and 246ff.; C. Brown, *Van Dyck* (1982), p. 145, pl. 146.

8 Thomas Gainsborough, R.A.

Sudbury 1727–1788 London

Born in Suffolk, Gainsborough moved to London in 1740, working there under the French engraver Hubert Gravelot. Returning to Suffolk in 1748, he set up as a portrait painter in Sudbury and from 1752 in Ipswich. In 1759, he established himself in Bath, attracting a wealthier clientèle of Society patrons. He was elected a founder member of the Royal Academy in 1768, and in 1774 moved permanently to London where he became a favourite painter of the Royal Family.

Philippe-Jacques de Loutherbourg R.A. (1740–1812)
Canvas, 76.5 × 63.2 cm., 30⅛ × 24⅞ in.
Inv. no. 66.

One of a series of portraits painted by Gainsborough in the 1770s of his friends, among whom were the composer J.C. Bach and the actor David Garrick, this painting represents the artist Philippe-Jacques de Loutherbourg. Born in 1740 in Strasbourg, De Loutherbourg was trained in Paris under Carle van Loo and the genre and battle-piece painter (and brother of the celebrated amorist) François Casanova, whose style he rapidly assimilated and excelled. He was acclaimed by Diderot when he began to exhibit at the Salon in 1763, and this quickly developing reputation was underlined first by his nomination as *peintre du roi* and second by his election (four years below the usual minimum age) as a member of the *Académie* in 1766. Apparently restless by nature (he later told the diarist Farington that as a young man he had *"a hot head and strong mind"*), De Loutherbourg spent the late 1760s working in the South of France, perhaps also visiting Germany and Switzerland; in November 1771, shortly after the opening of the Paris *Salon* at which he exhibited more works than any other artist, and appeared to be at the peak of popularity, he unaccountably left France, arriving in London with a letter of introduction to David Garrick, by whom he was engaged as a scene-painter. During the next few years, De Loutherbourg was to revolutionize the art of stage-design and to bring to English landscape painting a new dramatic quality. He also broadened the acceptable subject-matter of landscape to include battles, storms and shipwrecks (for which his model was the fashionable French artist Claude-Joseph Vernet), and he thus marks a transitional phase between the classical landscapists of the eighteenth century, such as Wilson and Gainsborough, and the romantics of the next generation, above all Turner.

De Loutherbourg's most renowned achievement was the invention of the Eidophusikon ('moving image') in 1781, a novel theatrical entertainment in which illusionistic effects of sunrise and sunset, storm, thunder, shipwreck and fire were created on a miniature stage, about six feet in width, with the aid of moving scenery,

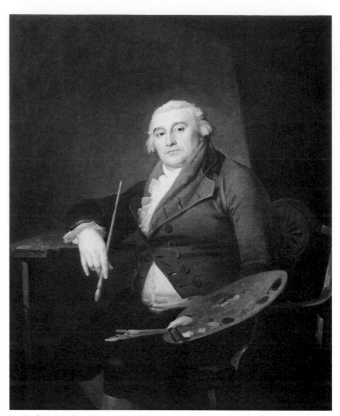

P.-J. de Loutherbourg: *Self Portrait*. Canvas. (National Portrait Gallery, London)

dramatic lighting and sound. An immediate success, the novel character of the Eidophusikon generated tremendous excitement, not least among De Loutherbourg's fellow artists, in particular Gainsborough, who *"for a time thought of nothing else – he talked of nothing else"* (W.H. Pyne, alias Ephraim Hardcastle).

Indeed, it seems that De Loutherbourg's Eidophusikon inspired Gainsborough's experiments in the early 1780s with landscapes painted on glass and illuminated from behind with candlelight, the spectator viewing the transparency at a distance of some three feet through a large peep-hole fitted with a magnifying lens. Gainsborough's aim was to heighten and dramatize the effects of light and shade, and to achieve a more exact pictorial approximation of nature's fleeting changes.

De Loutherbourg and Gainsborough were probably introduced to one another by their mutual friend Garrick. Both artists were mercurial and highly-strung in character – Garrick is reported to have said that Gainsborough's *"cranium is so crammed with genius of every kind that it is in danger of bursting upon you, like a steam-engine overcharged"*. This portrait, exhibited at the Royal Academy in 1778, was later owned by De Loutherbourg's pupil Sir Francis Bourgeois, one of the Gallery's great benefactors. A rapid chalk sketch of Gainsborough by De Loutherbourg, very probably executed at the time this

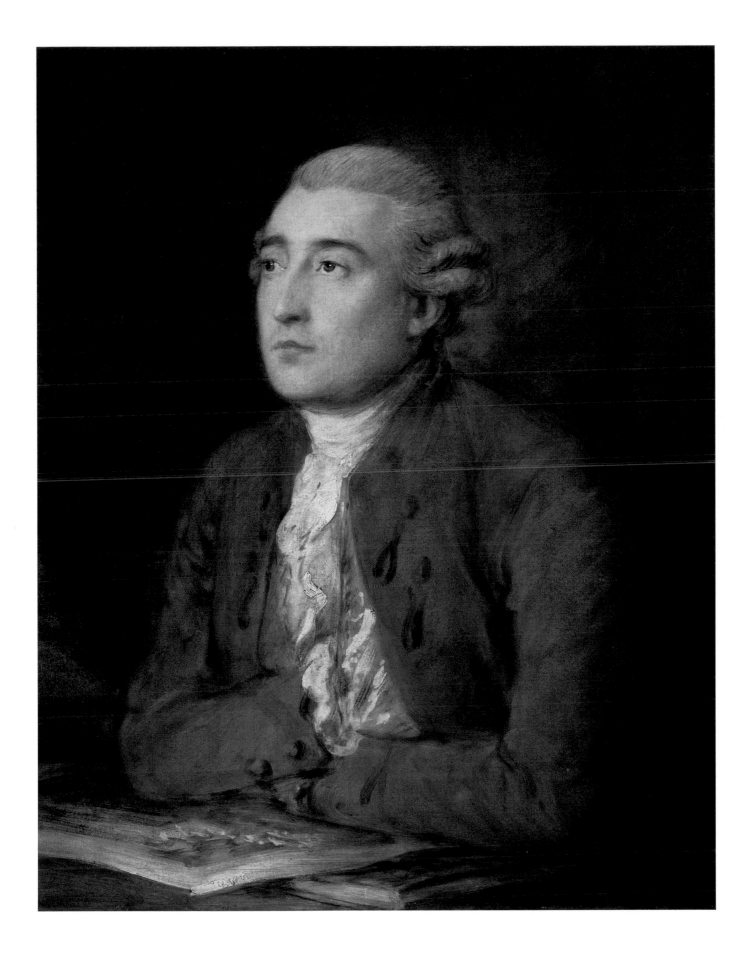

portrait was painted, is in the Mellon Collection.

Gainsborough's dissatisfaction with the incessant demands of portraiture was alleviated by opportunities to create intimate portraits of his friends, especially people in the musical and artistic worlds such as *Johann Christian Bach* (Bologna, Civico Museo), the members of the Linley family, and De Loutherbourg himself. He was happiest when painting his sitters from life, in their own clothes and attitudes (on one occasion he asked to be allowed to paint Lady Dartmouth *"in the Modern way"*, i.e. in contemporary dress, rather than in *"a factitious bundle of trumpery"*), and his feeling for naturalness is apparent in this portrait of De Loutherbourg, who is depicted in an attitude of eager attention. The immediacy of such paintings is in contrast to the languid remoteness sometimes seen in his portrayals of grandees whom he did not know well. The painting is executed with great brilliance, the brush strokes rapidly applied. L.S.

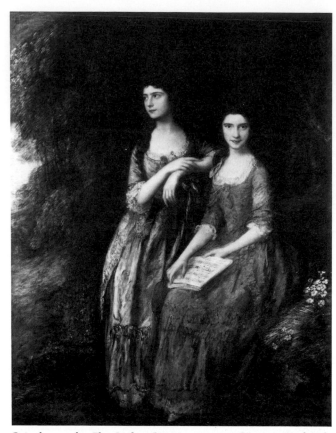

Gainsborough: *The Linley Sisters*, c.1772. Canvas. (Dulwich Picture Gallery)

PROVENANCE: Bourgeois Bequest, 1811.

LITERATURE: E.K. Waterhouse, *Gainsborough* (1958), p. 79, no. 456 and pl. 197; R. Joppien, *Philippe-Jacques de Loutherbourg RA 1740–1812* (exhibition catalogue, The Iveagh Bequest, Kenwood, London 1973), n.p., no. 1; J. Hayes, *Gainsborough* (1975), fig. 11 and p. 219, note 91.

9 Thomas Gainsborough R.A.

Samuel Linley R.N. (1760–1778)
Canvas, 75.8 × 63.5 cm., 29⅞ × 25 in.
Inv. no. 302.

Samuel Linley was one of the twelve children of Thomas Linley (1732–1795), composer, singing-teacher and leading figure in the musical life of the spa city of Bath during the middle of the eighteenth century. Gainsborough, an enthusiastic amateur musician, came to know the family intimately during the years he lived in Bath, from 1759 to 1774; later on, both families moved to London. Like his brothers and sisters, Samuel Linley was trained as a musician by his father, but joined the Navy as a midshipman and died of fever in 1778 – the same year in which his eldest brother Tom (1756–1778), a talented composer and violinist (as early as 1767 he led the Bath orchestra) was drowned in a boating accident. Several of the Linleys were drawn and painted by Gainsborough, two of the daughters, Elizabeth (1754–1792) and Mary (1758–1787), being the subject of one of his finest paintings of the 1770s, *The Linley Sisters*, exhibited at the R.A. in 1772, and presented to the Gallery by their brother William in 1831. Gainsborough's later portrait of Elizabeth, who married the playwright Richard Brinsley Sheridan in 1773, painted in 1785–86 (National Gallery of Art, Washington) is a masterpiece in a wholly new

style, anticipating Sir Thomas Lawrence's romantic approach to portraiture.

Traditionally, this portrait has been dated c.1777–78, but it may have been painted slightly earlier. According to a Ms. catalogue in the Gallery made in 1858, *"This picture was commenced and finished as it now exists in one sitting, and that sitting less than an hour. The authority for this is the testimony of his own brother."* The sketch-like character of this portrait indeed suggests that Gainsborough was working at great speed, his paint charged with turpentine to skim over the canvas. The resulting quality of spontaneity distinguishes Gainsborough's more informal portraits and recalls Reynolds's comments, in his Fourteenth Discourse to the students of the Academy Schools, delivered shortly after Gainsborough's death, *"I have often imagined that this unfinished manner contributed . . . to that striking resemblance for which his portraits are so remarkable . . . in this undetermined manner, there is the general effect, enough to remind the spectator of the original; the imagination supplies the rest, and perhaps more satisfactorily to himself, if not more exactly, than the artist with all his care, could possibly have done."*

Samuel's younger brother, the Rev. Ozias Linley (1765–1831) became a Junior Fellow and Organist at the College, and was responsible for lending the family

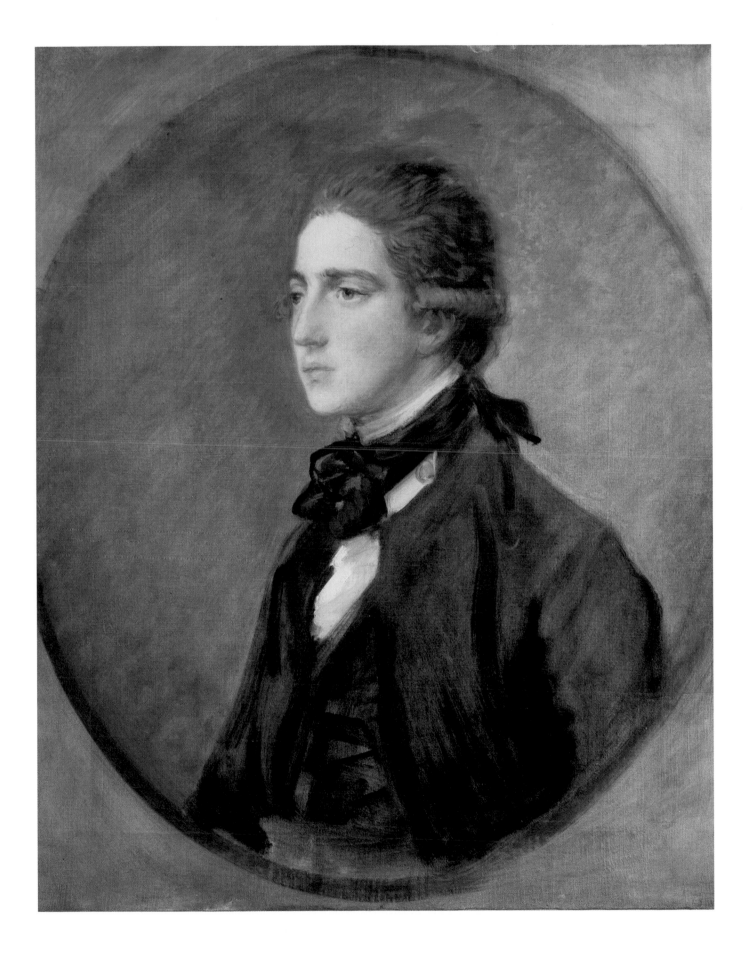

portraits to the Gallery in 1822. They were subsequently bequeathed by their youngest brother William, who died in 1835.

L.S.

PROVENANCE: Linley family; bequeathed by William Linley (1771–1835).

LITERATURE: E.K. Waterhouse, *Gainsborough* (1958), p. 78; C. Black, *The Linleys of Bath* (1971), p. 119 and fig, p. 120; L. Stainton, *Gainsborough and his Musical Friends* (exhibition catalogue, The Iveagh Bequest, Kenwood, London, 1977), *passim*.

10 Thomas Gainsborough R.A.

An Unknown Couple in a Landscape
Canvas, 76.2 × 67 cm., 30 × 26¾ in.
Inv. no. 588.

This portrait of an unidentified couple set in a landscape is among the finest of Gainsborough's early conversation pieces. It is influenced by his early training in the London studio of Hubert-François Gravelot, the French figure-painter, draughtsman and book illustrator. Probably through Gravelot, Gainsborough was introduced to the St. Martin's Lane Academy, the centre of the most avant-garde developments in contemporary art, led by Hogarth. Francis Hayman also taught there, and Gainsborough seems to have worked in his studio for a while. His knowledge of Hayman's conversation-pieces and small full-length portraits in landscape settings formed his style in portraiture when he set up his own studio.

Although Gainsborough apparently intended to practise as both a portrait and landscape painter, such commissions as he was able to secure were, he noted, *"chiefly in the Face way, I'm afraid to put people off when they are in the mind to sit"* (said probably to William Mayhew, 13th March 1758), and his inclination for landscape was restricted to drawings and to paintings executed chiefly for his own pleasure: *"these were the works of fancy and gave him infinite delight"* (Philip Thicknesse, 1788). However, there are a number of portraits dating from his years in Suffolk in which the landscape setting was as important as the figures, notably the double portrait of *Mr. and Mrs. Robert Andrews* (National Gallery, London) shown on their estate near Sudbury.

By the mid-1750s – the probable date of this painting – Gainsborough's style had become more sophisticated and fluent, and his portraits were described as *"the most exact likenesses I ever saw. His painting is coarse and slight, but has ease and spirit"* (William Whitehead, 6th Dec. 1758). Most of his Suffolk patrons belonged to the lesser gentry or to the professional middle classes; the identity of this couple is tantalizing, particularly since the woman (presumably an amateur artist) is shown holding a porte-crayon and a drawing that appears close in style to Gainsborough's

landscape studies of the early to mid-1750s.

Such early portraits are strikingly in contrast to the works of Gainsborough's maturity. Before he became familiar with the paintings of Rubens, Van Dyck and Watteau, and grew acquainted with the society of Bath and London, the principal influences on Gainsborough were the figure painting taught him by Gravelot and Dutch painting of the seventeenth century. Gravelot and his contemporaries (especially Arthur Devis, with whose conversation pieces Gainsborough's portraits may be compared, to Gainsborough's advantage) were in the custom of using small jointed dolls, in costume, as lay-figures, and this practice is reflected in the stiff little people in this picture, with their long necks and twig-like limbs. Not until about 1760 did Gainsborough master the art of the lifesize portrait. His study of Dutch landscape, especially the work of Wijnants [see cat. no. 35] and Jacob van Ruisdael, who were becoming fashionable in England (and particularly East Anglia) in the middle of the eighteenth century, is apparent in such details as the gnarled tree, the picturesquely varied foreground, the burdock beside the gentleman, and the employment, in the little landscape on the right, of a path to convey recession. Gainsborough's own contribution – particularly in the case of his later pictures – was his reconciliation of the landscape setting with the sitters, so evidently at home in this countryside. The method of painting the leaves, with a diagonal accent from top right to lower left, is characteristic of his work throughout his career.

This picture may be a marriage-portrait, the sheaves of corn acting as appropriate symbols of fertility, although Gainsborough could simply be emphasizing his sitters' status as land-owning gentry. The curving elements in the picture are a reminder that it was painted in Gainsborough's most Rococo phase.

After leaving Suffolk for the vastly more lucrative possibilities of Bath, Gainsborough gave up painting such small-scale portrait groups and concentrated on working on the scale of life.

L.S.

PROVENANCE: John Doherty, Birmingham, 1858; Doherty, Foxlydiate House, Redditch, 1880; with L. Lesser; Fairfax Murray Gift, 1911.

LITERATURE: E.K. Waterhouse, *Gainsborough* (1958), p. 99, no. 753.

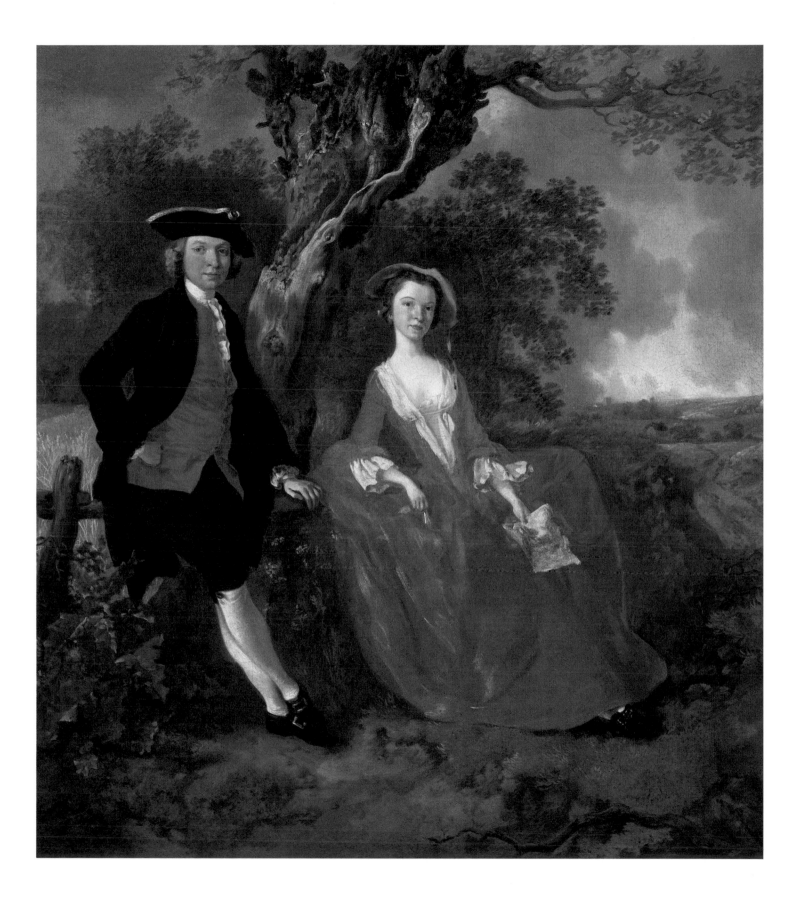

11 Aert de Gelder

Dordrecht 1645–1727 Dordrecht

Aert de Gelder was apprenticed as a boy to the painter Samuel van Hoogstraten in Dordrecht. At the age of sixteen, he moved to Amsterdam to work under Rembrandt, then in his fifties. De Gelder remained with Rembrandt for at least two years. After returning to Dordrecht, he continued to paint in his master's late style until his death in 1727.

Jacob's Dream

Canvas, 66.7 × 56.9 cm., 26¼ × 22⅜ in.
Signed lower right (incised with the end of the brush): ADeGelder (*AD* in monogram)
Inv. no. 126.

The picture illustrates the incident which took place when Jacob, fleeing from his brother, rested on his way to seek refuge in Mesopotamia. *"And he dreamed, and behold a ladder set up on the earth, and the top of it reached to heaven: and behold the angels of God ascending and descending on it"* (*Genesis*, XXVIII, 12).

Until the late nineteenth century, the picture was not only accepted as by Rembrandt but was almost invariably praised in extravagant terms, and it offers an eloquent example of what appealed to the taste of the period. In 1817, the *Annals of the Fine Arts* (vol. I, pp. 387–8) described it as *"all profundity and mystery . . . It is one of the most poetical and sublime pictures we ever saw."* Hazlitt (*Beauties of the Dulwich Art Gallery* (1824), p. 44) wrote no less enthusiastically and concluded that it was *"perhaps the most purely poetical picture he ever produced"*. More modified rapture was expressed in 1838 by J. Brady (*A New Pocket Guide to London and its Environs*, p. 250): *"a perfect miracle as regards atmospheric effect, though by no means deserving the unqualified encomiums which have been passed upon it in other respects"*. A painting of the same subject by Washington Allston, now at Petworth, appears, though very different in manner, to have been inspired by this painting. For Mrs. Jameson (*Handbook*, vol. II (1842), p. 440), it was *"wondrous"*, a general sentiment shared by such diverse people as Robert Browning, Kilvert and Samuel Palmer. Charles Blanc (*L'oeuvre complet de Rembrandt*) was taken by *"the strange figures neither human nor angelic, but like birds seen in a dream"*. And for the minor Victorian artist James Smetham *"It is always 'Jacob's Dream' which turns the scale as to whether I come to Dulwich or no . . . That picture was painted between Rembrandt's breakfast and his tea, on a late October day, when the wind was sighing and the leaves falling. I know it was."*

It was the sober professional eye of J.P. Richter (1880 cat., p. 127), who observed that *"The want of transparency in the colouring, and the flat modelling of the figures and trees clearly show that this picture was not painted by Rembrandt himself"*, an opinion which Henry Wallis (*The Magazine of Art* (1881), was quick to follow. Hofstede de Groot was the

Rembrandt: *The Angel appearing to the Shepherds*, 1634. Etching. (Photo: The National Gallery of Art, Washington)

first to recognize the hand of Aert de Gelder, an attribution which was confirmed when the signature became visible after restoration in 1946. Both the style and technique, with its loose brushwork and extensive use of the end of the brush, seen here in the execution of the foliage, are entirely typical of an artist who was Rembrandt's latest and most faithful follower. Lilienfeld, who believed it was a late work, makes a convincing comparison with the *Christ on the Mount of Olives*, which forms part of the Passion series at Aschaffenburg, executed sometime after 1700.

The subject was popular with Rembrandt, who made an etching (B.36) in 1655, and five drawings at different periods of his career (Ben. 125, 555, 557–8 and 996), as well as correcting a pupil's drawing (Ben. 1381). There is also a painting of the subject by Ferdinand Bol (Dresden). In all these the angel is shown in close proximity to Jacob, but rather than turning to any of these De Gelder took inspiration from Rembrandt's etching of *The Angel appearing to the Shepherds* (B.44) of 1634, although he followed the composition in reverse. Unlike Rembrandt's etching of the theme (B.36), De Gelder does not show the ladder but only rays of light. C.J.W.

PROVENANCE: Lebrun of Paris sale, Christie's, 18th–19th March 1785 (81), as Rembrandt, bt. Dillen (Desenfans?); Desenfans by 1802, as Rembrandt; Bourgeois Bequest, 1811.

LITERATURE: Smith VII, no. 12; K. Lilienfeld, *Arent de Gelder* (1914), p. 130, no. 10; HdG VI, no. 456, note 8 (as De Gelder).

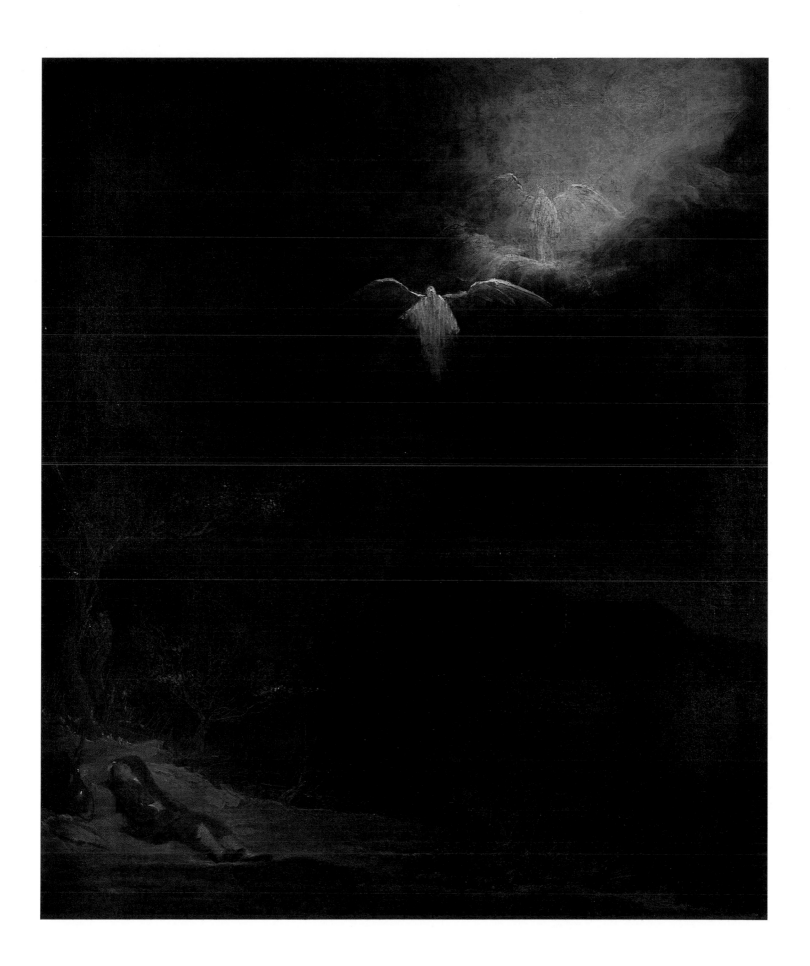

12 Guercino, Giovanni Francesco Barbieri

Cento 1591–1666 Bologna

Giovanni Francesco Barbieri, nicknamed Il Guercino ('Squint-eyed'), was born at Cento, half way between Bologna and Ferrara. He maintained his workshop at Cento (apart from a stay in Rome between 1621 and 1623, and other short periods of absence) until 1642, when he settled in Bologna immediately after the death of Guido Reni. Until his death in 1666 he was the leading painter in that city.

Christ and the Woman taken in Adultery
Canvas, 98.2 × 122.7 cm., $38\frac{5}{8} \times 48\frac{3}{8}$ in.
Inv. no. 282.

The subject is taken from St. John, VIII:
The scribes and the Pharisees brought unto him a woman taken in adultery, and when they had set her in the midst, They said unto him, Master, this woman was taken in adultery . . . Now Moses in the law commanded us, that such should be stoned: but what sayest thou? Jesus replied "He that is without sin among you, let him first cast a stone at her".

Guercino was in essence self-taught, his first paintings being influenced by the study of works of the schools of Bologna (the Carracci, and especially Ludovico) and Ferrara (especially Scarsellino). In this youthful period he evolved a free and fluid manner of painting with effects of fluctuating light which were in essence Venetian and Correggesque in origin; this style differs radically from that of Caravaggio, whose work he had had little or no opportunity to see until his arrival in Rome as a mature artist as late as 1621. His experiences during that two-year stay sowed the seeds for a fundamental change in his style, which became increasingly orientated in a 'classic' as opposed to a 'baroque' direction; the robust vigour of the early years came to be abandoned, and by around 1650 he had developed a striking delicacy of touch and a mastery of pale colouring which provided something of a parallel to what Reni had achieved in the last decade of his career.

From the stylistic point of view the Dulwich picture belongs to the culminating moment of Guercino's early style, fluid and 'baroque'. It must have been painted shortly before, or immediately after, his journey to Rome in May 1621 to work for the newly-elected Bolognese Pope, Gregory XV, whose portrait by him of 1622–23 is in Washington, D.C. (National Museum of American Art, on loan to the National Gallery of Art, Washington). The Dulwich picture cannot in any event date from after 1621.

The circumstances of the commission are not known, but it seems clear that Guercino must have been asked for a representation of the subject in the form of half-length figures. Such figures also appear in the preliminary studies

Guercino: *Preliminary study for "Christ and the Woman taken in Adultery"*. Pen and ink with brown wash; recto, double-sided sheet. (Albertina, Vienna)

for the painting on the double-sided sheet in the Albertina, Vienna. Their composition, characteristically for Guercino, is very different from that of the finished work.

The painting may be compared to two pictures also executed by the artist in 1621: *The Seizure of Christ* (Fitzwilliam Museum, Cambridge) and *The Incredulity of St. Thomas* (National Gallery, London). In all these works he introduced a horizontal composition with half-length figures, a type probably derived from Venetian tradition and one to which Guercino returned frequently during his career. They exemplify the artist's ability to convey the significance of the fleeting moment – notably, in this painting, through the arrangement of the hands.

D.M.

PROVENANCE: Mari collection, Genoa, until shortly before it was sold by an anonymous vendor in London (Christie, 24th May 1806, lot 52, "received within a few days from Italy and has long been admired as one of the chief Ornaments of the Palace of the Mari Family at Genoa"). According to a manuscript annotation in the catalogue in the library of Messrs. Christie, the name of the vendor of the painting was Champernowne. Since 1802 the collector Arthur Champernowne had been a partner with the dealer William Buchanan, joined later by the collector the Rev. William Holwell Carr, in financing acquisitions of paintings made in Italy on their behalf by James Irvine, who had frequently been active in Genoa; this partnership was dissolved in March 1806 (see W. Buchanan, *Memoirs of Painting*, 1824, II, pp. 172–5), an event which presumably accounts for the sale of the painting in the subsequent May. A manuscript note in the Christie copy records the purchaser as "Sir F.B." together with another painting similarly purchased at that sale (lot 16, by Poussin, sold by Buchanan, now Dulwich inv. no. 263); Bourgeois Bequest, 1811.

DRAWINGS: A sheet with preparatory pen and wash studies on the *recto* and *verso* is in the Albertina at Vienna (Inv. 2324; Alfred Stix and Anna Spitzmüller, *Beschreibender Katalog . . .* , VI, *Die Schulen von Ferrara, Bologna, . . .* , 1941, p. 23, no. 221, pl. 50, *recto*, and 49, *verso*).

LITERATURE: Carlo Giuseppe Ratti, *Instruzione di quanto può vedersi di più bello in Genova* (1766), p. 298 (as *il famoso [Quadro] dell'Adultera del Vangelo del Guercino* in the *Palazzo dell'Eccellentissimo Lorenzo Mari*); it reappears in various later guide books of Genoa down to *Description des beautés de Gênes et de ses environs* (1792), p. 217; Hermann Voss, in Thieme-Becker *Künstlerlexicon*, XV, 1922, p. 220 (*gutes Bild der früheren Zeit*).

13 William Hogarth

London 1697–1764 London

Hogarth was apprenticed to an engraver at the age of fifteen. By 1720, he was established as an independent engraver, but studied painting in his spare time. Improving the status of the artist took up much of his energy. He set up as a portrait painter about 1730, and produced sequences of satirical pictures, such as *Marriage à la Mode* (National Gallery, London). These were engraved, and sold so well that Hogarth lobbied for and secured the passing into law of the Copyright Act in 1735. He was also involved in setting up an Academy of Art, and in 1753 published *The Analysis of Beauty*, a treatise on aesthetic theory.

A Fishing Party

Canvas, 54.9 × 48.1 cm., $21\frac{5}{8} \times 18\frac{7}{8}$ in.
Inv. no. 562.

Hogarth experimented with various means of attracting patrons. This work, a conversation piece, is an example of one of his most successful attempts. After some years of modest attainment as an engraver, he established his position in 1729 with his marriage to Jane Thornhill, daughter of the ceiling painter Sir James Thornhill – regarded by his own generation, though not by others, as the first great English artist. Prompted by the demands of marriage, Hogarth secured his reputation by developing the newly popular mode of the conversation piece. As he put it himself *"It had some novelty . . . it gave more scope to fancy than the common portrait."*

The conversation piece has been defined by Mario Praz as a portrait of a group of people, identifiable (at least to their contemporaries) and in day-to-day dress, shown against an everyday background and engaged in sociable activity. The size of the figures is generally much smaller than life, and their setting carefully observed. This genre, already established on the Continent, had been brought to England in 1725 by the French artist Philippe Mercier, and the picture generally accepted as the first English conversation piece is his *Viscount Tyrconnel and his Family* (Belton House) of that year. This novel style quickly attracted commissions: not only were such pictures economical (including, as they did, numerous sitters for the price of one), but they suited the small rooms which were gaining favour at the time. Hogarth's involvement in the genre represented a shrewd exploitation of fashion. His work was much admired: according to Vertue, writing in 1730, *"The daily success of Mr. Hogarth in painting small family and Conversations with so much Air and agreeableness Causes him to be much followed, and esteemed whereby he has much imployment and like to be a master of great reputation in that way."* Hogarth's interest in 'Conversations' lasted only a few years: the first in his great series of moral prints, *The Harlot's Progress*, was issued in 1731. *The Fishing Party* must date from around 1730.

It is ironical that an artist so conscious of his Englishness should have been as much influenced by French art as was Hogarth. *The Fishing Party* has often been associated with the work of such painters as Watteau and Lancret, already popular in England at the time the picture was painted. Several characteristics of the painting recall Watteau: the light tone and the decorative contrasts of blues and greens, the interlinked composition of mother, child and maid, and the landscape with its quality of a theatrical backdrop. The mood is less close to Watteau. This is an English picture: no gallantry is involved. The participants are cheerfully and affectionately natural, especially the child, whose questioning determination is contrasted with her nurse's concentration and the calmness of the mother. Unidealized, in everyday dress, the participants sit on their rustic Windsor chairs on a pier, using such mundane objects as the baitbox at the mother's feet and the leather strap round her shoulder. Fishing had for some time been a highly popular sport with women.

Photographs of the 1920s and 1930s show interesting contrasts to the picture's present condition. Recent conservation has revealed on the extreme left a *pentimento*, in the form of a face in profile, suggesting that the picture may have been cut down (a possibility supported by the unusual chopping off of the chair at the edge of the canvas). The man seated to the left had his right profile painted over his wig. The most apparent difference was the fishing line, which instead of ending in the float held by the mother, curved across the painting to conclude in the hand of this seated man, depicted fixing a hook to the end of the line.

The Fishing Party is relatively unusual, as a study of the quiet sport of angling. It combines the sophisticated informality of the *fête galante* with a straightforwardness reminiscent of Dutch art of the seventeenth century.

G.W.

PROVENANCE: J.H. Manners-Sutton; Anon. Sale, Robinson & Fisher, London, 29th May 1902 (87), bt. Agnew; Fairfax Murray by 1908; his Gift 1911.

LITERATURE: R. Beckett, *Hogarth* (1949), p. 42 and fig. 29; F. Antal, *Hogarth* (1962), pp. 35, 111 and pl. 31b; R. Paulson, *Hogarth; His Life, Art and Times* (1971), I, pp. 218, 230 and pl. 77.

14, 15 Thomas Hudson

Devonshire 1701–1779 Twickenham

Thomas Hudson was the most fashionable portrait painter in London in the decade before the rise to fame of his pupil, Sir Joshua Reynolds. Like Reynolds, Hudson was born in Devon. In about 1725 he moved to London, where he trained under the portraitist and writer Jonathan Richardson, marrying his master's daughter before setting up on his own. Real success did not come to him until he was about forty. With the retirement or death of several of the leading portrait painters in about 1740 and the return to the continent of visiting foreign artists, the field was left more or less clear to Hudson and his main rival Allan Ramsay.

Unknown Gentleman

Unknown Lady

Canvas, both 127.3 × 101.9 cm., $50\frac{1}{8} \times 40\frac{1}{8}$ in.
Both signed and dated lower right: *T Hudson Pinxit. / 1750.* (TH in monogram).
Inv. nos. 579 and 578.

These portraits of an unknown man and his wife, painted at the height of Hudson's fame, are examples of the standard poses used by many English portrait painters in the mid-eighteenth century. It is characteristic of Hudson's busiest period, c.1745–50, that he relied on a limited range of poses, usually setting his figures against a dark background which is left plain except for a token column or curtain.

This woman's pose can be closely paralleled in Hudson's portrait of *Anne Weston* (location unknown) of 1747. She is wearing a white satin dress and a pale blue petticoat with matching ornamental bows; like her strings of pearls, the bows are placed symmetrically in a manner influenced by the contemporary fashion for Van Dyck costume.

The man's pose is first found in Hudson's *Jacob Selfe* (Methuen Collection) of 1744 and recurs in a standardized form in many of his works including dated portraits belonging to 1747, 1749 and 1750.

Such portraits, with left hand in waistcoat, hat under arm, and right hand in pocket, are surely the sort which attracted Horace Walpole's condemnation; he wrote of the country gentleman *"content with Hudson's honest similitudes, and with the fair tied wigs, blue velvet coats, and white satin waistcoats, which he bestowed liberally on his customers"*. Later, Laetitia Hawkins was to tell of Hudson's advice to Reynolds that the only way to make a fortune was *"to put hands in bosoms and waistcoat pockets"*, so avoiding the problem of painting the hands altogether. This position had the further advantage of reflecting the sort of pose thought polite in company, as laid down in contemporary etiquette manuals.

Hudson's portraits of this type are sometimes identical in costume to those of Ramsay down to each last fold of the coat or dress, a similarity to be explained by their employment of the same drapery painter, usually the brilliant Flemish immigrant, Joseph van Aken (c.1699–1749). In this instance the man is almost identical to Ramsay's *William Nisbet* (location unknown) also dated 1750, the year after Van Aken's death. These patterns were carried on for several years, probably by his less well-known brother Alexander (1701–1757). The style of draperies, especially of the woman's dress, is closely related to Joseph's work; it is, however, less rich in effect, perhaps as a result of the more laboured technique, most evident in the dragged brush-strokes of the highlights.

The earliest known owner of these portraits is Robert Hollond (1802–1887), Member of Parliament for Hastings, who in 1840 married Ellen Teed, a leading authoress and philanthropist and daughter of Thomas Teed of Stanmore Hall near London.

It is not known if these portraits by Hudson are family pictures, perhaps painted on the occasion of the marriage of an ancestor of either Hollond or his wife, or whether they were acquired to form part of the Hollond collection of Old Master and English paintings. If they are marriage portraits, as these matched pairs by Hudson can sometimes be shown to be, we lack precise enough knowledge of the Hollond ancestry to identify the sitters.

J.S.

PROVENANCE: Robert Hollond of Stanmore Hall, Middlesex; his sale, Christie's 27th April 1889, lots 33 ("A Gentleman in Court Dress") and 34 ("Portrait of a Lady", annotated as "in white satin" in Sir George Scharf's catalogue at National Portrait Gallery); bought Fairfax Murray; his Gift, 1911.

LITERATURE: *Thomas Hudson 1701–1779* (exhibition catalogue, The Iveagh Bequest, Kenwood, London, 1979), nos. 46 and 47.

15 Thomas Hudson

Unknown Lady

Canvas, 127.3 × 101.9 cm., 50⅛ × 40⅛ in.
Signed and dated lower right: *T Hudson Pinxit.* / *1750.* (*TH* in monogram).
Inv. no. 579.

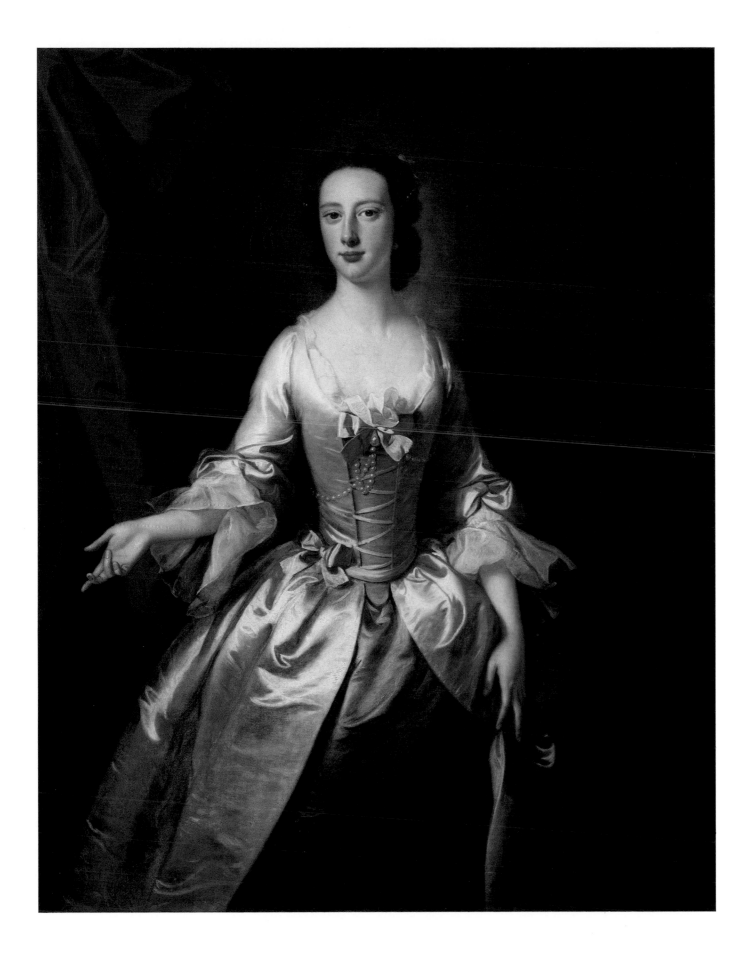

16 Jan van Huysum

Amsterdam 1682–1749 Amsterdam

Van Huysum began his career, like his three brothers, in the Amsterdam workshop of his father, Justus, a flower painter whose business was devoted to interior decoration in the French style fashionable in the later seventeenth century. Jan left with the apparent aim of discarding the artistically servile associations of such practice. He became an independent master in the same city: a fine art rather than a decorative painter. To achieve this rise in status he painted both classical landscape scenes and the fruit and flower pieces with which his fame is now associated. Van Huysum developed a style first to be seen in the flower pieces of Willem van Aelst, Cornelius Kick and Jacob Walscapelle. By 1726, when his first mature dated work was executed, he had developed this style to such an extent that it had become characteristically his own.

A Vase with Flowers

Canvas, 84.1 × 62.2 cm., $33\frac{1}{8} \times 24\frac{1}{2}$ in.
Signed: Jan van Huysum
Inv. no. 139.

Described during his own lifetime as "the phoenix of Dutch flower painters", Jan van Huysum produced masterpieces in the genre, many of which immediately entered major European collections and are now to be found in the world's leading galleries and museums. In contrast to his customarily finely detailed execution, the present work is unusually broadly painted. This has led to speculation that it might be a relatively late work. In manner it exhibits an affinity with the artist's drawing style. Van Huysum sketched compositions, often in black chalk with watercolour, in which details are suppressed in the interests of exhibiting the disposition of complex masses in a carefully defined light. Although in this instance the general compositional sweep, based characteristically on an 'S' curve, may tend to override the viewer's attention to representational detail, this latter aspect, usually in the forefront of the artist's concerns, has not been ignored. The juxtaposition of the fully-blown roses with the tiny hanging blossoms emphasizes the illusionistic delicacy of the latter, while the hovering fly also draws attention to this aspect of Van Huysum's art. The fly had long been used as a motif to demonstrate the painter's representational skill, but Van Huysum appears to have been the first to develop the additional refinement of depicting such an insect in flight.

It has been argued that any painted still life is *ipso facto* also a *vanitas*, and Van Huysum's cut flowers suggest such associations. Often nearing the end of their lives, their stems are frequently twisted and occasionally snapped; their petals regularly flare, as is the case with the prominent tulip in this work. Yet this intimation of transience appears to be a familiar, almost incidental commonplace rather than the primary, morally symbolic, purpose of such works. Similarly, attempts to ascribe specific emblematic significance to individual species of flower in Van Huysum's paintings seem for the most part to be anachronistic.

His first biographer, Johan van Gool, writing only shortly after his death, reported that the specialist fruit and flower growers of Haarlem, from whom Van Huysum obtained specimens, were so amazed by the deceptive likeness to nature of his paintings that they stood looking at them like statues. To achieve such realism Van Huysum did not necessarily assemble the bouquets as we see them, but painted the individual blooms, preferably from life, as they became available, sometimes in the course of more than one year. Thus his compositions can defy the seasons and his works bear more than one date.

Van Huysum regularly used terracotta vases of an Italian type for his spreading bouquets. As in the present work, they are often decorated with sporting *putti* in high relief, the same design recurring in several instances. These designs are in the style of François Duquesnoy, whose *putti* reliefs had been used prominently to decorate window embrasures in genre scenes by Gerrit Dou. Except insofar as these *putti* sometimes play with flower garlands, or bunches of grapes, no specific allusion would appear to be intended. Rather, they serve to enhance the opulently languid classical elegance which permeates Van Huysum's oeuvre.

This style, perfected by the mid-1720s at the latest, served the artist for the remainder of his life: a good twenty-five years. Johan van Gool recorded the artist's fame during his own lifetime, the high prices his works fetched both before and after his death (confirmed by eighteenth century sale catalogues) and the celebrity and status of his patrons, who included many of the rulers of Europe. Such success attracted emulators and successors, though he taught only a single pupil.

I.G.

PROVENANCE: Bourgeois Bequest, 1811.

LITERATURE: HdG X, no. 126; M.H. Grant, *Jan Van Huysum, 1682–1749* (1954), p. 23, no. 87.

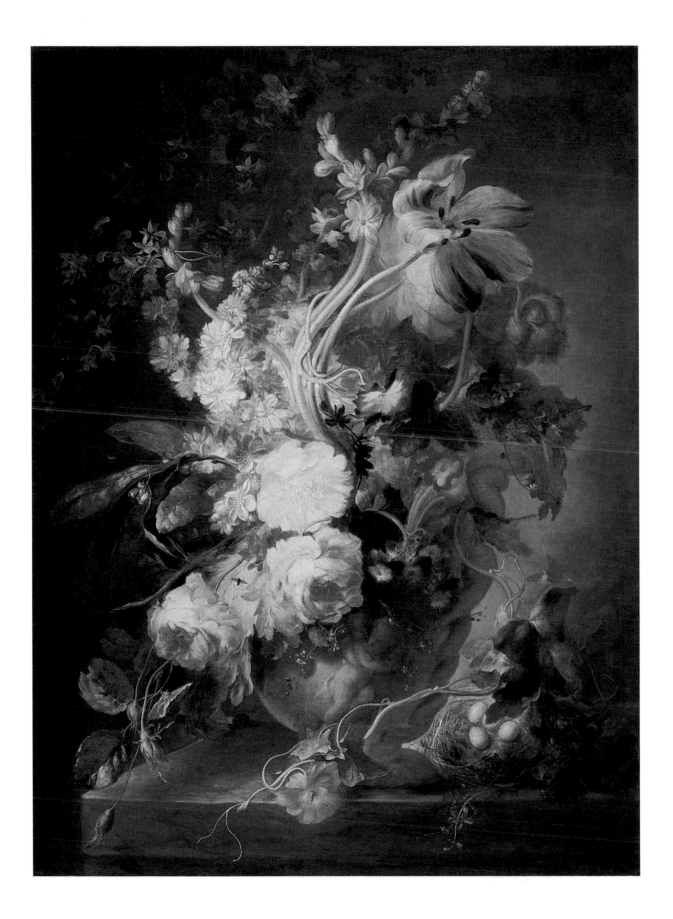

17 George Knapton

London 1698–1778 London

In contrast to many English artists of his time, Knapton appears to have been well-educated and socially accomplished. After training in London under Jonathan Richardson, Knapton travelled in 1725 to Rome, where he spent seven years engaged in painting and archaeology. He published his account of excavations at Herculaneum in 1740. In 1736 he gained the position of statutory painter to the newly-formed Society of Dilettanti. Knapton had royal connections: he was recommended to Frederick Prince of Wales as 'the most skilful judge or Connoisseur in pictures' (Vertue), catalogued the royal collection, and in 1765 became keeper of the King's pictures. He apparently abandoned painting in the mid-1750s, an act which, as with Thomas Hudson, may have been due to the advent of Reynolds. He was known especially for his work in pastels.

Lucy Ebberton

Canvas, 76.5 × 64.1 cm., $30\frac{1}{8}$ × $25\frac{1}{4}$ in.
Inv. no. 606.

Knapton is remembered particularly for his portraits of members of the Society of Dilettanti, a group of young noblemen who met to pursue archaeology and conviviality. His twenty-three portraits of members of the Society, begun in 1740, show them in the fanciful allegorical dress they wore to meetings. His other sitters included such people of distinction as Handel, Burlington and the family of the Prince of Wales.

Lucy Ebberton was less notable. A mezzotint made after this picture by James McArdell between 1746 and 1765 establishes the identity of the artist (in spite of a recent unsupported suggestion that the picture might be the work of the Dutch artist Frans van der Mijn). The identification of the sitter as "Lucy Ebberton" rests on a handwritten note by Horace Walpole on his version of the print: *"Lucy Ebberton – afterwards the wife of Capt. Greeg of the Marines by whom she had three or four children. She resided sometime at Blandford and afterwards removed to Exeter. Barton who kept the London Tavern in Poole was her uncle."* This note suggests that Lucy came from a prosperous middle class family, based in the South West of England, but little further information has emerged about her. A Captain Gregg is recorded in the Royal Marines between 1757 and 1782, and a "Mr. Barton" is listed in *The Church Ledger in the Parish of St. James, Poole*, as resident in a modest property in the High Street, Poole, between 1761 and 1769, but no mentions of Ebbertons or Greggs survive in the parish records of Blandford or Exeter. A second impression of the mezzotint suggests the sitter's lack of personal importance: not only her headwear but her features are changed, converting the print, presumably, into a portrait of another sitter.

On grounds of dress, the portrait can be dated to the late 1740s, and can hardly date from later than 1750 (information from Dr. Aileen Ribiero). The sitter wears an informal morning gown, suited to the pastoral setting in which she sits. The hat over a linen cap, the kerchief edged with lace, and the delicate apron contribute to the elegant casualness of her costume. She follows the fashion of the 1740s in the large floral pattern of her magnificent Spitalfields silk dress, in her ringlets, and in her dress's stiffened cuffs and short sleeves. Her necklace – almost certainly paste – also displays the taste of the 1740s, though it is more elaborate than jewellery shown in most portraits of private individuals.

Paintings by Knapton are of uneven quality: often inventive and finely painted, they can be stiff, reflecting Vertue's comment that like many of his contemporaries he was assisted by drapery painters. In this case it seems unlikely that he called on assistance; the paint is of fine quality throughout. The artist's success with pastels is reflected in the picture's soft colour-scheme.

The frame is of high quality, of the mid-eighteenth century, and probably original to the picture.

G.W.

PROVENANCE: Fairfax Murray by 1908; his Gift, 1917.

LITERATURE: G. Goodwin, *J. McArdell* (1903), no. 130; A. Staring in *Nederlands Kunsthistorisch Jaarboek* (1968), p. 200.

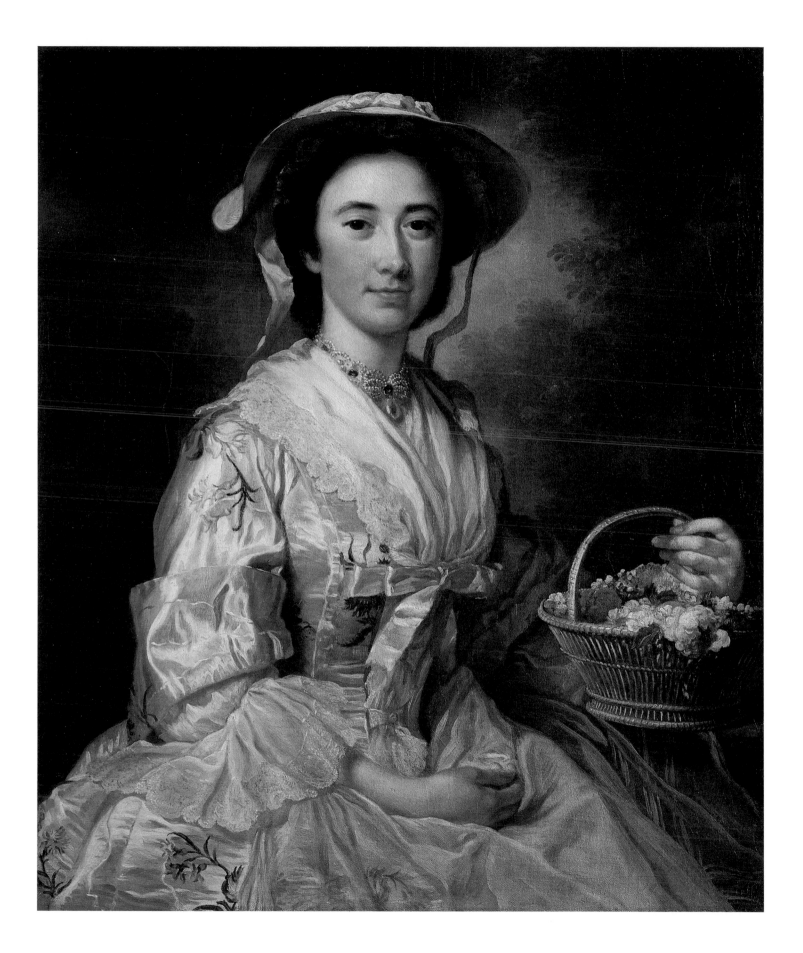

18 Sir Thomas Lawrence, P.R.A.

Bristol 1769–1830 London

Thomas Lawrence was almost entirely self-taught. At the age of twenty he was commissioned to paint Queen Charlotte, and other important commissions followed. He was elected A.R.A. in 1791 and R.A. in 1794, knighted in 1818 and elected President of the Royal Academy in 1820. He formed an extraordinary collection of Old Master drawings, many of which are now in The British Museum.

William Linley

Canvas, 76.2 × 63.5 cm., 30 × 25 in.
Inv. no. 178.

William Linley, (1771–1835), the youngest son of Thomas Linley the composer, and brother of the celebrated singer Elizabeth Linley who married Richard Brinsley Sheridan, was himself a man of parts, an accomplished singer, an author and a composer, albeit of rather less distinction than other members of his family. He was born in Bath, and although his father became joint-manager of the Drury Lane Oratorios in 1774 and had other London commitments, the Bath connection was kept up. Thomas Lawrence, two years William Linley's senior, made his name as an artistic prodigy in Bath where his family settled in 1782, and his reputation would undoubtedly have been well-known to the Linleys at an early stage. The pastel portraits by him of William Linley's brother and sister Ozias Thurston and Maria, which also belong to the Dulwich Picture Gallery, were almost certainly drawn in Bath. William Linley was sent to London, to St. Paul's School, in 1785, and young Lawrence moved from Bath to London in 1786. Lawrence, who was himself a gifted amateur singer and actor, soon made friends in musical and theatrical circles, particularly in that of the Siddons and Kemble families, and an acquaintance with the Linleys must have been strengthened at that time. In fact a letter survives from Lawrence senior to his daughter, Anne, which is addressed *Miss Lawrence / at Thomas Linley Esqr. / Norfolk Street / London.*

When Lawrence arrived in London he had very little experience of painting in oils. He spent a few months as a student at the Royal Academy Schools and made quite extraordinary progress. By 1788 he was exhibiting portraits in oil as well as pastel at the Royal Academy annual exhibition, and in 1789 when the portrait of William Linley was exhibited, twelve of his portraits were accepted, the majority, in so far as they can now be identified, being in oil. Thereafter, he abandoned pastel almost completely, but continued to make highly accomplished portrait drawings. One of the very best drawings of these years is of William's mother, Mary Linley, at around the age of sixty, which is now in the collection of the Yale Center for British Art, at New Haven.

Throughout his life, Lawrence tended to be most successful with sitters who were comparatively young or comparatively old. In the first decade of his London career, when he was himself still in his twenties, he made some memorable portraits of young men who were more or less his own contemporaries, notably *Sir Gilbert Heathcote* (1791) a portrait still in the possession of the sitter's family, *Arthur Atherley* (1792) now in the Los Angeles County Museum, and *William Linley*. One senses in these portraits the dawning of a new romantic age. The large-eyed gaze is more self-conscious than, for instance, the comparative reticence of the expressions of similar young men painted by Romney. They are isolated on the canvas in a slightly more stagey manner. The paint is handled deftly. Lawrence's gift for drawing, whether in crayon, chalk or oil, was exceptional.

It is interesting to note that in the portrait of William Linley he obviously had second thoughts. There are indications around the head and shoulders that the figure was originally sketched in on a larger scale, probably just too large to be accommodated comfortably within the dimensions of the canvas. At some stage the canvas was relined, a process which has resulted in some flattening of the paint surface. On the whole, however, the painting is in a satisfactory condition. It is also of some interest that the handling of the paint is in any case less theatrical than it soon became. There is little evidence of the exaggerated highlights and over-use of red in the shadows for which Lawrence was later criticized.

In 1790 William Linley sailed for Madras where he became deputy secretary to the military board. He returned to England in 1796 and entered into a partnership with his brother-in-law, R.B. Sheridan, at Drury Lane Theatre. After another journey to India in 1800 he was back in London in 1806, and from that time was best known as a singer and a composer of songs and anthems. Coleridge's sonnet *"While my young cheek retains its youthful hues"* was occasioned by hearing him sing Purcell.

K.G.

PROVENANCE: Bequeathed by the sitter, 1835 (on loan to the Gallery from c.1822).

LITERATURE: Waagen II, p. 348; W.J. Whitley, *Artists and their Friends in England* (1928), II, p. 385; K. Garlick, *Catalogue of the Paintings, Drawings and Pastels of Sir Thomas Lawrence*, Walpole Soc. XXXIX (1964), p. 126.

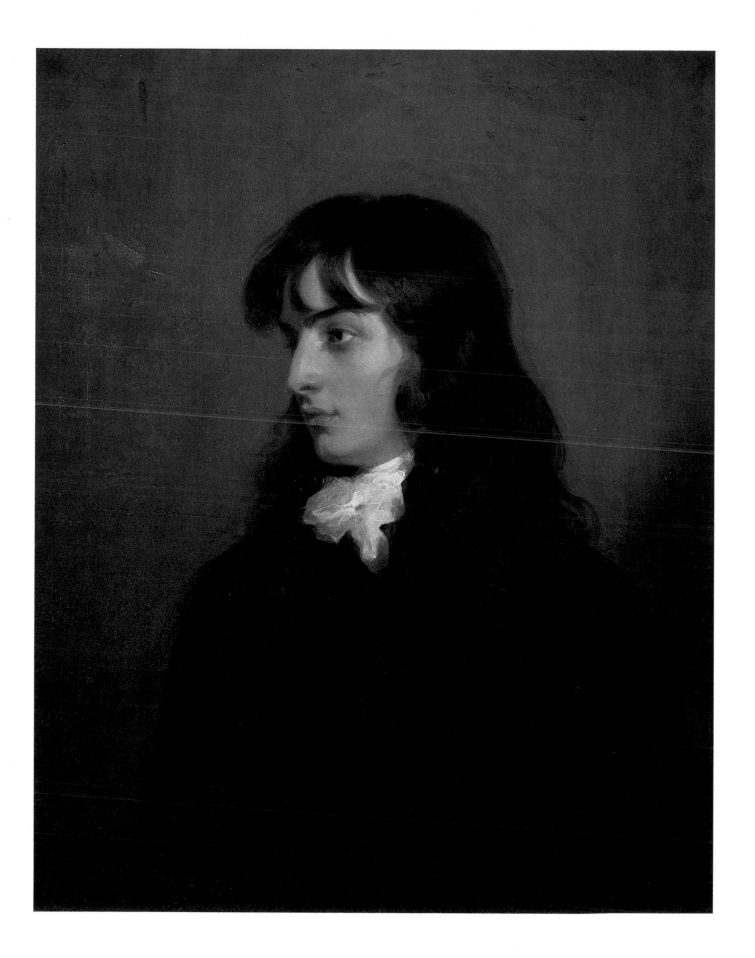

19 Charles Lebrun

Paris 1619–1690 Paris

Lebrun, the son of a master-sculptor, trained as a painter under Vouet and Perrier, and between 1642 and 1646 with Poussin in Rome. Poussin was the most important influence on Lebrun's art, but while in Rome he also studied the Italian Baroque decorators. On his return to Paris, he gained a number of commissions, including ornate decorative schemes, as at Vaux-le-Vicomte. In 1660–61, he painted his first work for Louis XIV the *Queens of Persia kneeling before Alexander*, (Musée National, Versailles) and two years later, was made Director of the *Académie Royale de Peinture et de Sculpture*. He received several other important offices, and for the next twenty years was virtual dictator of the arts in France. He masterminded the decoration of Versailles from 1671. Through his lectures and his Directorship of the Academy Lebrun helped to ensure that the classical ideals of Poussin took root as a permanent ingredient of French art.

The Massacre of the Innocents

Canvas, 133×187.4 cm., $52\frac{3}{8} \times 73\frac{3}{4}$ in.
Inv. no. 202.

The Massacre of the Innocents is mentioned by the official historian of the Academy and Lebrun's first biographer, Guillet de Saint-Georges, as having been begun for a canon of the church of Saint-Honoré, who was a friend of the artist, and finished some years later for M. Du Metz. Guillet also refers to the contemporary engraving after the picture by Alexis Loir, leaving no room for confusion over the identification.

Modern scholars are agreed that the painting was begun in or shortly before 1650, a few years after Lebrun's return from Rome. More problematical is the extent to which the execution really belongs to two distinct phases. Blunt (*loc. cit.*) thought that the background represented the early phase, still under the influence of Poussin, and that the foreground figures showed a more extravagant baroque style characteristic of Lebrun's later years. X-rays taken in 1963 failed to reveal, however, any marked differences between one part of the picture and another. What is more, as J. Montagu has pointed out, the numerous preparatory drawings for the figures (e.g. fig. 1) seem all to belong to a single period, around 1650 (one drawing is on the same sheet as a study for *The Brazen Serpent* in Bristol, which is definitely of this period). The likely explanation is that Lebrun initially executed the whole picture as far as the lower layers of paint for his friend, the canon of Saint-Honoré, and at the final stage strengthened the modelling and emphasized the facial expressions of some of the foreground figures. Such additions would not show up in x-rays. That some work of this kind was done later is suggested by the very detailed modelling of certain areas, particularly the central group, including the horse, and the distraught woman on the right, where the handling recalls Lebrun's style in the *Alexander* series (mid-1660s). Furthermore, the woman's facial expression is reminiscent in type of the illustrations to his *Treatise on the Expression of the Passions*, which he first delivered as a lecture in 1668. The comparatively subdued colouring of the picture also suggests the artist's later period.

While in Rome, Lebrun would have learnt from Poussin the importance of preparing a composition thoroughly and arranging the figures in distinct yet related groups, as well as the value of revealing the emotions of participants in an action through their gestures and expressions. Lebrun transformed this well-established practice, a principle of Poussin's work, into a system which would become part of the curriculum of all academies of art. The massacre of the young children of Bethlehem, by Herod's order, was a subject full of violence and terror, if not of much emotional variety. The skill of the artist was made apparent in varying the poses of the figures, showing the soldiers contorted by the acts of brutality while the mothers struggle or collapse in despair. An unusual feature of Lebrun's composition is the large chariot drawn by four horses looming out of the semi-darkness. One of the early commentators, Nivelon (*loc. cit.*), identified the occupants of this chariot as *"those dangerous lawyers or councillors who concealed from Herod the true meaning of the words of the prophet Micah concerning the birth of the Messiah"*.

The background architecture, like the composition generally, is reminiscent of many of Poussin's paintings of the 1630s and 1640s; for example, a similar bridge, situated parallel to the picture plane, occurs in the *Ordination* from the second series of *Sacraments* (Duke of Sutherland), which Lebrun would have seen in or after 1647 in the collection of the patron, Chantelou. Another specific echo of Poussin is the temple portico with an obelisk rising from the dome behind it, which could have been taken from a similar motif in the background of the older artist's *Finding of Moses* (Louvre), then recently arrived in Paris for the banker, Pointel.

Compositions containing as many figures as Lebrun's *Massacre of the Innocents* are common in Poussin's work of the 1630s. Poussin himself, however, in his two versions of the theme, had used few figures. C. Goldstein (*loc. cit.*) has made the point that Lebrun seems to follow Rubens in his rendering of the subject in the Alte Pinakothek, Munich; he sets the scene in front of a temple and includes a large crowd of figures, in contrast to the Italian tradition, adhered to since the time of Raphael, where a few figures occupy an open stage. During the 1630s, there had been a debate in the Roman Academy of St. Luke as to whether compositions should be organized with few or many figures. Those of the classical persuasion, followers of Raphael, had argued in favour of few figures; those of the party now recognized as baroque, led by Pietro da Cortona, had urged the advantages of many. Both Poussin and Lebrun (while in Rome) would have been well aware

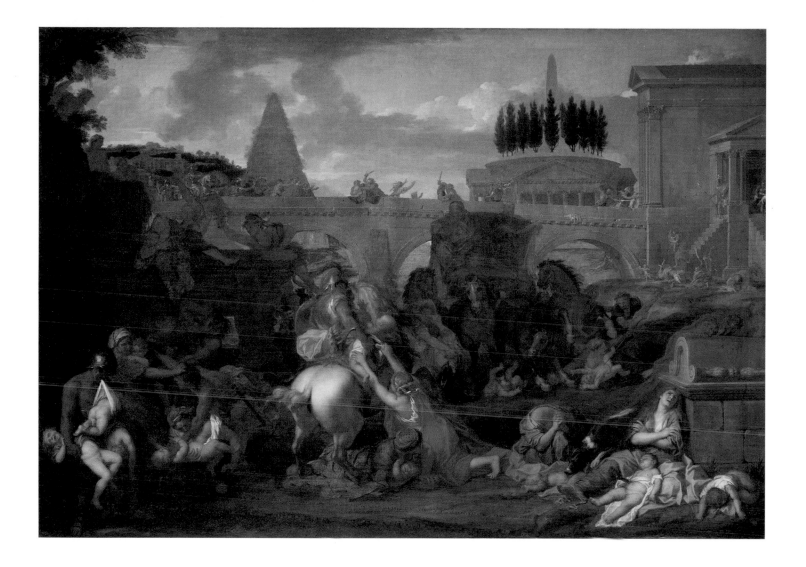

Lebrun: *Study of Seated Woman for "Massacre of the Innocents".*
Chalk with white heightening. (Louvre, Cabinet des Dessins)

of this debate. After 1640, Poussin never included more than twenty figures in his compositions, but Lebrun kept an open mind. Where the subject suggested it, as in the *Massacre of the Innocents*, the *Victories of Alexander* or in grand decorative schemes, he followed the example of Rubens and Pietro da Cortona and adopted the baroque solution. There is even a hint of Rubens's stylistic influence in the figures on the left of the Dulwich picture.

Not very long after this period, the *Massacre of the Innocents* ceased to be a subject for artists. In 1702, as Goldstein mentions, it was the theme set for a drawing prize in the Academy of St. Luke, when the majority of the competitors chose the same method of approach as Lebrun. Nevertheless, the growing rationalism of the age, of which Poussin was a pioneer and Lebrun an early exponent, would soon confine religious subject matter to the realm of devotional altarpieces and icons for private meditation. The great moral themes of cruelty and sacrifice, pride and loyalty, and those *"eminent instances of*

heroic action or heroic suffering" (to borrow Reynolds's phrase in his definition of history painting) would henceforth be illustrated not with scenes from the Bible but with episodes from classical history. M.K.

PROVENANCE: M. Du Metz, Keeper of the Royal Treasury, for whom completed; Duc d'Orléans, before 1734; to England with the Orléans Collection, 1798, and bt. by Desenfans; Insurance list, 1804(80); Bourgeois Bequest, 1811.

LITERATURE: Guillet de Saint-Georges, *Mémoire Historique sur les principaux ouvrages de Charles Le Brun . . .,* 1693 (MS publ. by L. Dussieux and others in *Mémoires inédits . . . des membres de l'Académie Royale de Peinture et de Sculpture,* 1854), pp. 14f, 341f; C. Nivelon, *Vie de Charles Le Brun et description détaillée de ses ouvrages,* c.1700 (MS, Paris, Bibl. Nat., MS fr., 12987, p. 37); *Highmore's Paris Journal,* 1734 (MS publ. by E. Johnston, *Walpole Soc.,* XLII 1970), p. 81 and n. 96; A. Blunt, "The Early Work of Charles Lebrun" – I, *Burl. Mag.* LXXXV (1944), p. 173; J. Montagu, *Charles Le Brun* (exhibition catalogue, Versailles, 1963), under nos. 64–70; C. Goldstein, *"Art History without Names: a Case Study of the Roman Academy",* Art Quart. (NS I, no.2, Spring 1978), p. 13.

20 Sir Peter Lely

Soest 1618–1680 London

Lely was born in Soest, Westphalia (now part of West Germany) to Dutch parents. He trained as a painter in Haarlem before becoming a Master of the Haarlem Guild in 1637. Nothing definite is known of his work before his arrival in England in about 1641. By 1650, he had established the largest practice of any portrait painter in Britain. With the Restoration in 1660, he became Principal Painter to Charles II, and his services were in even greater demand. He was knighted in the year of his death. His large workshop was extremely prolific, though the quality of the pictures varies considerably.

Nymphs by a Fountain

Canvas, 128.9 × 144.8 cm., 50¾ × 57 in.
Inv. no. 555.

This painting is arguably the finest example of a type of picture which Lely is known to have painted in his earliest years in England (and presumably before), but which for commercial reasons he was forced to abandon in favour of portraiture. Richard Graham, in the first printed account of his career, the *Short Account of the Most Eminent Painters both Ancient and Modern* (1695), notes that on his arrival Lely "*pursu'd the natural bent of his Genius in Landtschapes with small Figures, and Historical Compositions: but finding the practice of Painting after the Life generally more encourag'd, he apply'd himself to Portraits*". This report is confirmed in a "Panegyrick" to the artist by his friend the cavalier poet Richard Lovelace, published in his *Lucasta* (1660). Lely's earliest works, he writes, were treated with "*transalpine barbarous Neglect*" in this "*un-understanding Land*" where portraits were the only means of making a living, even for an artist of Lely's calibre.

Although the picture is said once to have been signed and dated, no trace of signature or date can now be found. They were last read for the 1926 catalogue of the collection, when the date was interpreted, almost certainly wrongly, as 1670. Collins-Baker had earlier noted that the painting was "*said to be signed and dated earlier than his [Lely's] arrival in England*". The date of his arrival, however, has not been established. He was certainly here by 1647 when he painted Charles I, and, if the tradition reported by Collins-Baker is correct, this would suggest a date for *Nymphs by a Fountain* in the early to mid-1640s. In the catalogue of the 1978 Lely exhibition, on the other hand, Sir Oliver Millar preferred a date in the early 1650s.

Lely's earliest works do appear to have been the "*Landtschapes with small Figures*" mentioned by Graham. Surviving examples include the *Diana and Nymphs Bathing*, (Nantes; signed and indistinctly dated 1640 or 1646) and the *Infant Bacchus* (Helmingham Hall, Suffolk), works which are on an appealing small scale in the Dutch-Italianate landscape tradition. They are prettily coloured, and touched with faint reminiscences of Titian and Van Dyck. The rather clumsily grouped figures call to mind those which people the landscapes of Cornelis van Poelenburgh, who had come to England in the late 1630s, and whose work Lely must have known.

In several paintings of about the same date or slightly later, such as the unfinished *Concert* (Courtauld Institute of Art, London), the figures tend to dominate the landscape, revealing an increasing concentration on the nude female form. The *Nymphs by a Fountain* almost certainly represents a further stage in this development. In it the elements of landscape serve merely as a foil to the nude figures, and the mood, though still reflective, is modified by the markedly less ethereal treatment of the nude. Lely delights in the rounded, irregular forms of the

Fig. 1. Lely: *Study of a Woman for "Nymphs by a Fountain"*.
Pencil. (Collection unknown)

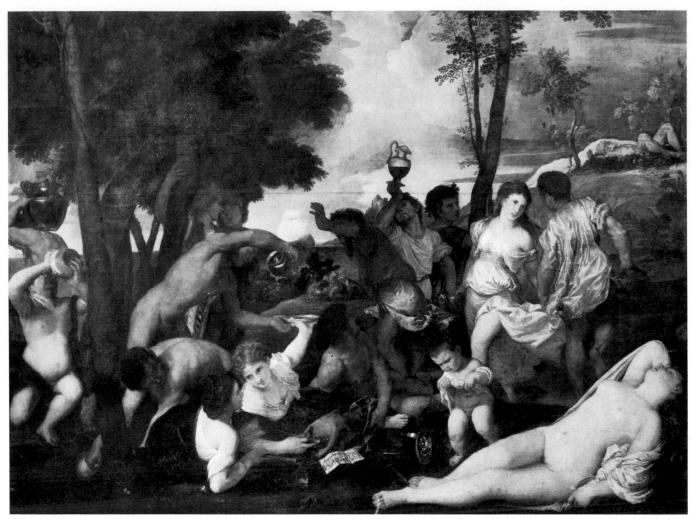

Fig. 2. Titian (c.1487–1576): *The Andrians*, 1554. Canvas.
(Prado, Madrid)

sleeping nymphs (and of the fountain), defined by the warm afternoon light, framed by the deep shadows of the rocks, their smoothness contrasted with the scrubby vegetation. More than any other of his works in this mode, this picture reveals Lely's affinities with the fully-fledged Dutch baroque style, and therefore should perhaps be dated, as Millar suggests, to the early 1650s.

Despite Lely's confident handling of the individual figures, they are somewhat awkwardly integrated in the composition, and were probably made from a series of separate studies. A drawing of the type Lely may well have used when constructing this type of composition was in the C.R. Rudolf Collection (sold Sotheby Mak van Waay, Amsterdam, 18th April 1977 (40)) (Fig. 1). Although attributed at the time of sale to Rubens this drawing is almost certainly by Lely. That Lely had trouble organizing the figures is emphasized by the now visible alterations made to the head of the rather cramped nymph on the left at the base of the fountain. This was originally shown complete, but then changed so as to be partly hidden by

the drapery of the figure on her left. The sleeping nymph on the left of the group perhaps owes something to Psyche in Van Dyck's late idyll *Cupid and Psyche* (Royal Collection), then in the collection of Charles I, and later in Lely's. Her brilliant blue and pink draperies were clearly inspired by Van Dyck. The sleeping nymph at the back echoes in reverse the sleeping Ariadne in Titian's *Andrians* (Prado, Madrid) (fig. 2) perhaps known by Lely in the reversed engraving by G.A. Podestá.

M.R.

PROVENANCE: Bought in Paris by Fairfax Murray; his Gift, 1911.

LITERATURE: C.H. Collins-Baker, *Lely and the Stuart Portrait Painters* (1912), I, p. 139 note; R. Beckett, *Lely* (1951), no. 594; O. Millar, *Lely*, no. 25 (exhibition catalogue, N.P.G., London, 1978).

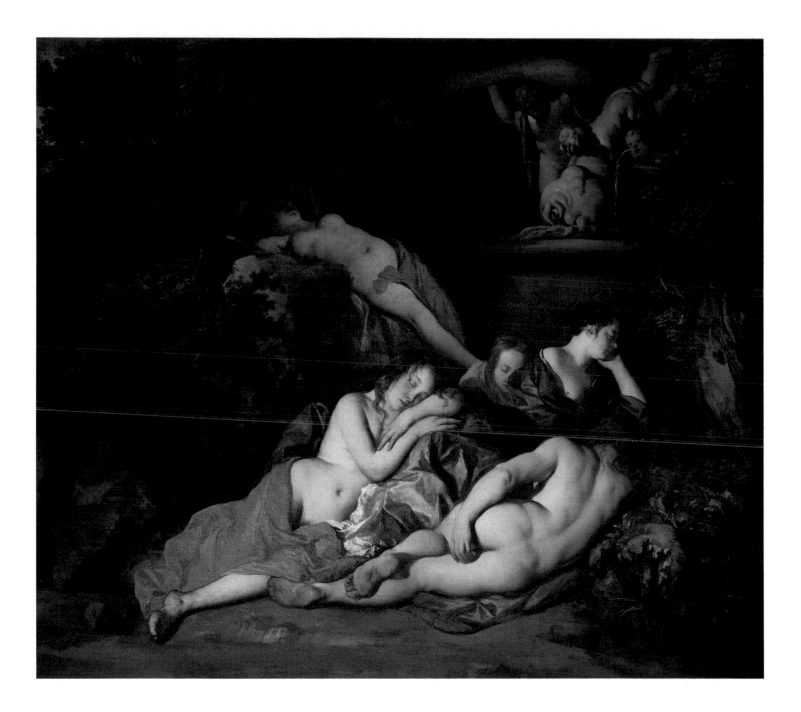

21 Sir Peter Lely

Portrait of a Boy as a Shepherd
Canvas, 91.4 × 75.6 cm., 36 × 29¾ in.
Signed: PL in monogram
Inv. no. 563.

This portrait is an especially poetic instance of Lely's use of the pastoral or Arcadian mode, which he favoured for female and youthful sitters both before and after the Restoration. The picture is entirely characteristic of Lely's mature style, even in the slight anatomical uncertainty with which the sitter's arms are linked to his body. The painting of the flesh is especially rich and creamy, and the treatment of landscape and draperies betrays no sign of studio assistance. It has most recently been dated c.1658–60, but may have been painted as late as c.1665.

The boy, with his shepherd's crook and recorder, lips slightly parted, appears lost in thought or listening for some distant sound, and this mood of pastoral reverie is intensified by the muted range of colours – browns and fawns, blue, pale gold and green – which Lely uses, and the glimpse of densely wooded landscape beyond. The boy's face is painted with great luminosity and tenderness, the effect heightened by his mane of golden hair, silhouetted against the deep shadow of the rock, in which the golden lights are touched in with particular affection. Horace Walpole, who owned this picture, wrote of the portrait's *"impassioned glow of sentiment, the eyes swimming with youth and tenderness"*.

From at least the mid-eighteenth century onwards the sitter has been identified as the poet Abraham Cowley (1618–1667), a child prodigy whose first works were published when he was fifteen. This identification is entirely fanciful, though it appealed greatly to Walpole, who did much to foster it. The sitter bears no resemblance to authentic portraits of the poet, who was in any case aged about forty when the picture was painted. It may be that the provenance gives a clue to the boy's true identity. When Walpole first saw the picture at Edward Lovibond's house he noted that he had there *"several pictures that were Mrs Beale's"*, that is, which had belonged to Mary Beale (1633–1699) the portrait-painter, who was a close friend and associate of Lely. It may be significant that a drawing of the head of *Portrait of a Boy as a Shepherd* by her younger son Charles Beale also belonged to Lovibond, and that another is in the British Museum. By 1661 Mary and her husband Charles owned a self-portrait by Lely (probably that now in the National Portrait Gallery, London), which was also copied by her son Charles. Among Mary Beale's own works are several portraits of a blond youth, all said at one time or another to represent Cowley (e.g. at Althorp, at Rugby School, and in the National Portrait Gallery, London.). These have recently been plausibly reidentified as portraits of Mrs. Beale's elder son Bartholomew (1656–1709), on the basis of the resemblance to the one certain image of him, the small likeness

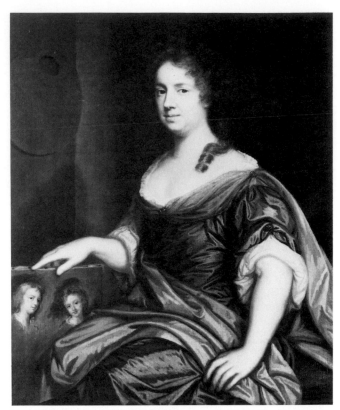

Mary Beale (1633–99): *Self-Portrait with portraits of her Sons*, c.1665. Canvas. (National Portrait Gallery, London)

incorporated with that of his brother Charles in the self-portrait of their mother in the National Portrait Gallery, London. The sitter in the Dulwich painting bears a distinct resemblance to both the certain and supposed portraits of Bartholomew, and it may be that the picture is also a portrait of the elder son of Lely's friends the Beales, painted c.1665, at a time when he was in the habit of sitting for his mother. The identification would help to explain the painting's tone of emotional intimacy, and the poetic vein which places it ambiguously on the boundary between strict portrait and subject-picture.

M.R.

PROVENANCE: Edward Lovibond (1724–1775), Hampton, by c.1770, when seen by Horace Walpole (identified as Abraham Cowley); Lovibond Sale, 27th–28th May 1776, bt. Walpole, £63; hanging in the Breakfast Room, Strawberry Hill; Strawberry Hill Sale (11th day), 6th May 1842 (21), as Cowley, bt. Seguier, £105; Sir Robert Peel; Peel Heirlooms Sale, Robinson and Fisher, 10th May 1900 (203), as Cowley, bt. Agnew, £670; Fairfax Murray Gift, 1911.

LITERATURE: H. Walpole, *Visits to Country Seats*, p. 69; idem., *Anecdotes of Painting*, ed. R.N. Wornum (1888), III, p. 29; C.H. Collins-Baker, *Lely and the Stuart Portrait Painters* (1912), II, p. 122; H. Walpole, *Correspondence*, XXXII (1965), pp. 294–5; *A Description of Strawberry Hill* (1784), p. 20; R. Beckett, *Lely* (1951), no. 129, rejecting the identification as Cowley and with a dating of c.1657; O. Millar, *Lely* (exhibition catalogue, N.P.G., London, 1978), no. 28, as "a boy", c.1658–60.

22 Bartolomé Estéban Murillo

Seville 1617/18–1682 Seville

Murillo was born in Seville and spent the greater part of his life there. His knowledge of Flemish and Venetian works came from his study of the royal collection in Madrid, probably in the early 1640s. In 1645 and 1646, he executed a series of paintings in the cloister of S. Francisco el Grande, Seville, and these established his reputation. He was a strongly religious man and during the later part of his career produced many large-scale sacred subjects, especially of the Immaculate Conception.

The Flower Girl

Canvas, 121.3 × 98.7 cm., 47¾ × 38⅞ in.
Inv. no. 199.

Excepting his religious pictures, *The Flower Girl* is Murillo's most celebrated depiction of a single female figure, a subject comparatively rare in his oeuvre. Compared to the *Fruit Vendor* (Pushkin Museum, Moscow) and the *Young Girl raising her Veil* (English private collection), *The Flower Girl* is more subtly composed, more portrait-like and less arch in expression. The painting is usually dated c.1665–70, and the same heavy-cheeked model (possibly Murillo's only daughter Francisca, who became a nun in 1671) also sat for the Franciscan Saint Rosalia who offers the Christ Child a spray of roses in the Thyssen-Bornemisza Collection *Virgin and Child with Saints*, dated by Angulo to c.1670.

The full-blown roses which the girl holds signify for Angulo the transience of life, love and beauty. He cites a contemporary Sevillian poem on a rose by Villegas to support his allegorical *vanitas* interpretation – the most familiar English version of this theme being Herrick's *"Gather ye Rose-buds while ye may"*. Frankfort Harris has recently suggested that Murillo has produced an Andalusian country Flora, a modern version of the Roman Goddess of Flowers.

The girl's costume, unique in Murillo's art, has given rise to controversy; it has been variously identified as Andalusian peasant, as Moorish and in nineteenth-century England, more implausibly, as Gipsy. Murillo may have intended nothing more than the creation of an appealing summery image of a lovely girl adorned with flowers and colours and rendered more exotic through the invented orientalism of her accessories, the shawl and turban. For a seventeenth century buyer the sitter with her half-smiling response to an imaginary spectator may have seemed mildly erotic, for in offering her lap full of flowers, she, who is of an age just right for plucking, may well be offering herself. In L. Chalcondyles' *Histoire de la Décadence de l'Empire Grec* (Paris, 1662) which re-uses the illustrations from N. Nicolai's *Von der Schiffard und Rays in die Turckey* (Nuremberg, 1572), one print (no. 45) is entitled *"Fille de Joye Turque"* and is accompanied by the

following comment, *"Nous avons un proverbe commun entre nous qui dit quand nos Dames ont le bouquet sur l'oreille qu'elles sont à vendre."*

Murillo's *genre* scenes may be compared to those of Velasquez, who also depicted low-life characters and sometimes placed his religious subject in strongly realistic settings, a practice which Murillo sometimes followed. His introduction of such subjects as flower girls and peasant boys was innovatory, and only a relatively small number of such pictures exist from his hand. It has been suggested by Angulo that they may have been commissioned by the merchants from northern Europe trading in Seville. They have certainly been popular in the north from the end of Murillo's own century.

J.F.

PROVENANCE: Comtesse de Verrue before 1737; Comte de Lassay, d.1750; Comte de la Guiche; Blondel de Gagny; his Sale, Paris 10th December 1776 (3), bt. Basan (as ex-Verrue and Lassay); probably wrongly said to have been in the Randon de Boisset Collection; Le Brun of Paris Sale, Christie's, 18th–19th March 1785 (2nd day, 29); C.A. de Calonne; his Sale, Skinner & Dyke, 23rd ff. March 1795 (4th day, 99; as ex-Randon de Boisset), bt. Desenfans; Bourgeois Bequest, 1811.

LITERATURE: W. Buchanan, *Memoirs . . .* I, (1824), (as ex-R. de Boisset, Calonne Collections); W. Hazlitt, *Sketches of the Principal Picture Galleries in England* (1824), pp. 44–5; *Museo Pintoresco* (1852), p. 41; C.B. Curtis, *Velasquez and Murillo* (1883), no. 426; A.L. Mayer, *Murillo* (1923), p. 216; G. Kubler and M. Soria, *Art and Architecture in Spain and Portugal and their American Dominions 1500–1800* (1959), p. 276; J.A. Gaya Nuño, *L'opera completa di Murillo* (1978), no. 169; D. Angulo, *Murillo. Su vida, su arte, su obra*, III vols. (1981), I, p. 452, II, no. 395; E. Frankfort Harris, *"Murillo en Inglaterra"* in *Goya* (1982), pp. 7–17; *Bartolomé Estéban Murillo 1617–1682* (exhibition catalogue, Prado, Madrid, 1982, R.A., London, 1983), no. 69; M. Harazti-Takács, *Spanish Genre Painting in the Seventeenth Century* (1983), p. 183.

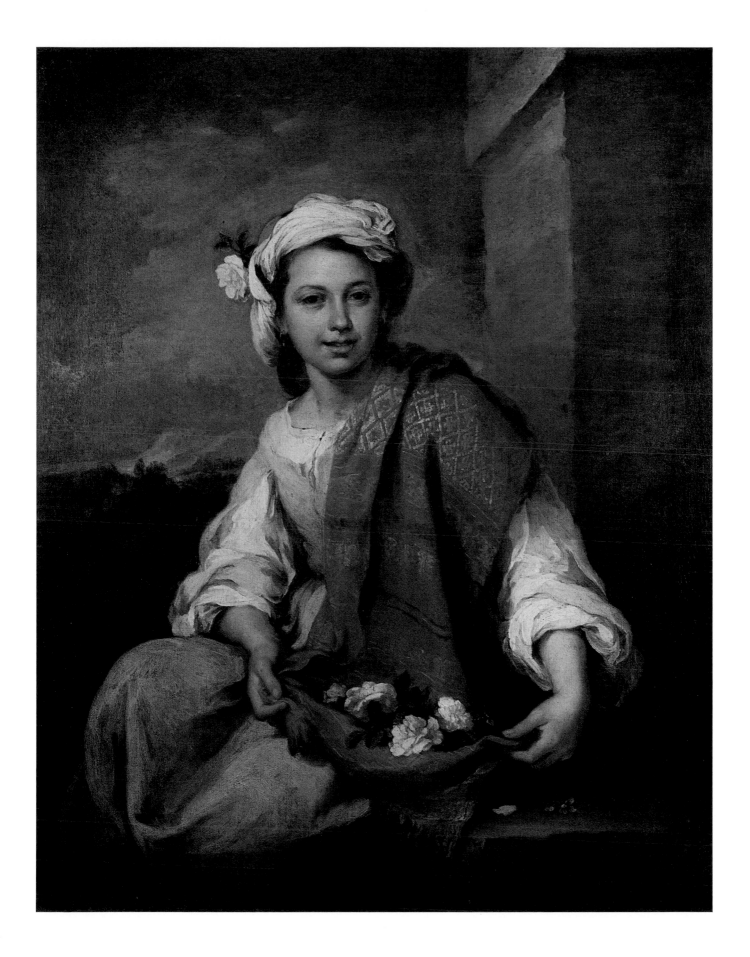

23 Bartolomé Estéban Murillo

Two Peasant Boys and a Negro Boy
Canvas, 168.3 × 109.8 cm., 66¼ × 43¼ in.
Inv. no. 222.

This picture, which is a companion piece to the Dulwich *Two Peasant Boys* (inv. no. 224), can be related to a group of similarly anecdotal genre paintings in the Bayerische Staatsgemäldesammlungen, Munich, such as the *Peasant Boys*, depicting ragged urchins eating and gambling. In contrast to the Munich pictures, the Dulwich pair are larger and taller, and the figures are smaller in relationship to the landscape background. On stylistic grounds the pictures are usually dated about 1665–70. It has been suggested that the negro boy who asks for a piece of the tart was modelled on Murillo's black servant Juan, born in 1657.

While the wistful charm and sentiment of this type of Murillo inspired 'fancy' pictures by Reynolds and Gainsborough, their originality has not been fully appreciated in this century. Although these works depend upon the example of Velasquez's *Bodegones* and Ribera's pictures of beggars and musicians, the sharp observation of childish expressions and gestures, the physiognomic precision combined with generalized over-atmospheric scenic backgrounds, the juxtaposition of seated and standing figures whose patched, off-the-shoulder, rags afford opportunities for broken colour and rich impasto, are peculiar to Murillo, the youngest of fourteen and father of three sons.

Unlike the children in contemporary Dutch genre paintings Murillo's are often free from adult supervision and discipline. They are usually male and are more frequently depicted out of doors consuming bread, pies or fruit. The moral, if indeed any is intended, is not strongly emphasized and recently discovered evidence proves that Murillo's patrons related the figures in such works to the characters in Spanish picaresque novels, to those humorous episodic tales which revolve around the petty crimes and quick-wittedness of the half-starved juvenile delinquents who populated the contemporary Sevillian underworld. This relationship was made explicit in the 1690 inventory of Murillo's most important patron, the Antwerp merchant Nicolás de Omazur. (I thank Peter Cherry for informing me of the discovery of this inventory which will shortly be published by Duncan Kinkead.)

It is significant that none of Murillo's fully authenticated genre scenes has remained in Spain: like Velasquez's *Bodegones* they appealed early to foreigners, Flemish merchants resident in Seville and British diplomats. The first Murillos (probably copies) recorded in England were just such genre pictures, and in 1693 John Evelyn described a pair of *"boyes of Morella the Spaniard for 80 ginnies, deare enough"* in Lord Melfort's Whitehall sale. The Dulwich pair were the most celebrated Murillos in nineteenth century England. They provoked Hazlitt's

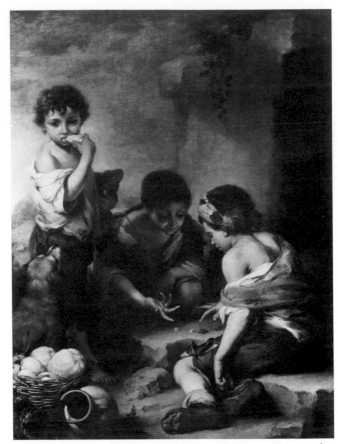

Murillo: *Peasant Boys*, c.1665–70. Canvas. (Bayerische Staatsgemäldesammlungen, Alte Pinakothek, Munich)

admiration and Ruskin's wrath. The former praised their truthfulness and the elevation of a low subject through the subtlety of the artist's observation and the brilliance of his technique, while Ruskin was particularly incensed by the cunning manipulation of the composition in the *Two Peasant Boys* so that the sole of the seated boy's dirty foot is forced on the spectator's attention. For Ruskin these *"repulsive and wicked children"* showed Murillo's *"mere delight in foulness"*.

J.F.

PROVENANCE: Possibly Desenfans Sale, 1786; Insurance List, 1804; Bourgeois Bequest, 1811.

LITERATURE: W. Hazlitt, *Sketches of the Principal Picture Galleries in England* (1824), pp. 44–5; J. Ruskin, *The Stones of Venice* (1853), II, pp. 193–4; C.B. Curtis, *Velasquez and Murillo* (1883), no. 452; A.I. Mayer *Murillo* (1923), p. 213; D.J. Fischer, *Murillo as Genre Painter* (Unpublished M.A. thesis, New York, 1953), résumé in Marsyas, VI (1953), p. 80; H. Söhner, *Spanische Meister* (1963), pp. 117–22; A Gaya Nuño, *L'Opera completa di Murillo* (1978), no. 168; D. Angulo, *Murillo. su vida, su arte, su obra* III vols. (1981), I, p. 449; II, no. 383; A. Braham, *El Greco to Goya* (exhibition catalogue, N.G., London, 1981), no. 45; *Bartolomé Estéban Murillo 1617–1682* (exhibition catalogue, Prado, Madrid, 1982, R.A., London, 1983), no. 68; M. Harazti-Takács, *Spanish Genre Painting in the Seventeenth Century* (1983), p. 182.

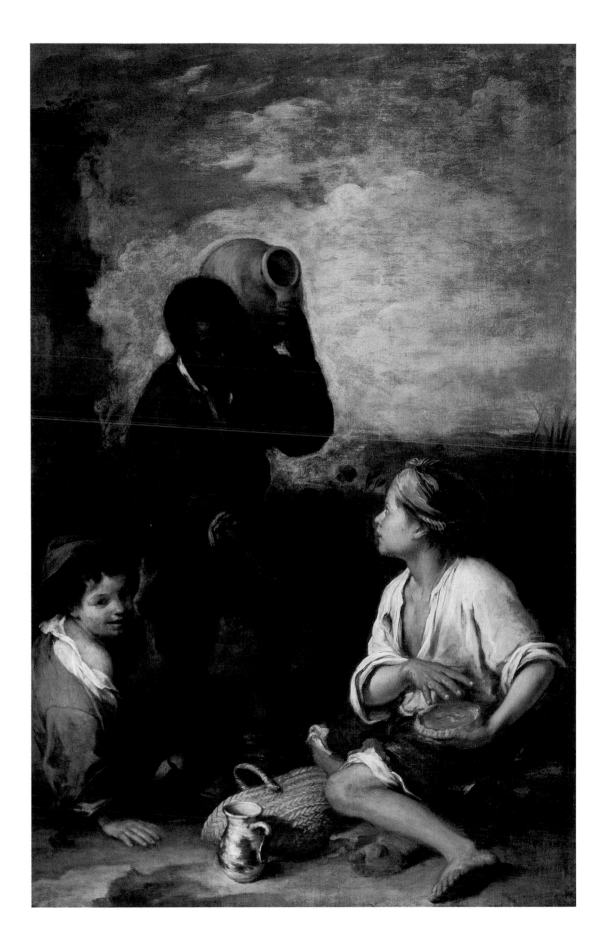

24 Nicolas Poussin

Les Andelys 1594–1665 Rome

Born in Normandy, Poussin moved to Paris in about 1612, studying under various masters. He arrived in Rome in 1624, working in Domenichino's studio and gaining commissions from a small circle of intellectuals. In 1640, he was persuaded to move to Paris to work for the King of France and Cardinal Richelieu, but stayed only two years. He returned to Rome, where he spent the rest of his life. His work was extremely influential, especially in the French Academy.

The Triumph of David

Canvas, 118.4 × 148.3 cm., 46⅝ × 58⅜ in.
Inv. no. 236.

This painting is one of the most reasoned and rigorous of Poussin's early works and one of his first great masterpieces. The scene depicts David with the head of Goliath (I. *Samuel*, XVII 54; XVIII, 6–9). "*And David took the head of the Philistine, and brought it to Jerusalem . . . the women came out of all cities of Israel, singing and dancing, to meet King Saul, with tabrets, with joy, and with instruments of musick. And the women answered one another as they played, and said, Saul hath slain his thousands, and David his ten thousands. And Saul was very wroth . . . And Saul eyed David from that day and forward.*" Saul is sometimes identified as the man on horseback at the right, though this figure would appear to be too young and inconspicuous for the identification to be certain. Even if it is correct, it is noteworthy that he is treated as merely part of the crowd. Poussin seems to be less concerned here with the emotional undercurrents of the biblical scene than with the creation of a triumphal procession in which the victorious David is surrounded and celebrated by actors of all ages and of both sexes, all of them expressing joy or admiration in a manner appropriate to their condition.

Fig. 1. Poussin: X-ray of *The Triumph of David.*

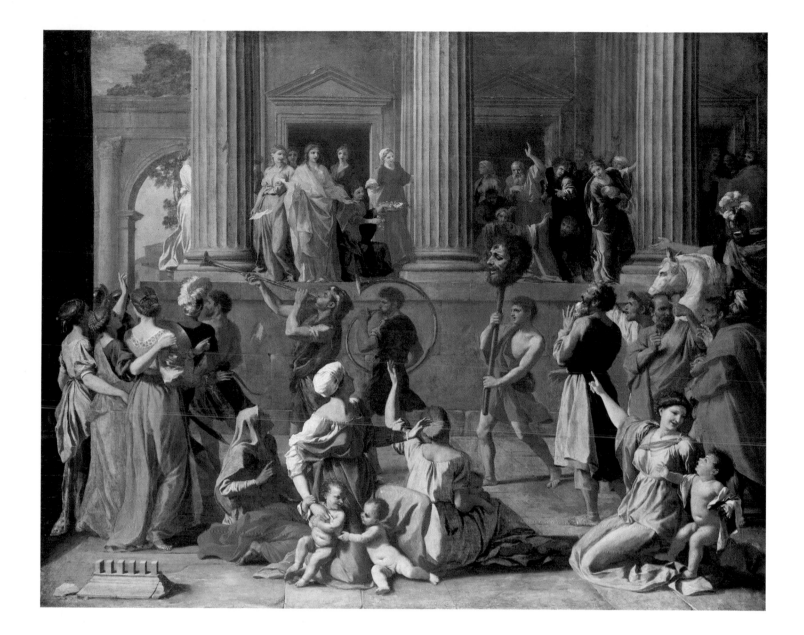

X-rays reveal a number of major changes in the course of composition (fig. 1). The architectural background at the extreme left originally showed a portico with a flat entablature supported by columns at the left and pilasters at the right. The original form of the temple itself is unclear, probably because Poussin scraped away some of the paint in this area. The present double row of fluted columns has replaced an arcade; and the remains of arches or blind niches are still visible between these columns. Numerous changes have been made to the figures standing in the portico, some of which were painted at the same time as the architecture while others were added after the completion of the columns, which now show through them. The group of women in the left foreground was originally painted much further to the right and was moved to open up a space in front of the trumpeter. This transfer was apparently carried out with the aid of a pricked cartoon, parts of which survive on the *verso* of a drawing at Chantilly. This is the only known instance of Poussin's resorting to so mechanical a means of altering a picture.

Two works are commonly cited as sources for Poussin's composition. Both the figure group and the architectural setting are manifestly inspired by an engraving after Giulio Romano's *Triumph of Scipio* of c.1533 (fig. 2). In spirit, however, the picture is more profoundly indebted to the Spartan simplicity and austerely planimetric construction of Domenichino's *Flagellation of St. Andrew* of 1608–09 (San Gregorio al Celio, Rome), a fresco which Poussin is known to have admired (fig. 3). Even in an early work such as the Dulwich picture, however, Poussin may be seen to improve upon his sources. Gone are the clutter and confusion of Giulio's composition and the incohesiveness of Domenichino's. In their place Poussin creates a tautly disciplined and incisively rhythmic design which, in its lucidly articulated space, its crisply chiselled figures, and its emphatic poses and expressions, already looks forward to the severely classical creations of his maturity and possesses a clarity and finality which remain among the chief gratifications of Poussin's art.

In its classicism and maturity the picture is usually thought to date from the early 1630s, at a time when Poussin was forsaking the Venetian ideals of his earliest works and turning instead to an art modelled on that of Raphael and his followers. Such a date – which would place the picture just after the Louvre *Plague at Ashdod* (1630–31) and before the Dresden *Adoration of the Magi* (1633) – is probably correct, though there is some evidence that the gestation of the picture took longer than this and that its earliest stages may go back to the mid-1620s. In addition to the large number of *pentimenti* to be found on the canvas itself, the most important evidence of this is provided by two compositional drawings at Windsor Castle and Chantilly, both of which are for the group of women at the extreme left. The latter of these is in red chalk, a medium rarely used by Poussin, and is thereby difficult to date. But the Windsor drawing, which

Fig. 2. Giorgio Ghisi after Giulio Romano (c.1499–1546): *The Triumph of Scipio*, c.1553. Engraving.

Fig. 3. Domenichino (1581–1641): *The Flagellation of St. Andrew*, 1608–9. Fresco. (San Gregorio al Celio, Rome)

is closer in design to the finished picture, is drawn in a loose and scratchy manner which one associates with Poussin's very early years in Rome, c.1625–26. This suggests that the Dulwich canvas may have its origins much earlier in the artist's career. Although such a view is inconsistent with the quality, mastery, or intricacy of the final composition, it may explain the extensive reworkings the picture underwent. Moreover, it would account for the consciously archaic nature of the design, which owes a debt to an older master (in this case Giulio Romano) and which seems more befitting to Poussin's apprenticeship than to his maturity. However, it is hard to believe that the existing paint surface dates from any earlier than the beginning of the 1630s.

The picture represents one of Poussin's first attempts at a type of composition which is indelibly associated with his name – that of an heroic subject in which a complex and diverse group of self-consciously noble figures

Fig. 4. Poussin: *The Triumph of David*, 1629–30. Canvas.
(Prado, Madrid)

articulate the narrative through a variety of gestures and expressions which must be 'read' by the viewer. Although notionally a scene of triumph, it is significant that Poussin devotes most of his attention (and most of his picture) not to the procession itself but to the onlookers, and thereby converts a scene of pageantry and victory into one of dramatic import. Poses and expressions are varied throughout to encompass a range of responses to David's miraculous feat on the part of a representative group of humanity. Young maidens sing, throw flowers, or raise their arms in decorous expressions of rejoicing or salutation. Aged figures act with greater restraint and express wisdom or wonderment with tense, moderated gestures in which hands now seem to speak rather than to sing. Thus, at the right an elderly man points authoritatively to his forehead, thereby indicating the point at which David aimed his sling and felled the giant Goliath. Children, on the other hand, remain characteristically

indifferent to the momentous events which surround them; and in Poussin's treatment of these alone may be seen the resourcefulness and appropriateness of his pictorial thinking. Infants (upper right) lie nestled in their mother's arms, while slightly older children turn their backs upon the procession either to suck their thumbs or to engage the attention of one another (centre foreground). Those still older recognize and react without, one suspects, fully understanding (bottom right); while grown children, now past the age of innocence, register fear or horror at the sight of the slain giant's head (right middle distance). In the centre foreground many of these ideas are brought together in a masterly group which may be seen to represent the Three Ages of Man and to contain the essence of much of the rest of the picture.

For all its logic and clarity the picture remains a remarkable example of Poussin's powers of invention and pictorial composition. Without disturbing the harmony of

the whole, David is subtly singled out by the spaces opened up to either side of him, by the cold slate blues which frame him, and by being the only figure in the main group who is not significantly overlapped by another. Nor can one fail to notice the ironic contrast which Poussin creates here between David's profile and that of the vanquished Goliath, the one so proud and the other so pained. Interest is sustained throughout the composition by an answering sequence of limbs, poses, and colours which both rivet the attention and ensure the organic coherence of the whole. No detail seems left to chance, no interval unpremeditated. At the upper left a maiden disappears behind a column, her hues and contour echoing those of the background landscape and unobtrusively drawing this passage into the web of relations which bind together the rest of the design. In the centre of the canvas a curved trumpet sets the pattern for the disposition of the main figure group, which itself revolves around this motif in an ever-widening circle. Finally, the fragment of a pilaster which frames the scene at the bottom left repeats in miniature the main axes and rhythms of the temple which forms the backdrop to Poussin's picture. Such a passion for exactitude and for a total integration of the picture space and surface constitutes one of Poussin's chief bequests to more recent artists, who – from David and Ingres to Cézanne and Picasso – have recognized in him one of the supreme masters of formal design.

Another version of the subject, showing David crowned by a winged figure of Victory, is in the Prado, Madrid, and dates from 1629–30 (fig. 4). In its romantic mood and Venetian colouring it contrasts strikingly with the Dulwich canvas and exemplifies a tendency which is often to be found in Poussin: namely, the desire to create two contrasting and complementary versions of the same theme, often in quick succession. It is as though the artist was seeking deliberately here to explore his chosen subject from opposing points of view – one lyrical and the other heroic, one intensely poetical and the other sternly rational. This approach is also apparent in Poussin's treatment of such themes as *The Inspiration of the Poet*, *Tancred and Erminia*, *The Nurture of Jupiter*, and his two painted self-portraits. R.V.

PROVENANCE: Pierre Lebrun, Paris, sold to B. Vandergucht, London, before 1771; 2nd Lord Carysfort by 1776; C.A. Calonne, c.1787; his Sale, Skinner and Dyke, London, 26th March 1795 (92), bt. Desenfans; Bourgeois Bequest, 1811.

LITERATURE: A. Blunt, *Poussin Studies III: The Poussins at Dulwich, Burl. Mag.*, XC (1948), pp. 4f.; S. Rees Jones, *Burl. Mag.*, CII (1960), pp. 304ff.; D. Mahon, *Poussiniana. Afterthoughts arising from the Exhibition, Gaz. des B-Arts*, LX (July–August 1962), pp. 30–36, 38–42, 47, 50, 55, 75, 82f., 86–89, 93, 136; W. Friedländer, *Nicolas Poussin, A New Approach* (1966), p. 31; A. Blunt, *The Paintings of Nicolas Poussin, A Critical Catalogue* (1966), pp. 26f., no. 33; idem, *Nicolas Poussin* (The A.W. Mellon Lectures) (1967), text vol. pp. 59, 70ff., 73, 77, 85, 90, 94, 127, 179; K. Badt, *Die Kunst des Nicolas Poussin* (1969), text vol. pp. 30, 32, 81, 173, 203, 222, 310f., 456, 462, 536, 538f., 614; J. Thuillier, *Tout l'oeuvre peint de Poussin* (1974), p. 115, B26; D. Wild, *Nicolas Poussin, Leben, Werk, Exkurse* (1980), I, pp. 41f., 50f., 185, 191, II, p. 41, no. 41; W. Friedländer and A. Blunt, *The Drawings of Nicolas Poussin* (1939–74), I, pp. 14f. nos. 29–30; V, p. 70; A. Blunt, *The Drawings of Poussin* (1979), pp. 89, 96; *Exposition Nicolas Poussin* (catalogue, Louvre, Paris, 1960), p. 49f., no. 9; *Poussin, Sacraments and Bacchanals* (exhibition catalogue, National Gallery of Scotland, Edinburgh, 1981), p. 31, no. 13.

25 Nicolas Poussin

Rinaldo and Armida

Canvas, 82.2 × 109.2 cm., 32⅜ × 43 in.
Inv. no. 238.

The subject is from Torquato Tasso's epic poem, *Gerusalemme Liberata* (Book XIV), first published in 1581, which tells of the liberation of Jerusalem during the first Crusade. Rinaldo, the Christian hero, has been lulled to sleep by the magic powers of Armida, the Saracen heroine. Just as she is about to kill him, she is overwhelmed by love. This is the scene depicted in the Dulwich picture. Three other canvases by Poussin treat later moments in the story: (1) Armida, captivated by Rinaldo's beauty, prepares to transport him to her palace on the Fortunate Isles (Pushkin Museum, Moscow, c.1635) (fig. 1); (2) Armida and her attendants carry the sleeping warrior to her chariot (East Berlin, c.1637) (fig. 2); and (3) Carlo and Ubaldo, the companions of Rinaldo, encounter a dragon on their way to rescue the Christian knight (Metropolitan Museum of Art, New York, c.1633–35). In addition, a magnificent drawing of the late 1640s in the Louvre depicts Carlo and Ubaldo dragging Rinaldo away from Armida, who falls in a faint. Somewhat surprisingly, Poussin did not treat the most oft-depicted moment from this story, the love scene between Rinaldo and Armida in the enchanted garden, which forms the subject of canvases by Annibale Carracci, Domenichino, Vouet, Van Dyck, Tiepolo, and many others.

The Dulwich picture is among the best preserved and most brilliantly painted of Poussin's early works and would appear to date from 1628–29. Its forceful gestures, robust modelling, and sculpturesque treatment of the figure group are closest in style to the Chantilly *Massacre of the Innocents*, which is also dated to these years and which shares something of the Dulwich picture's arbitrary handling of space. In their vigour and vehemence both works mark a brief phase of baroque classicism in Poussin's art, which finds its fullest expression in the

major commission of these years, the altarpiece of the *Martyrdom of St. Erasmus* for St. Peter's, Rome, completed in 1629 (Vatican, Pinacoteca).

X-rays reveal another composition beneath the present design, which may depict the same or a similar subject. These show a man lying asleep or dying, supported by a putto, while at the right a woman stretches out a hand towards him. Traces of this lower layer of paint may be seen above and below Armida's blue draperies at the left.

The picture is remarkable both for the richness and intensity of its colour and for its poetical rendering of the scene. Armida, whose power and treachery are conveyed by her severe profile, her sweeping gestures, and her billowing draperies, is about to slay Rinaldo when she is suddenly struck by his beauty. Lacking the words which are the poet's natural means of expression, Poussin enlists a number of devices to convey the mixed emotions of this moment and to explain Armida's change of mind. The most obvious of these is the inclusion of a winged putto, which is not included in Tasso's account but is introduced here both to stay the heroine's hand and to indicate the future course of the action. Scarcely less noticeable is the treatment of Armida's arms, her right arm already poised powerfully with the dagger and her left one suddenly caressing its would-be victim. As both of these open out to encompass the figure of Rinaldo, they indicate her dominion over him. Finally, Armida's kindled passion is reflected in the golden glow of the sky. This rises above a hilly landscape painted with an atmospheric subtlety and a liquid freedom which anticipate the *plein air* landscapes of such later French artists as Desportes and even Corot.

Reinforcing the passion and intensity of the scene is the sumptuous colouring, which, in the gleaming highlights of Rinaldo's armour and in his smouldering orange breeches, shows a delight in the sensuous application of paint which makes this one of the most arresting of Poussin's early works.* It is almost as though the artist was here equating lust with lustre; for it is noteworthy that the Chantilly *Massacre*, which contains the same basic hues, possesses none of the blandishments for the eye of the Dulwich picture. Instead, as befits its horrific subject, its colour is itself cold and deathly.

Poussin's attraction to the love story of Rinaldo and Armida may be explained by the symbolic significance which Tasso attached to the events related in his poem. These were intended to be read allegorically and thereby to instruct – rather than merely to delight – the reader. Seen in this way Rinaldo symbolizes the warlike instincts in man which are beneficial if directed by the Understanding but evil if they succumb to Concupiscence (or sexual desire). Although this may account for Poussin's recurring interest in this subject, it is worth noting that the general theme of man's dependence upon (or subservience to) woman is frequently encountered in his earliest works. Often this theme takes a pictorial form not unlike that of the Dulwich picture, with the male figure sleeping, dying, or imploring a female figure who

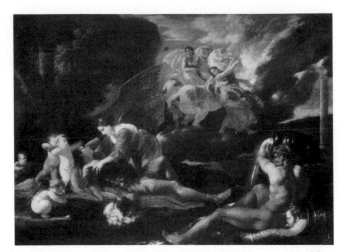

Fig. 1. Poussin: *Rinaldo and Armida*, c.1635. Canvas. (Pushkin Museum, Moscow)

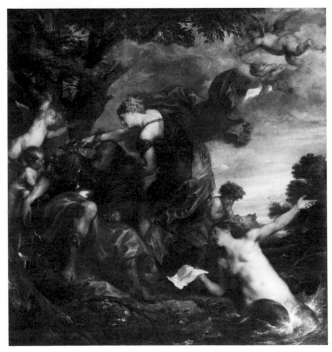

Fig. 3. A. Van Dyck: *Rinaldo and Armida*, 1628–29. Canvas. (The Baltimore Museum of Art; The Jacob Epstein Collection)

expresses power or pity over him. The most obvious examples of this are the *Venus and Adonis* (Musée des Beaux-Arts, Caen), the two versions of *Cephalus and Aurora* (National Gallery, London, and Private Collection, England), the *Diana and Endymion* (Institute of Art, Detroit), and the two canvases depicting *Tancred and Erminia* (Hermitage, Leningrad and Barber Institute of Fine Arts, Birmingham), the last of which represents another episode from Tasso. In all of these pictures Poussin reveals a fondness for psychologically complex themes which mix love or lust with a sharply contrasting

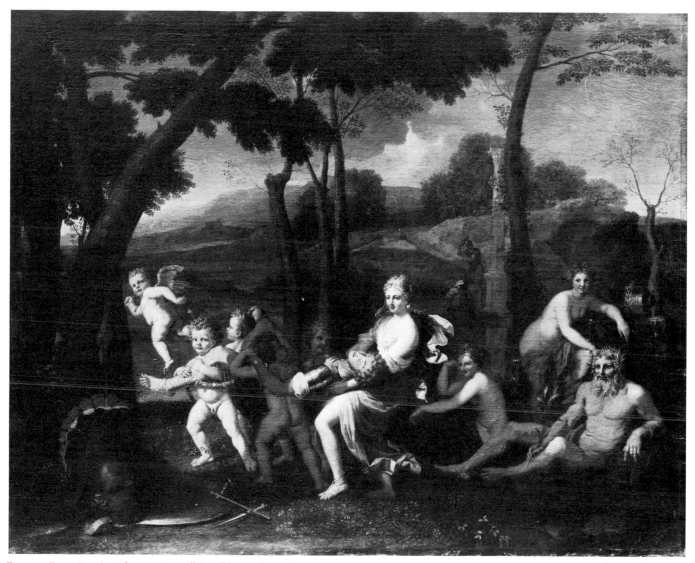

Fig. 2. Poussin: *Armida carrying off Rinaldo*, c.1637. Canvas.
(Staatliche Museen, Gemäldegalerie, East Berlin)

emotion, be it grief, enmity, or honour. Whatever may be
the significance of this it is undeniable that Poussin did not
view the story of Rinaldo and Armida simply as an erotic
tale of abduction, seduction, and separation as many
other artists had done. Rather he saw it as an essentially
human drama and dilemma. This is apparent if one
compares the Dulwich picture with one of the most
celebrated of all treatments of this moment in the story,
Van Dyck's *Rinaldo and Armida* of 1629 in the Baltimore
Museum of Art (fig. 3). While the latter concerns itself
solely with Armida's sudden infatuation with the
handsome warrior, Poussin explores instead her deep –
and divided – emotions. R.V.

*A recently discovered sheet of studies by Poussin after the
Antique includes a drawing of a helmet which is nearly identical
to the one depicted in the Dulwich picture and which is datable
to the mid 1630s. Cf. Anthony Blunt, "Further Newly Identified
Drawings by Poussin and his Followers", *Master Drawings*, XVII,
no. 2, Summer 1979, pp. 136ff. and fig. 15 (upper right).

PROVENANCE: Possibly Anon. Sale, Christie's, London 29th April 1788
(88); Noel Desenfans by 1804; Bourgeois Bequest, 1811.

LITERATURE: A. Blunt, *Poussin Studies III: The Poussins at Dulwich, Burl.
Mag.*, XC (1948), p. 7; *idem., Art and Architecture in France, 1500–1700*
(4th. edn., 1980), p. 277; D. Mahon, *Poussiniana. Afterthoughts arising
from the Exhibition, Gaz. des B-Arts*, LX (July–August 1962), pp. 23–25,
29, 57, 59, 78; W. Friedländer, *Nicolas Poussin, A New Approach*, (1966),
pp. 49f.; A. Blunt, *The Paintings of Nicolas Poussin, A Critical Catalogue*
(1966), p. 140, no. 202; *idem., Nicolas Poussin* (The A.W. Mellon
Lectures) (1967), text vol. pp. 83, 90, 148; K. Badt, *Die Kunst des Nicolas
Poussin*, (1969), text vol. pp. 33, 63, 163, 294–5, 451f., 510; J.
Thuillier, *Tout l'oeuvre peint de Poussin* (1974), p. 87, no. 24; D. Wild,
Nicolas Poussin, Leben Werk, Exkurse (1980), II, p. 236, M43; *Exposition
Nicolas Poussin* (catalogue, Louvre, Paris, 1960), p. 54, no. 14; *Poussin,
Sacraments and Bacchanals* (exhibition catalogue, National Gallery of
Scotland, Edinburgh, 1981), p. 26, no. 8.

26 Rembrandt Van Rijn

Leiden 1606–1669 Amsterdam

Rembrandt van Rijn studied under a Leiden painter, Jacob van Swaneburgh, and later under Pieter Lastman in Amsterdam (c.1624). He returned to Leiden c.1625, to establish his own studio. He moved to Amsterdam c.1631–32, where he remained until his death. During the 1630s his services as a portraitist were in great demand. In 1657 and 1658 he was forced to sell many possessions. He died in poverty in 1669, after the deaths of his mistress, Hendrijke (d.1663) and his son, Titus (d.1668).

Girl leaning on a Stone Pedestal

Canvas, 82.6 × 66 cm., $32\frac{1}{8}$ × 26 in.
Signed and dated: *Rembrandt / ft.* 1645
Inv. no. 163.

The subject has almost invariably been described as a girl either looking out of a window or leaning on a window sill, but this is incorrect. She is resting her elbows on top of a mediaeval stone pedestal, which abuts a wall, open in the centre behind her head and revealing a landscape(?); some foliage is growing on the left of the wall. The remainder of the background is difficult to read. The statement in Bredius-Gerson (*op. cit.*) that the top of the picture was originally straight at the sides with a semi-circular projection in the centre is based on a misreading of the x-rays, although some evidence of cusping may suggest that the top was straight rather than arched (I am grateful to Mr. Robert Bruce-Gardner for his opinion). A green curtain on the right was removed in a restoration of the 1940s. In the lower right are two blocks of stone with the top of a gold object (helmet?) appearing behind. (X-rays show that the former were only added as an afterthought largely covering the latter.) The *mise-en-scène* appears to be an invention of the artist. There are numerous *pentimenti* visible; the outline of her sleeve covering her right upper arm originally extended further, and some material (her chemise?) was originally draped over the stone on the right. The background is very much less finished than the figure and was reworked by the artist. What appears to have been the lower part of a pillar or plinth on the left has been extensively painted over to provide a flatter more neutral background.

A small drawing in black chalk of a girl in a more frontal position with hands clasped, probably done from the life, in the Princes Gate collection, Courtauld Galleries (Benesch no. 889), may have served as a preliminary idea for the Dulwich picture.

The subject of a young female model studied half-length recurs in several pictures by Rembrandt or his circle at this period. In a picture dated 1645, in the Art Institute, Chicago (Bredius-Gerson no. 367, as possibly by a pupil),

Rembrandt: *A Girl*. Chalk. (Princes Gate collection, Courtauld Galleries, London)

a girl stands at a door, while six years later, in the picture in the Nationalmuseum, Stockholm (Bredius-Gerson no. 377), another model is seen leaning on a window sill. (The same girl as the latter, this time holding a broom, recurs in the picture in the National Gallery of Art, Washington, but both the date of 1651 and the attribution have been questioned; Bredius-Gerson no. 378.) Although painted in the same year, it seems unlikely, as claimed by Rosenberg (*op. cit.*) that the model in *Girl leaning on a Stone Pedestal* is the same as that in the Chicago picture. Valentiner's identification (*op. cit.*) of the model in the present picture as Hendrijke Stoffels, remains, despite a general resemblance, speculative. She was first recorded as living in Rembrandt's household in 1649, aged twenty-three. In 1645 she would have been nineteen and would surely have looked older than the girl represented here, although it is perhaps worth noting that the artist was arguably more concerned here with a genre subject than a portrait likeness.

The girl, whose fully modelled figure is forcefully projected from the dark background, is depicted with a touching directness of observation without sentimentality, which clearly appealed to both French and English tastes in the eighteenth century. Santerre's copy inspired

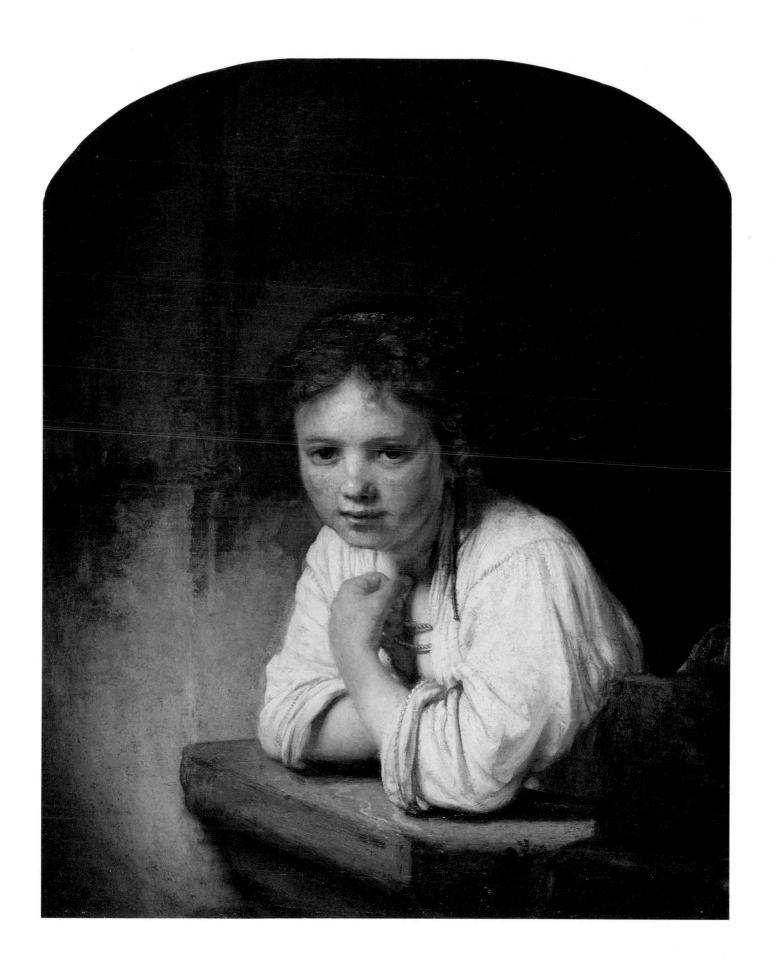

his *Cuisinière*, in the Musée des Beaux-Arts, Bordeaux (Cailleux, *loc. cit.*, fig. 190). Moreover, this copy was itself very popular, and apart from being engraved by Surrugue, was, as M. Claude Lesné kindly informs me, copied at least twice; it is not clear whether a third copy, with the addition of a basket of onions in the lower right, in the Museum at Orléans (1981 cat.) is after Santerre or Rembrandt. Reynolds, who also probably copied the original, produced along with John Opie and Benjamin Wilson variations on the theme (see Yale Center for British Art, New Haven, *Rembrandt in Eighteenth Century England* (1983) p. 23). (Cailleux, *loc. cit.*, records a copy by David Russell on the Paris art market, 1971.) The original stands out as one of Rembrandt's most harmonious compositions, produced during a period in which his work was distinguished by calm and intimacy expressed through a conception of form approaching the classical. C.J.W.

PROVENANCE: First recorded in Desenfans Private Sale, 8th ff. April 1786 (390); his Insurance List, 1804 (88); Bourgeois Bequest, 1811 (engraved in mezzotint by W. Say in 1814).

The earlier history of the picture remains conjectural. It was possibly already in a British collection in 1774 (but see below), when a crayon copy was made by A. Grenville Scott, now in the collection of Lord Polwarth (National Gallery of Scotland, *Rembrandt* (1950) no. 21); another copy traditionally attributed to Sir Joshua Reynolds, probably

executed c.1780, is in the Hermitage, Leningrad (B. Haak, *Rembrandt* (1969) p. 190, fig. 310).

A copy by Jean Santerre, now destroyed but formerly in the Musée Crozatier, Le Puy (Cailleux, *loc. cit.*, fig. 189), strongly suggests that no. 26 was in France earlier in the eighteenth century.

A number of pictures of this subject by or connected with Rembrandt were circulating in France in the eighteenth century. Recently Cailleux (*loc. cit.*) has argued that no. 26 is identical with that in the Angran de Fonspertuis sale, Paris, 4th March 1748 (435), bt. Blondel de Gagny; Blondel de Gagny sale, Paris, 10th December 1776 (70) 81 × 64 cm., arched at the top (MS note in the auctioneer's copy of the sale catalogue that it was bought by Lebrun and immediately sold to an Englishman). Gersaint, who prepared the Fonspertuis sale catalogue, claimed that earlier it had belonged to Roger de Piles and was *La servante de Rembrandt* (later known as *La Crasseuse*), bought by him in Holland and twice praised in his writings (*Cours de Peinture* (Paris, 1708), pp. 10–11) and *Abregé de la Vie des Peintres...*, 2nd ed. (Paris, 1715), p. 423; (see S. Slive, *Rembrandt and his Critics 1630–1730* (1953), pp. 129–30), and that after De Piles's death in 1709, it passed through the collections of Du Vivier, Comte d'Hoym and De Morville. But against Gersaint's account it should be noted that among "Mons de Piles's Sale of Pictures brought over and sold by Geminiani" in London on 29th–30th April 1742 was *Girl leaning out of a Window* by Rembrandt, 2nd day (77), bt. Duke of Bedford (information from Mr. Frank Simpson); this picture, which is clearly a school-piece, remains in the collection at Woburn Abbey (KdK, pl. 322). In the past it has sometimes been assumed that the Blondel de Gagny picture is that bought by Gustavus III of Sweden and now in the Nationalmuseum, Stockholm (Bredius-Gerson no. 377; 78 × 63 cm., not arched at the top).

LITERATURE: Smith VII, no. 178; W. Valentiner, *Rembrandt und seine Umgebung* (1905), pp. 41, 44; HdG VI, no. 327; J. Rosenberg, *Rembrandt* (1964), pp. 89–91; Bredius-Gerson no. 368; J. Cailleux, "*Les artistes français du dix-huitième siècle et Rembrandt*", Etudes d'art français offertes à Charles Sterling (1975), pp. 302–3, no. 18.

27 Rembrandt Van Rijn

Portrait of a Young Man, sometimes identified as the Artist's Son, Titus
Canvas, 78.6 × 64.2 cm., 31 × 25¼ in.
Supposedly signed and dated: *Re... f... 63*
Inv. no. 221.

Nearly half-length, depicted without the lower arms, the young man appears to be standing in front of a row of books, with further books on top of one another in the lower left.

Although accepted as genuine in the earlier part of the nineteenth century, and fancifully identified as a portrait of the painter Philips Wouwermans (born 1624), the painting was downgraded as the work of a pupil or imitator by J.P. Richter, who also remarked that the picture was in poor condition. Reinstated as genuine by Valentiner (before 1916), it was identified as a portrait of Titus. With the exception of W. Martin (see literature below), scholars have subsequently accepted the picture and praised its quality. Whether or not the date of 1663 can be read, the colour harmony, composed of red, brown, gold and black, with the paint applied in broad open strokes, clearly establishes it as a late work executed during this decade.

Whether the sitter is Titus, an identification about which there has been much less unanimity, remains conjectural. The latest accepted portrait of Titus is that in the Louvre, Paris (Bredius-Gerson no. 126), painted c.1660–62, in which the sitter appears more youthful,

with features not compellingly close to those in the Dulwich picture. To represent the same sitter, one would have to suppose that the latter was painted some years later, shortly before his death in 1668.

Unlike his etched portraits in which setting and attributes allowed something of the sitter's status and interests to be perceived, Rembrandt tended in his later painted portraits to concentrate on the figure and especially the face. In this portrait, although some indication of the room and a pile of books can be made out, suggesting a sitter of some education if not learning, it is the face with its haunting introspective gaze which catches the spectator's attention. The simple oval of the face, flanked by parallel tresses of golden curly hair, the diagonal accents of which are picked up in the straight lines of the summarily painted costume, creates a monumental yet intimate image, which emerges from the plain but subtly varied background. The whole area of the canvas is marvellously unified by the balance of sympathetic colours and the use of broad brushstrokes skilfully related to one another. With superb artistry Rembrandt persuades us of a deep empathy between himself and his sitter. C.J.W.

PROVENANCE: Possibly Calonne Sale, Skinner & Dyke, 23rd ff., March 1795, 3rd day (78); Bourgeois Bequest, 1811.

LITERATURE: Smith VII, no. 443(?); HdG VI, no. 705; W.R. Valentiner, *Rembrandt, Wiedergefundene Gemälde* (1921), xxiii and pl. 86; W. Martin, *Kunstwanderer* III (1921–22), p. 34; Bredius-Gerson, no. 289.

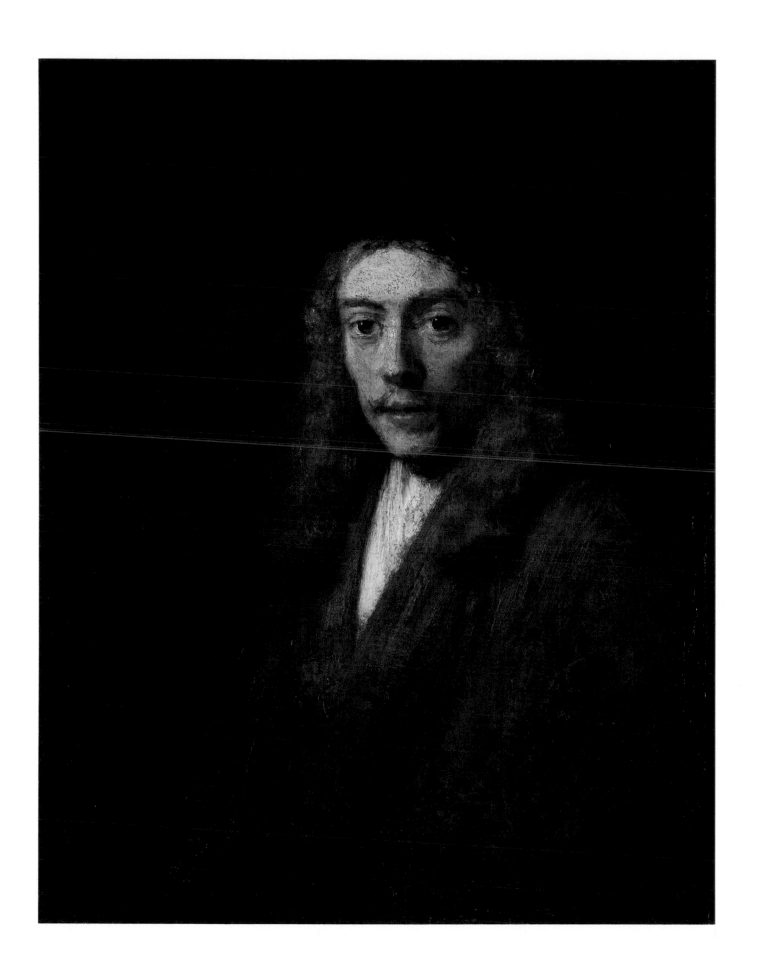

28 Sebastiano Ricci

Belluno 1659–1734 Venice

At the age of twelve, Ricci left Belluno for Venice to study painting. In 1681, he moved to Bologna and then on to Parma, where he entered the service of the Duke, Ranuccio II Farnese, who sent him to study in Rome. The death of Ranuccio in 1694 led him to return to Venice in 1696, where he married the wealthy ex-mistress of his former patron. Commissions were plentiful, and he gained an international reputation. He worked in England between about 1712 and 1716, was made a member of the French Académie in 1716, and spent the rest of his life in Venice.

The Resurrection of Christ

Canvas, 88.7 × 118.7 cm., 34¾ × 46¾ in.
Inv. no. 195.

This sketch for the painting in the apse of the chapel of the Royal Hospital, Chelsea, London, is one of two extant. This one has a strong claim to be the original preparatory study and the recent (1984) publication, in the catalogue of the exhibition *John Wootton, 1682–1764* (Kenwood) of the sale catalogue of Wootton's collection (12th and 13th March 1761), provides important corroborative evidence for this. Lot 32 is *"Seb. Ricci: The Altar Piece at Chelsea Hospital, after"*, which it seems reasonable to identify with the Dulwich sketch. Ricci would almost certainly have sold it (if he did not present it to the patron) before he left England and it is just conceivable that Wootton bought the work from the artist, whose *Last Supper* is lot 111 in the same sale catalogue. The other sketch for the *Resurrection*, which belongs to the South Carolina Museum of Art, Columbia, South Carolina, is probably a copy of the Dulwich picture. Sketches of this sort were intended to give the patron an idea of what he would get for his money. In this case, there are fewer figures than Ricci was eventually to include in the composition, suggesting that the picture is a *modello*, painted before the ceiling was executed. It is fluidly executed in what Horace Walpole described as *"the artist's best manner"*, which in this instance may be taken to mean 'highly finished'; always an argument in Ricci's case for a noble or even royal commission.

The Earl of Manchester arrived in Venice as Ambassador Extraordinary from Queen Anne of England to the Serene Republic. Sebastiano's nephew, Marco, returned to England with Manchester, and Sebastiano who was then working in Venice followed some three years later, arriving in London in the winter of 1711–12. His most important English patrons were Lord Burlington and the Earl of Portland, but the prize at which he aimed, the decoration of the newly-completed dome of St. Paul's Cathedral, was denied him for religious and political reasons, as was the chance to work at Hampton Court

Chapel of Chelsea Hospital, London, showing "The Resurrection of Christ". (Photo: The Royal Commission on the Historical Monuments of England)

Palace. The commission to paint a Resurrection of Christ in the apse of the Chapel of the Royal Hospital, may well have been given to Ricci as some sort of compensation, probably through the influence of the Duke of Shrewsbury, a Catholic and, for almost a year after the death of Queen Anne (at the end of July 1714), one of the most powerful men in the Kingdom. The theme would be entirely appropriate as a commemoration of the last of the Protestant Stuarts – who might reasonably expect to find herself among the saved rather than the damned. It was one that Ricci had already treated at the Church of San Geminiano in the Piazza San Marco, Venice.

The Dulwich picture is a fine example of the Venetian Rococo, of which Sebastiano Ricci was the creator: both in its weaknesses – a tendency to superficiality and theatricality – and in its strengths: elegance, effective use of colour, freedom of handling, and a lively sense of movement. The composition of the painting derives from a number of sources, principally Annibale Carracci's treatment of the same subject which Ricci could have seen during his sojourn in Bologna. Veronese seems to have inspired the *motif* of the angels opening the lid of the tomb, as recounted in the gospel according to St. Matthew, which gives the fullest account of the miraculous event. An unfinished engraving by Simon Gribelin is mentioned by George Vertue, whose description of Ricci as *"a lusty man, inclinable to fat"* has immediacy as well as accuracy.

J.D.

PROVENANCE: Retained by the artist, by whom (?) sold to John Wootton; Wootton Sale (12th and 13th March 1761); Bourgeois Bequest, 1811.

LITERATURE: M. Whinney and O. Millar, *English Art 1625–1714* (1957), p. 301; *English Baroque Sketches* (exhibition catalogue, Marble Hill, London, 1974), no. 73; J. Daniels, *Sebastiano Ricci* (1976), no. 177; idem., *L'Opera completa di Sebastiano Ricci* (1976), no. 328.

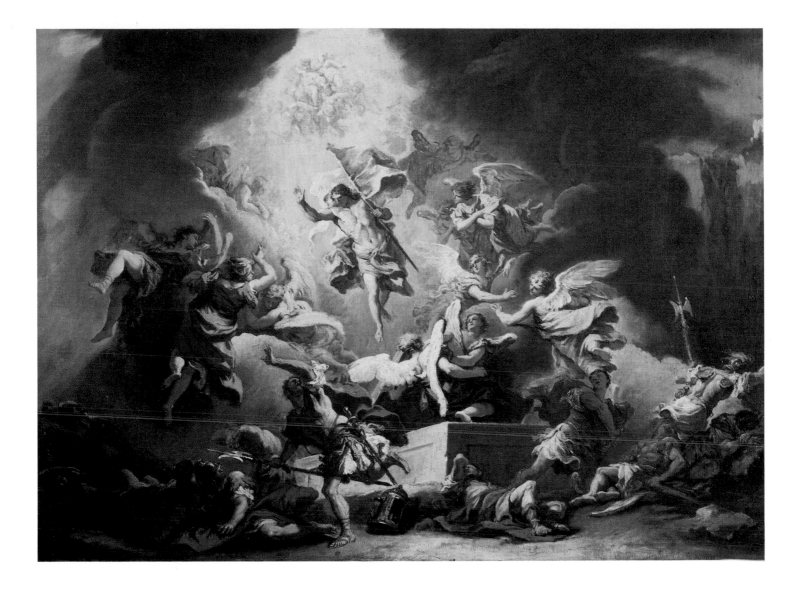

29 David Teniers The Younger

Antwerp 1610–1690 Brussels

Teniers practised as a young man in Antwerp, initially with his namesake father (with whose works his have often been confused) and after 1632 as an independent master. In 1647 he entered the service of the governor of the Spanish Netherlands, the Archduke Leopold Wilhelm, acting as both court painter and custodian of the Archduke's picture gallery. One of his duties was to paint copies of the works in this rapidly expanding and predominantly Italian collection, which were subsequently engraved.

A Winter Scene with a Man about to Kill a Pig

Canvas, 68.9 × 95.7 cm., $27\frac{1}{8}$ × $37\frac{3}{4}$ in.
Signed: DTF in monogram
Inv. no. 112.

This canvas was composed in the visual tradition found in illuminated books of hours and subsequently secularized: that of the seasonal landscape in which figures are engaged in tasks and amusements appropriate to the time of year. Although in this instance no companion pieces are known, similarly conceived works are to be found in sixteenth and seventeenth century series of paintings and prints representing *The Four Seasons* or *The Months*.

Teniers's scene exemplifies a Bruegelian strain in his art, for it is an inventive variant of Pieter Bruegel the Elder's *Hunters in the Snow* (1565), one of a cycle of *The Months*, in the Kunsthistorisches Museum, Vienna. This work must have been known to Teniers, for it was in the collection of his employer, the Governor of the Spanish Netherlands, the Archduke Leopold Wilhelm. Although earlier in his career Teniers had been inspired by the carousing peasant interiors of Adriaen Brouwer, while serving the Archduke and his successor he painted landscapes, kermesse scenes and bucolic idylls, some of which reflect the Bruegel tradition. Furthermore, a personal connection with this most persistent of Flemish schools had been afforded by Teniers's marriage in 1637 with Anna Brueghel, daughter of Jan Brueghel the Elder.

Teniers enlivened his scene of snow and heavy frost with small figures. The two on a path in the foreground carry long poles and appear to be engaged in conversation. Two men play on the ice in the centre of the composition watched by two others, while a couple in what would seem to be pilgrims' cloaks appear to be soliciting alms from a woman at the door of the furthest of the three houses which dominate the left hand side of the composition. Outside the nearest of these houses a pig is about to be slaughtered. The butcher kneels on the flank of the victim and whets his knife while looking up at the aproned woman who holds a pan to receive the blood. Boys with straw faggots for singeing the carcase gather about while the younger children are brought out of the house to witness what was one of the most important annual events in the domestic regimen. The butchering of the household pig had been a conventional motif associated with winter since at least the time of Hans Sebald Beham who had used it in a woodcut to represent December. It is found in works by Hans Bol, Abel Grimmer, Marten de Vos and the Brueghels and their followers. Teniers himself used it in his scene of *Winter*, one of *The Four Seasons*, in the Noord Brabants Museum, 's Hertogenbosch. The meat, puddings, trotters and sausages provided ritual foodstuffs for the festive period from Christmastide until Shrovetide, the imagery of the latter being dominated by pork products. Thereafter the austerity of Lent with its fish diet prevailed. To a seventeenth century viewer Teniers's scene would have signified the festivity as well as the physical discomfort of the pre-Lenten winter period, by its appeal to familiar visual *topoi* and social conventions.

Although perhaps left behind by changing fashions, Teniers continued to paint and to deal in pictures until his death at the age of seventy-nine in 1690. His style and native arcadian imagery enjoyed a revival towards the end of the seventeenth century and well into the next in the fine tapestries of the Brussels weavers, Jérôme Le Clerc and Jacques van der Borcht and their imitators who depicted seasonal scenes, including that of *Winter* with the butchering of the pig. Teniers was a much imitated artist and his reputed oeuvre is diluted by the works of followers.

I.G.

PROVENANCE: Noel Desenfans (Insurance List, 1804, no. 94); Bourgeois Bequest, 1811.

LITERATURE: Smith III, no. 603.

30 Giambattista Tiepolo

Venice 1696–1770 Madrid

Born in 1696, Giambattista Tiepolo studied in Venice where he was influenced by the works of Veronese, the Ricci and Piazzetta. He is chiefly known for his numerous decorative fresco paintings, the majority of which were executed in North Italy. He gained an international reputation, decorating palaces in Würzburg (1750–53), and in Madrid, where he worked from 1762 until his death in 1770. His son Giandomenico was his principal assistant from the 1740s, accompanying his father to Madrid, and working in a similar style after the father's death.

Joseph receiving Pharaoh's Ring

Canvas, 106.1 × 178 cm., 41¾ × 70¼ in.
Inv. no. 158.

The subject is from *Genesis*, XLI: *"And Pharaoh said unto Joseph, See, I have set thee over all the land of Egypt. And Pharaoh took off his ring from his hand. . ."*.

The subject is an extremely uncommon one for paintings of any period. Joseph is a traditional Old Testament prefigurement of Christ, and the painting may have had connotations for the original patron. Nothing is known about the circumstances of its commissioning; there are no early records of it, and it is not clear if it was, as seems more likely, for a private destination rather than a church. The attribution to Giambattista Tiepolo was accepted until Richter in 1880 gave it to Domenico. Morassi re-attributed it to Giambattista in 1955 and dated it to c.1734–36. There can be no doubt that this is the correct attribution, and the painting must date from approximately the mid-1730s, shortly before or after the Villa Loschi frescoes of 1734. In that connection it seems significant that the unusual crested helmet of the standard bearer between Pharaoh and Joseph is exactly the same as that worn by the personification of Valour in the Villa Loschi series (fig. 1).

Also previously unremarked are the features of the more distant of the two trumpeters, at the right of the painting (fig. 2). Comparison of those with a similar face often appearing in Tiepolo's work (e.g. Apelles in *Apelles painting Campaspe*, Museum of Fine Arts, Montreal) confirms that the trumpeter is a self-portrait. Tiepolo's appearance accords well enough with a date in the mid-thirties.

Handling of the paint is typical of Tiepolo's oil painting at this period, as is also the brilliant colour. For both handling and colour, analogies can be found in the large-scale *Finding of Moses* (National Gallery of Scotland, Edinburgh), executed probably early in the decade of 1730. Traces of Tiepolo's debt to Piazzetta can be detected in parts of the present painting – in, for example, Pharaoh's hand holding the ring – which indicate a fairly

Fig. 1. G.B. Tiepolo: *Detail of fresco at Villa Loschi, showing Helmet worn by Valour*, 1734.

Fig. 2. G.B. Tiepolo: *Detail of Trumpeter from "Joseph receiving Pharaoh's Ring"*.

early period. Morassi's dating may reasonably be refined, to suggest a slightly earlier bracket, of 1733–34, for the execution. Knox cites a related drawing, a head of a soldier and two others, the style of which, he states, suggests a date c.1744.

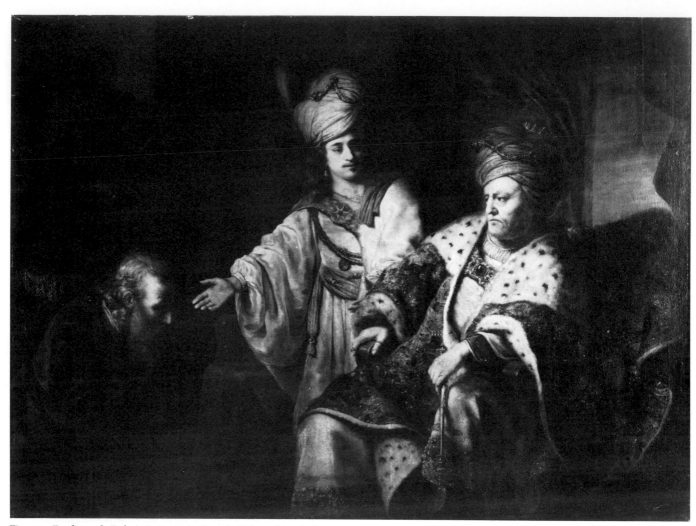

Fig. 3. Ferdinand Bol (1618–80): *Joseph brings his Father before Pharaoh*. Canvas. (Staatliche Kunstsammlungen, Dresden)

Pharaoh's costume, especially his turban and crown, and indeed the whole horizontal format of the composition, suggest some awareness, perhaps through engravings, of Dutch seventeenth century treatments of similar Biblical subjects in the circle of Rembrandt. Worth citing in this context is Bol's painting, *Joseph brings his father before Pharaoh* (Staatliche Kunstsammlungen, Dresden) (fig. 3).

Nothing is known of the present painting's provenance before it appears as part of the Bourgeois Bequest in 1811. However, the correspondence of John Strange, English Resident at Venice from 1773 to 1788, with G.M. Sasso, records Strange's offer (in a letter of 25th October 1790) to buy a Tiepolo *"Giuseppe"*, see Haskell, *op. cit.*, below. Since Tiepolo seems not otherwise or elsewhere to be mentioned in connection with the subject of Joseph, and bearing in mind the English provenance, it is tempting to

think that Strange's reference is to this painting. No reference to it occurs in any of the Strange sales, but he might have disposed of it privately, always assuming that he had eventually acquired it.

M.L.

PROVENANCE: Bourgeois Bequest, 1811.

LITERATURE: A. Morassi, *Burl. Mag.*, XCVII (1955), p. 11; *idem., Complete Catalogue of . . . Tiepolo* (1962), 17; G. Piovene and A. Palluchini, *L'opera completa di . . . Tiepolo* (1968), no. 107; G. Knox, *Giambattista and Domenico Tiepolo: . . . the Chalk Drawings* (1980), M. 222; F. Haskell in *J. of W.C.I.*, XXIII, p. 268, note 55.

Glory and Virtù celebrated by Fame
Canvas, 64.2 × 35.6 cm., 25½ × 14 in.
Inv. no. 278.

Glory embraces Virtù in the centre, with Fame below right. At the bottom of the composition, Ignorance (or Envy) is vanquished.

The painting, enhanced by recent cleaning, is a brilliant preparatory sketch, and probably the original *modello*, for Tiepolo's ceiling in the Villa Cordellina at Montecchio Maggiore, near Vicenza (fig. 3). He frescoed the ground floor salone there; apart from the ceiling (considerably damaged), the main frescoes are the two lateral scenes of *The Continence of Scipio* and *The Family of Darius before Alexander*. The villa (fig. 1) was begun in 1735, on designs attributed to Massari, for the lawyer Carlo Cordellina (1703–1794), who commissioned Tiepolo's frescoes. The date of the ceiling fresco is established by a letter from Tiepolo to Algarotti, of 26th October 1743, which speaks of his having completed about half of it and his hopes of finishing it by 10th or 12th November. There is no mention of the lateral frescoes, which would inevitably be executed after the ceiling and which probably date from the subsequent year.

The two central figures of the ceiling and the related sketch have been variously identified, frequently as "Fortitude and Wisdom". Much closer to the real theme and subject is the identification of them as "Nobility and Virtù" (or "The Triumph of Nobility and Virtù over Error"), though even that seems not precisely correct.

Tiepolo almost certainly based his figures on personifications in Ripa's *Iconologia* (fig. 2). Ripa describes Virtù as winged, holding a spear in one hand and a wreath of laurel in the other, and with the sun on her breast. Such a figure occurs frequently in Tiepolo's ceilings, and also in a drawing inscribed by him as Virtù (at Trieste; see the catalogue by A. Rizzi, *Disegni del Tiepolo*, Udine, 1965, no. 28), and though the spear is missing here (and also the sun), the winged figure does hold a wreath and seems most likely to represent Virtù. The figure in yellow, holding up a statuette, seems better identified as Glory rather than as Nobility. Both are described as holding statuettes (Nobility's being of Minerva) but Ripa distinguishes between them partly through costume: Nobility is soberly dressed, while Glory displays her breasts and is richly clad, "*vestita d'oro*". These references fit well with the figure in the present sketch. Tiepolo's unequivocal depiction of Nobility, inscribed as such, is the monochrome figure at the Villa Loschi, shown in a dress high-necked and sober, and holding a spear, as specified by Ripa for Nobility but not for Glory. Few major changes were made between *modello* and ceiling. Fame occupies a lower place in the ceiling composition, and several putti have been added. In the fresco the vanquished figure is accompanied by a bat and poppies(?), signifying Night and

Fig. 1. *The Exterior, Villa Cordellina, Montecchio Maggiore.*

Fig. 2. *Figure of Virtù from Ripa's "Iconologia",* publ. 1611. Woodcut.

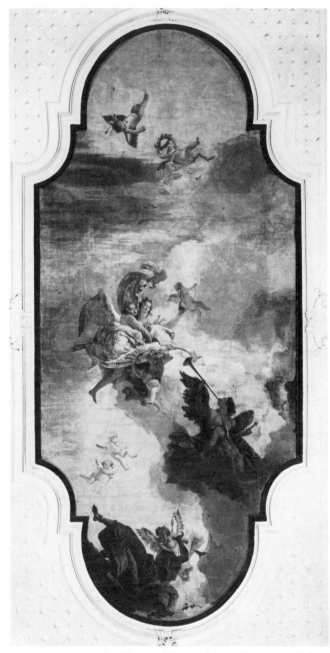

Fig. 3. G.B. Tiepolo: *Glory and Virtù celebrated by Fame*. Ceiling fresco, Villa Cordellina, Montecchio Maggiore.

central figures, is a popular one in Tiepolo's ceilings and related sketches. With variations, he used it in the Palazzo Barbarigo, Venice (now in the Ca' Rezzonico there), in the Palazzo Gallarati-Scotti, Milan, and also for a ceiling in the Palazzo Caiselli, Udine (now in the Museo Civico there). To establish the order of priority among these is not easy, though the Palazzo Barbarigo ceiling is apparently documented as of 1744–45. It can be only a hypothesis, though stylistically it makes good sense, that the composition originated with the commission for the Villa Cordellina ceiling, and that the present sketch is Tiepolo's earliest treatment of the subject. The sketch may have preceded execution of the fresco by several months, or even longer. A dating around 1742 would seem reasonable. Morassi, calling it an Allegory of Fortitude and Wisdom, dated it 1743.

The sequence of the various ceilings, with loosely related drawings, has been discussed by Knox, who prefers to identify the figure here called Glory as Nobility.

M.L.

therefore Ignorance.

The theme of the ceiling refers to the pattern of behaviour exemplified by two famous heroes of antiquity – Scipio and Alexander – in the incidents frescoed below. Their glory lies less in their military prowess than in their virtue: that is what Fame celebrates. They are thus examples of the good life, of continence and magnanimity, and a lesson to the spectator. The general composition of the present sketch, especially as it concerns the two

PROVENANCE: Bourgeois Bequest, 1811.

LITERATURE: A. Mariuz in *Gli Affreschi nelle Ville Venete*, (1978), I, pp. 197–9; Morassi, *op. cit.* (1962), p. 17; G. Knox, *Museum Studies*, 9, Art Institute of Chicago (1978), pp. 78–81.

32 Willem Van De Velde the Younger

Leiden 1633–1707 London

Willem Van de Velde the Younger studied under his father, a marine painter and draughtsman and under Simon de Vlieger. Van de Velde the Younger moved to Amsterdam by 1652, and specialized in seascapes. Following the invasion of Holland in 1671, he and his father emigrated to England. They were taken into the service of King Charles II in 1674, the father being employed to make the initial sketches, the son to execute these in oils.

A kaag and a smalschip with other vessels in a breeze

Canvas, 52.1 × 65 cm., 20½ × 25⅝ in.
Signed, lower right: W.V.V.
Inv. no. 103.

Van de Velde the Younger, like his father before him, devoted his life to the depiction of shipping and craft. He received numerous commissions from the Dutch admiralty and, later, from the English monarch Charles II. His calm estuary scenes were popular with English gentlemen on the Grand Tour, while his sparkling seascapes and coast scenes were greatly admired by the artists of the Romantic movement.

This lively picture of shipping on the Dutch coast is characteristic of the latter type. Here, as with so many Dutch paintings of the seventeenth century, the artist opens a window onto nature. The boats are beautifully rendered, and the clouds and waves accurately observed; yet the fresh and apparently artless depiction of a typical Dutch scene disguises the subtle methods employed by Van de Velde to create a balanced and harmonious composition. Alternate bands of shadow and sunlight across the surface of the water break the monotony of the sea and focus the eye on particular ships. Masts and spars are cunningly disposed to create vertical and horizontal accents. Some sails are darker than the sky beyond, others gleam in the sunlight, and by his disposition of these strong shapes, together with the massing of the clouds, Van de Velde produces an overall design which is full of interest and yet as satisfying in its own way as an ideal landscape by Claude.

The sailing vessels in the foreground are typical of the working craft to be found on the Dutch coast in the mid-seventeenth century. In the left foreground is a *kaag*, a sturdy vessel used for carrying general cargoes. Her crew are spilling the wind from the sprit-rigged mainsail, and lowering the foresail. To the left is a *hoeker*, a common type of fishing vessel. In the centre of the picture is a *smalschip*. She has her spritsail half lowered and is towing a small boat. In the distance are several warships, heeling under the stiff breeze.

Michael Robinson considers the picture to be a work of the early 1660s. At this period Van de Velde was still working in Amsterdam with his father, and was producing the finest of his calms and estuary scenes. He had assimilated the teaching of his master Simon de Vlieger, had learnt from Van de Cappelle, but had developed his own characteristic approach to the sea-scape, which combined a sensitive observation of nature with meticulously accurate drawing of shipping.

G.F. Waagen saw this painting in 1850 and was lavish in his praise. "*A warm evening light, happily blended with the delicate silver tone of the master, and the most exquisite finish of all the parts, make one of his most charming pictures.*" The painting was given the title *A View of the Texel* by John Smith in 1835, but the location cannot be identified with certainty because there are no visible landmarks. The 1980 Dulwich Catalogue entitles the work *A brisk breeze*, but Michael Robinson's more descriptive title *A kaag, and a smalschip with other vessels in a breeze* is to be preferred.

D.C.

PROVENANCE: Bourgeois Bequest, 1811.

LITERATURE: Smith VI, no. 40; Waagen II, p. 345; HdG VII, no. 493; M. Robinson, Unpublished cat. raisonné. no. 103.

33 Claude-Joseph Vernet
Avignon 1714–1789 Paris

Claude-Joseph Vernet trained under local Provençal artists before moving to Rome in 1734 to draw antiquities and study the Old Masters. His studio in Rome attracted artists and art collectors of all nationalities, and his own works were much imitated. He returned to France in 1753, and worked on a major series of paintings, *The Ports of France*, commissioned by Louis XV. He died in his studio in the Louvre.

Italian Landscape
Canvas, 123.8 × 174 cm., 48¾ × 68½ in.
Signed and dated, *Fait à Rome par J Vernet 1738*
Inv. no. 328.

The Dulwich picture is one of the earliest dated landscapes known from Vernet's hand. While in Rome, Vernet, although he had not undergone the official training of the Royal Academy of Painting and Sculpture in Paris, was offered the working facilities of its branch in Rome. Mariette informs us that he preferred the less formal activity of studying landscape from nature, and to this end he explored Rome and its surrounding countryside. This assiduous study of nature laid the basis for his reputation among contemporaries as a painter of landscapes more 'natural' in their observation of colour, light, atmosphere and terrain than the artificial and decorative landscapes of contemporaries such as François Boucher or Domenchin de Chavannes.

In Rome and Naples Vernet soon established a reputation as a painter of landscapes and coastal scenes, attracting commissions from Italians and from French and British visitors to Italy. He was in demand both for topographical works and for imaginative evocations of the Italian coasts or popular sites of scenic grandeur and beauty such as the Roman Campagna and Tivoli, celebrated by landscape painters since early in the previous century. In Italy Vernet was well placed to study the landscapes and coast scenes of his eminent seventeenth-century predecessors, Claude Lorrain, Gaspard Dughet and Salvator Rosa. The grander, more monumental landscapes of the last two artists could have formed starting points for the Dulwich *Italian Landscape*, which also shows the benefits of Vernet's study of nature's effects.

As demand for his works grew, he began in the early 1740s keeping fairly regular account books, and we can often identify the patrons of particular works. This is not the case with the present picture. It is not recorded until 1795, in the sale of the collection of Charles Alexandre de Calonne (1734–1802). Calonne would have purchased it late in the century in Paris or in London, where he went into exile in 1787.

Vernet's early works – those executed during his Italian period between 1734 and 1753 – were especially sought after by later eighteenth century collectors, and the Dulwich picture is a fine example of the type. Towards the end of his career, critical opinion was that Vernet's works painted before his return to France in 1753 were more attractively broad and supple in handling.

The remarkable Dulwich landscape hardly conforms to our conventional ideas of French (or Italian) painting around 1740. Indeed in its darkness, grandeur, and essentially tonal effects it is unusual in Vernet's works as at present known. When put up for auction in 1795, it reminded the author of the sale catalogue of the type of mountainous sites which inspired Salvator Rosa (*"It is evident that Vernet has imitated the style of Salvator Rosa"*) – and with some reason, not only because of the type of site and predominant brown tonality, but also because we know that at least by the 1740s Vernet was indeed receiving specific commissions for landscapes in the manner of the seventeenth century artist. The small classical temple on the cliff-top, similar to the famous round temple at Tivoli, led the 1795 cataloguer to identify the site as *"near Tivoli"*. But really this feature (which appears more prominently, for example, in the 1746 *Coast Scene with the Temple of Vesta, Tivoli* in the Minneapolis Institute of Arts) is employed in this landscape in a general associative way to evoke some remote ancient religion, while the fortified tower reminds us of the warring lords of mediaeval Italy. The physical grandeur of the place is underlined by the presence of the tiny figures going about mundane business – a laden ox-cart labouring up the slope, foot-travellers resting by the road with their loads, and other little figures clambering over the rocks to appreciate the view or peer down into the awesome gulleys. The figures are deliberately small in scale to impress upon us the sublime vastness of nature.

It is a wonderfully sustained and still fresh piece of painting – bold in design, and with a range of handling from the solidly modelled figures, to the fluid and varied treatment of the rocky crags to the left, the thinly scumbled clouds of an approaching storm, and a softer impasto for the misty distance of evening as it falls on a far town to the right.

P.C.

PROVENANCE: C.A. de Calonne; his Sale, 23rd ff. March 1795, no. 72 of the fourth day's Sale; bt. privately by Desenfans; Bourgeois Bequest, 1811.

LITERATURE: F. Ingersoll-Smouse, *Joseph Vernet: peintre de marine* (1926), I, 1973, p. 69, no. 466; P. Conisbee, *Burl. Mag.*, CXV (1973), p. 789ff; P. Conisbee, *Claude-Joseph Vernet* (exhibition catalogue, The Iveagh Bequest, Kenwood, London, 1976, & Musée de la Marine, Paris, 1976–77), no. 4.

34 Jan Weenix

Amsterdam c.1642–1719 Amsterdam

Jan Weenix studied under his father, Jan Baptist Weenix. Between 1702–10, he was court painter to the Elector Palatine Johann Wilhelm, for whom he executed a series of large still life paintings. He is best known for such large, but extremely detailed, still lifes, which often include dead game and particularly, dead hares.

Landscape with a Shepherd Boy

Canvas, 81.6 × 99.6 cm., 32⅛ × 39¼ in.
Signed and dated: J. Weenix 1664
Inv. no. 47.

Some of Jan Weenix's early works are so closely related to the Italianate landscapes of his father, Jan Baptist, that confusions of attribution have arisen. The present work is dated 1664, four years after the death of the elder Weenix, so that it is one of a small number of pieces by which the son's exercises in this genre can be defined. It was executed in the year that the artist entered the Utrecht guild of painters, though he was subsequently to move to Amsterdam.

Behind the boy, an object that appears to be a tilted sarcophagus lies beneath a ruined and overgrown structure. The single visible sunlit column would seem to be derived from the Temple of Vespasian, a Roman ruin which the elder Weenix had incorporated into a number of his compositions, such as those in the Cleveland Museum of Art and Schloss Wilhelmshöhe, Kassel. The younger Weenix is not known to have travelled to Italy and probably depended on the Italianate compositions made by his father, who had worked in Rome in the mid-1640s. In the middle and background of the canvas, travellers can be seen approaching and crossing a ford in the river, which flows through a mountainous landscape on the right.

Stechow described this canvas as *"A brilliant 'calligraphic' piece"* – an epithet which characterizes the artist's breadth and freedom in handling paint. The highlights on the boy's shirt and on the sheep's forelegs are displays of painterly fluidity, while long, sweeping strokes are employed to depict the middle ground schematically. Remains of black blocking strokes for the attendant dog are clearly visible to the left of the animal's final position, whilst its head is clearly painted over the boy's arm. This early sketch-like brilliance – the younger Weenix's career probably began in about 1660 – developed into the elegant and mannered style which he employed in the fantastic Italianate coastal scenes painted throughout his life. His fame, however, was principally spread by his smoothly executed hunting still lifes in parkland settings, often with classical remains. These works brought him to the attention of princes, such as the Elector Palatine Johann Wilhelm.

Compositionally this work is related to paintings by the

Weenix: *Sleeping Girl*, 1665. Canvas. (Bayerischen Staatsgemäldesammlungen, Munich)

elder Weenix, such as the *Shepherd Boy* of 1656 in the collection of Lord Allendale. The younger Weenix's *Sleeping Girl* (fig. 1) of 1665 in Munich is similarly conceived. The imagery of this latter panel has been cogently interpreted by Christine Skeeles Schloss as an allegory of sloth, so the possibility exists that the present canvas has allusive connotations. Images of removing fleas from dogs' fur have been related to the Dutch colloquialism 'to de-flea a dog', meaning to waste time. Yet to interpret this shepherd boy as an exemplar of idleness would seem perverse: his sheep do not stray and care of his dogs might be thought of as a duty appropriate to his station.

I.G.

PROVENANCE: Noel Desenfans (Insurance List, 1804, no. 79); Bourgeois Bequest, 1811.

LITERATURE: W. Stechow, *"Jan Baptist Weenix"*, Art Quart., XI (1948), pp. 195–6; Bernt, III, p. 136 and pl. 1376.

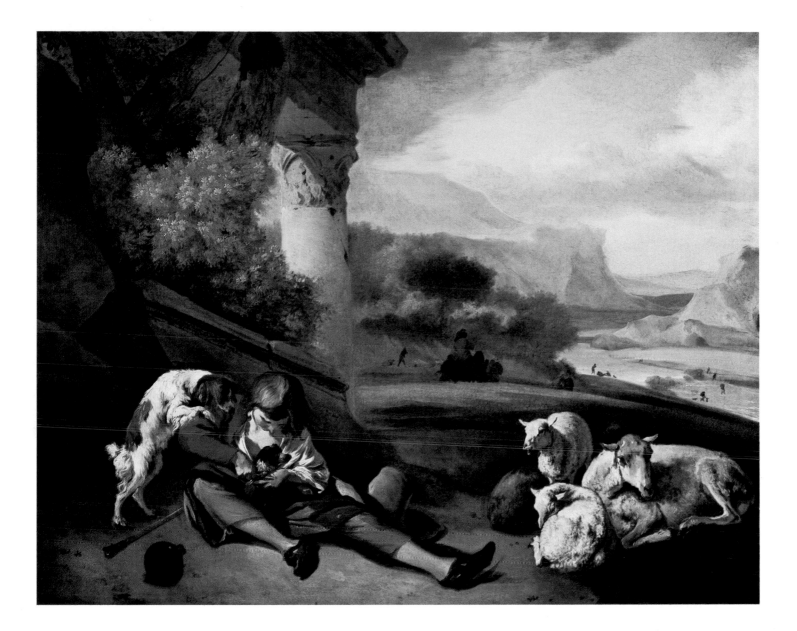

35 Jan Wijnants

Haarlem c.1627–1684 Amsterdam

Little is known about Wijnants' life. His date of birth has not been discovered, nor the identity of his master. He was a native of Haarlem and his early work – there are dated paintings from 1643 – shows the strong influence of the great Haarlem landscape painter, Jacob van Ruisdael. Wijnants moved, however, towards a lighter palette and more detailed, descriptive technique. The motifs of a felled tree, and a road winding into the distance, often occur in his landscapes. In 1660 Wijnants is recorded for the first time in Amsterdam, where he lived and worked for the rest of his life.

A Wood near The Hague, with a view of the Huis ten Bosch

Canvas, 118.7 × 154.9 cm., 46¾ × 61 in.
Inv. no. 210.

This painting entered the Dulwich collection as by Jacob van Ruisdael, but as early as 1835 John Smith attributed it to Jan Wijnants. In the 1880 Dulwich catalogue it was said to bear Jacob van Ruisdael's monogram, but this cannot now be seen. Although the painting is on an unusually large scale for Wijnants, the attribution to him is now generally accepted; Gerson suggested it was painted in collaboration with Jan van Kessel. Smith thought that the figures were by Adriaen van de Velde, and Hofstede de Groot that they were by Jan Lingelbach. The figures in Wijnants' paintings are often by other hands, notably Adriaen van de Velde (who according to Houbraken was his pupil), Jan Lingelbach and Dirck Wijntrack. The present writer considers that this painting is in its entirety the work of Wijnants and that it should be dated to the second half of the 1650s, that is, soon after the completion of the Huis ten Bosch.

The Huis ten Bosch, the 'House in the Wood', stands about a mile and a half east of The Hague. It is a small summer palace built between 1645 and 1652 for Amalia van Solms, the wife of the Stadholder, Prince Frederik Henry of Orange, to the designs of the Dutch classical architect, Pieter Post. After Frederik Henry's death in 1652, Amalia transformed the just-completed Huis ten Bosch into a mausoleum for her husband. The principal room, the *Oranjezaal*, was decorated with huge allegorical representations of the Prince's career by a team of artists led by Jacob Jordaens from Antwerp.

Of the remarkable campaign of palace-building undertaken during the Stadholdership of Frederik Henry, only the Huis ten Bosch survives today. The larger palaces of Rijswijck and Honselaersdijk were both demolished in the nineteenth century.

C.B.

Jan van der Heyden (1637–1712): *The Huis ten Bosch at the Hague*, c.1670. Canvas. (National Gallery, London)

PROVENANCE: Bourgeois Bequest, 1811.

LITERATURE: Smith VI, no. 168 (as Wijnants); HdG IV, no. 761 (as Ruisdael); H. Gerson in *Burl. Mag.* XCV (1953), pp. 34, 51, note 17.

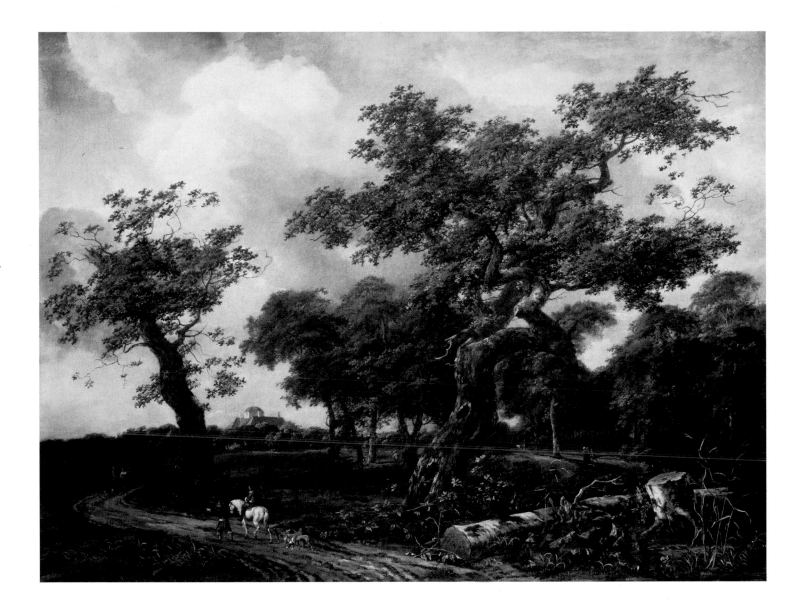

36 Richard Wilson

Penegoes 1713/14–1782 Colommendy

Born in Wales, the son of a clergyman, Wilson moved to London in 1729 and worked as a portraitist. From 1750, he was in Italy, principally in Rome where he took up landscape painting. Returning to England in 1756/57, he at first established a successful practice as a landscape painter, but in later life received fewer commissions. He was a founder member of the Royal Academy. His works exerted considerable influence on early nineteenth-century British landscape painters.

Tivoli, the Cascatelle and the 'Villa of Maecenas'

Canvas, 77.3 × 97.2 cm., 28⅞ × 38¼ in.
Inv. no. 171

Another version of this painting, close but not identical, is in the National Gallery of Ireland and according to an inscription on the back was painted in 1752. The Dulwich picture is accepted by W.G. Constable as dating from Wilson's Italian period and if it does belong to the same year as the Dublin picture, represents one of the artist's earliest Italian landscapes. The differences between the two versions are typical of the variations that Wilson made when depicting his favourite subjects: the Dublin painting has only one foreground figure, the foreground itself is less pronounced, without the bank of earth, and the plain in the far distance is more open to view.

Wilson executed this painting when he was exploring the landscape of the Roman Campagna and the reactions to it of earlier artists, in particular the two masters of classical landscape, Claude Lorrain and Gaspard Poussin. His approach to the subject is influenced by Claude's concept of the landscape seen between *repoussoirs* on either side of the composition, and by Gaspard's creation of an effect of perspective through receding planes. But though he was studying a popular subject Wilson's view of it was based on personal observation: his pupil Joseph Farington recorded in his Biographical Note on Wilson the long visits that his master made to the countryside to draw, just as Claude had done before him.

The subject of the painting was a favourite one for artists in the seventeenth and eighteenth centuries. The famous Cascatelle is seen on the left, with the town of Tivoli above it. Tivoli was associated in ancient times with the great artistic patron Maecenas, and the building in ruins below the town was considered to be his villa, though it is now recognized as the remains of the Sanctuary of Hercules Victor. Such views of famous subjects had been painted for visiting Northerners throughout the seventeenth century, and Wilson was following an old tradition in working for the Grand Tourist. His approach, with the use of rather Venetian colouring and summary brushwork, does not resemble the work of his more topographically painstaking predecessors. The inclusion of an artist in the painting –

supposed by Farington to be Wilson himself – need not be taken to mean that the work was executed out of doors.

Wilson did not sustain his reputation throughout his life, but after his death his fame rose steadily as his ability to revitalise the classical tradition of landscape came to be appreciated. The reactions of the founders of the Dulwich collection are typical of their period, as recorded by Farington in his Diary of 17th January 1799: "*Wilsons pictures mentioned. Bourgeois and Desenfans acknowledged that some years ago they did not like them, from the execution being so slovenly compared with Loutherbourg &c, but now delight in them.*" Bourgeois recorded his desire for his own works to imitate the "forms and grandeur" of Wilson, and it is fitting that the artist should be one of the very few British landscape painters in the Bourgeois collection. The painting had previously belonged, according to Farington, to "Dr. Monro" – either Dr. John Monro, an authority on the treatment of insanity, or his son Dr. Thomas Monro, the patron of Turner.

A drawing, possibly for this picture, is recorded in Ackermann's Repository of Arts "Series II vol. XIII" as being on exhibition: "*that of Tivoli, as it deviates from the picture in the Dulwich Gallery, is curious, as exhibiting the changes made for the sake of composition*". This drawing does not appear to survive.

G.W.

PROVENANCE: Dr. Monro, perhaps 1796; Mr. Norris of Manchester; his Sale, Wright, Liverpool, 14th March 1804 (49); presumably Hill; Desenfans before 1807; Bourgeois Bequest, 1811.

LITERATURE: J. Farington, *Diary*, 3rd May 1809; W.G. Constable, *Wilson* (1953), pp. 82, 225, pl. 117a.

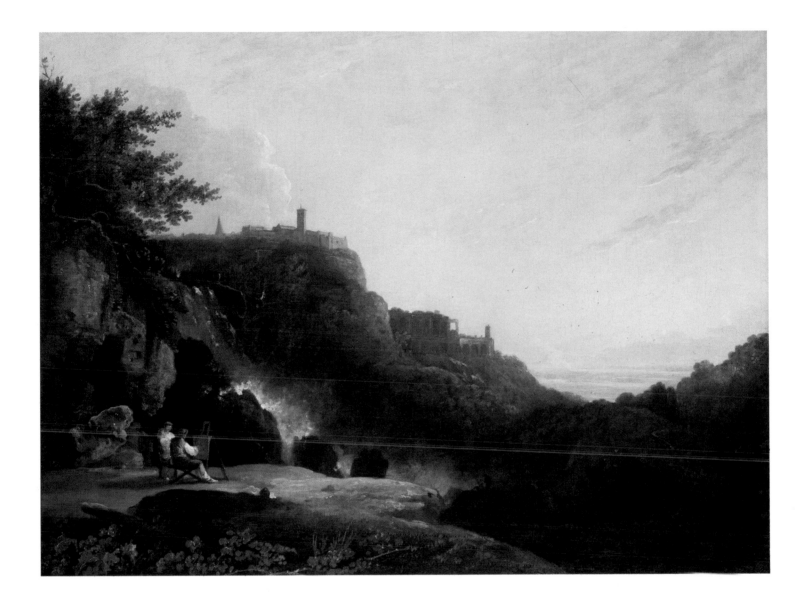

37 Philips Wouwermans
Haarlem 1619–1668 Haarlem

Philips Wouwermans was one of the most successful, and wealthy, of Dutch seventeenth century painters. The son of an artist, he is said (by Cornelis de Bie) to have been a pupil of Frans Hals, but there is no trace of Hals' influence in his early style. Wouwermans entered the Haarlem guild in 1640 and lived and worked in the town for the rest of his life. He was enormously prolific, specializing in scenes of riders in landscapes, often with camps, hunts and battles, but he also painted a handful of religious and mythological subjects. His work was widely imitated, by his brother Pieter and by later painters.

Halt of a Hunting Party
Canvas, 55.6 × 82.9 cm., $21\frac{7}{8} × 32\frac{5}{8}$ in.
Signed, lower right: *PHLS W*
Inv. no. 78.

Wouwermans dated very few works and a detailed chronology is difficult to construct. It seems that he adopted the signature PHLS W in place of a PW monogram in the latter part of his career. The fine, detailed brushwork and light, decorative palette of this painting is that of his last years and it should be dated c.1665.

The painting shows a hunting party consisting of two well-dressed couples – one resting in the foreground and the second still on horseback on the right – and their attendants. They have halted by a river to take refreshment. Hunting and falconry were aristocratic recreations in seventeenth century Holland and strict ordinances governed their pursuit: there were, for example, limitations on the number of greyhounds which could be used, and the hunting of certain game birds such as pheasants and partridges was restricted to the nobility. Hunting is particularly associated with the Orange court: the Stadholders Maurits, Frederik Henry and Willem II were enthusiastic huntsmen, especially the latter (later King William III of England) who hunted from his palace, Het Loo, near Apeldoorn.

Wouwermans' hunting scenes were enthusiastically sought after by aristocratic collectors in France and Germany in the eighteenth century: the archducal collection at Kassel, formed in the mid-eighteenth century, contains no fewer than thirty-six paintings by Wouwermans. The Dulwich painting is recorded in one of the most notable French aristocratic collections, that of the Duc d'Orléans, in 1739.

C.B.

PROVENANCE: Orléans Collection, Paris, by 1739 (J. Moyreau, *Oeuvres de Phpe. Wouwermans [sic] Hollandois: gravés d'après ses meilleurs tableaux qui sont dans les plus beaux cabinets de Paris et ailleurs*, Paris, 1737–80, plate 38. Inscribed: PETITE CHASSE A L'OYSEAU. Gravé d'après le Tableau Original de Ppe Wouvermens [sic] de deux pieds sept pouces de large sur vingt pouces de haut qui est au Cabinet de MONSEIGNEUR LE CHEVALIER D'ORLEANS. 1739); (Hofstede de Groot, followed by Murray, identifies this painting as lot 10 in the I. Hoogenburgh sale, Amsterdam, 10th April 1743: Een Valkejacht Kapitaal en konstig door Philip Wouwerman, br. 2v. 8d., h. 2v en een half d. Not only do the measurements not agree with the Dulwich painting but the description could apply to a number of paintings by the artist. It seems unlikely that the Dulwich painting left the Orléans collection as early as 1743): J. Danser Nijman sale, Amsterdam, 16th August 1797 (lot 303; sold for 1800g. to Van Santvoort); Bourgeois Bequest, 1811.

LITERATURE: Smith I, no. 215; Waagen II, p. 343; HdG II, no. 659; Rosenberg/Slive, pl. 141A.

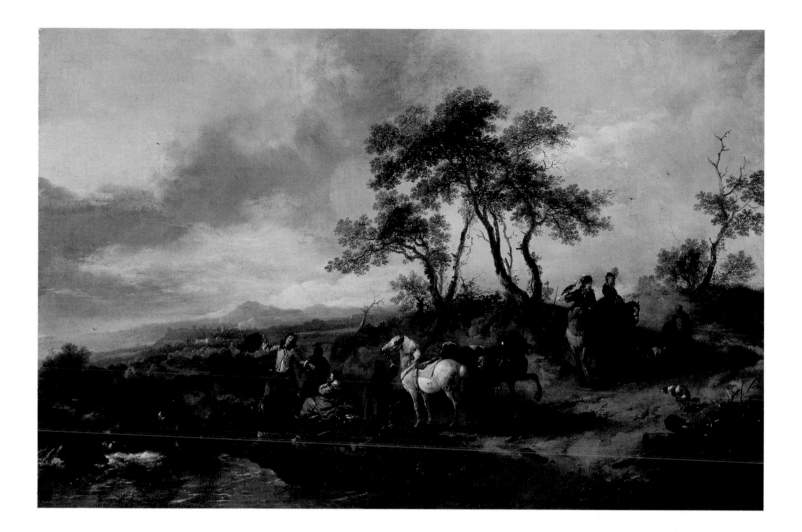